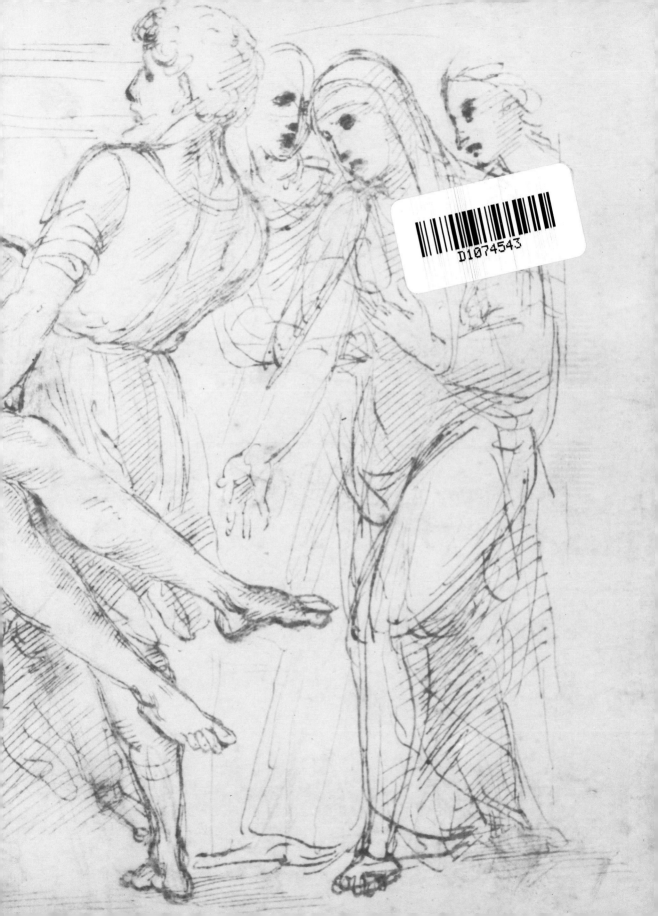

RAPHAEL
The life and the legacy

David Thompson

RAPHAEL
The life and the legacy

British Broadcasting Corporation

The three Raphael films on which this book is based were first broadcast on BBC2 in April 1983. The principal members of the BBC crew involved were as follows:

Producer and director: Ann Turner
Film Editor: Roy Fry
Assistant Film Editor: Jacqueline Powell
Film Cameraman: John Baker
Assistant Film Cameraman: Nick Squires
Dubbing Mixer: John Hale
Film Lighting Electricians: John Montgomery, Des O'Brien
Rostrum Cameraman: Ivor Richardson
Location Research: Elizabeth Kilham Roberts
Stills Research: Margaret McKenzie
Stills Photographer: Mike Sanders
Production Assistant: Angela Lance

Published by the British Broadcasting Corporation
35, Marylebone High Street, London W1M 4AA

ISBN 0 563 20149 5

Set in 11/13pt Monophoto Bembo
and printed in England by Jolly & Barber Ltd, Rugby
Colour separation by Bridge Graphics Ltd, Hull

Contents

Selective Reading List

RAPHAEL

Crowe, J. A. and Cavalcaselle, G. B. *Raphael: his life and works*, 2 Volumes; John Murray, 1882–85: op.

Fischel, O. *Raphael*; Kegan Paul, 1948: op.

Pope-Hennessey, J. *Raphael*; Phaidon Press, 1970: op; Harper and Row, paperback, 1979.

Prisco M. and de Vecchi, P. *L'Opera completa di Raffaelo*; Milan, Rizzoli, n.e., 1979.

Salmi, M. and others. *The Complete Work of Raphael*; New York, Harrison House, 1969.

Shearman, J. *Raphael's Cartoons in the Collection of HM The Queen. . .*; Phaidon Press, 1972.

Vasari, G. *Lives of artists*; Penguin Books, 1965.

GENERAL

Burckhardt, J. *The civilisation of the Renaissance in Italy*; 1860: Phaidon Press, 1944: op; Paperback, 1981.

Castiglione, B. *The book of the courtier*; 1561: (Everyman Edition) Dent, 1928; Penguin Books, 1976.

Clark, K. *Civilisation*, BBC: John Murray, 1969; Paperback, 1971.

Clark, K. *The nude*; John Murray, 1956: op; Penguin Books, 1976.

Clark, K. *Rembrandt and the Italian Renaissance*; John Murray, 1966.

Haskell, F. J. H. and Penny, N. *Taste and the antique*; Yale University Press, 1981.

Hendy, P. *Piero della Francesca and the early Renaissance*; Weidenfeld and Nicolson, 1968.

Lees-Milne, J. *Saint Peter's*; Hamish Hamilton, 1967.

Masson, G. *Rome*; Collins, n.e., 1980.

Murray, P. *The architecture of the Italian Renaissance*; Thames and Hudson, 1979.

Wolfflin, H. *Classic art: an introduction to the Italian Renaissance*; Phaidon Press, 1948: op; Paperback, 1980.

Preface

We kept getting two immediate reactions. One was: 'I'm really very ignorant about Raphael.' The other was: 'I hope you're going to help me to like him.' They are reactions which stayed very much in our minds since the start of 1982, when Ann Turner and I began to work out a television project for the quincentenary of Raphael's birth. This book, which grew out of the programmes, is intended for people who make such devastatingly honest remarks. It omits some things the programmes included, and includes others which could not be explored in such a visual medium. But it is an attempt primarily to tell the main story and evoke something of the general background and circumstances which might not seem necessary in a more specialist study.

For help in making the films, we owe many a debt. Her Majesty The Queen has graciously given permission to reproduce works of art from the Royal Collection and drawings from the Royal Library, as well as to film and photograph the Royal Mausoleum at Frogmore. For valuable information we would also like to thank Sir Oliver Millar, Keeper of The Queen's Pictures; Sir Robin Mackworth Young, the Royal Librarian, and the Hon. Mrs Jane Roberts, Curator of the Print Room; Mr John Rowlands, Keeper of the Department of Prints and Drawings at the British Museum, and Mr Nicholas Turner, Assistant Keeper. The Secretary of the Vatican Museum, Dott. Walter Persegati, and Mrs Marjorie Weeke of the Vatican Commission for Social Communications gave us invaluable help, as did Dott. Paolo dal Poggetto, Soprintendente delle Gallerie delle Marche, Urbino. We would like particularly to thank Elizabeth Kilham Roberts for opening many doors for us in Italy.

On the book itself, it would be invidious for me to try listing all those I am indebted to for information, opinions and helpful suggestions. Far too often I cannot even remember who first told me a fact I should have known or made a revealing comment which was promptly absorbed into my own thinking. But without Ann Turner neither programmes nor book would have been possible. She took a tentative suggestion and coaxed, prompted, supported and filled it out until it became a feasible reality. She alerted me to aspects of the subject I would never have spotted for myself and though she must be absolved from my choice of words, she is in a very real sense part-author of the book. My admiration and gratitude are very deep. For their patience, help and skill in preparing the book for the press I would like to thank Stephen Davies, Judy Moore and Linda Blakemore. My wife Freda listened to the text in endless fragmentary instalments and brought an instinctive editorial flair to her suggestions for improving it. The book is for her.

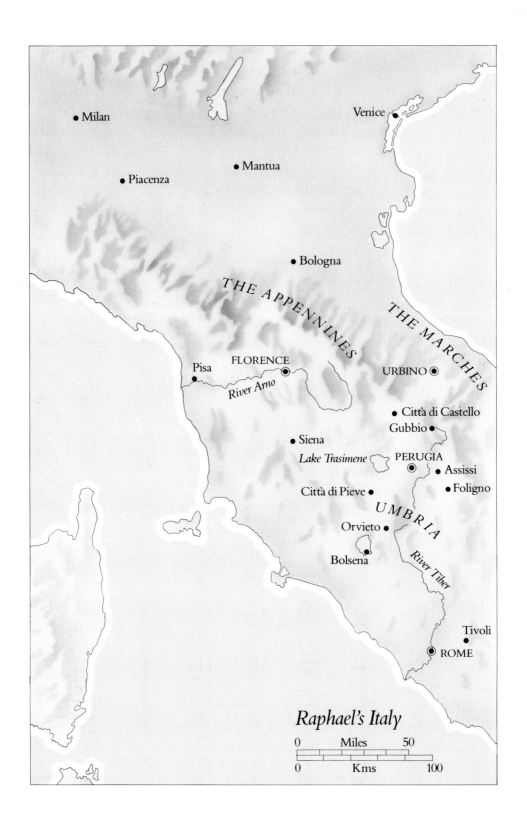

Milan

Venice

Mantua

Piacenza

Bologna

THE APPENNINES

THE MARCHES

Pisa

FLORENCE ◉

URBINO ◉

River Arno

Città di Castello

Gubbio ●

Siena

Lake Trasimene

PERUGIA ◉

Assisi ◉

Foligno

Città di Pieve ●

UMBRIA

Orvieto ●

Bolsena ●

River Tiber

Tivoli

◉ ROME

Raphael's Italy

0 Miles 50

0 Kms 100

Introduction
The School of Athens

Every year over a million and a half visitors from all over the world make their way to a not over-large room in the Vatican to look at a painting called *The School of Athens*. It is a fresco, in the rather pale chalky colours of fresco, about twenty-two feet wide with an arched top, occupying the whole upper wall of one side of the room. The furthest you can stand back from it is less than its own width, so that you are permanently in the front stalls, as it were, looking up at what is not unlike a wide, deep stage on which is gathered a cast of over fifty characters. They are all men, some old, some young, dressed in multicoloured robes of no discernible period. Who they are or what exactly they are doing is not immediately clear, though many are engaged in earnest or animated discussion while a few sit plunged in solitary thought. As at a play where you feel you have lost track of the plot because you're not sure you understand the language, your attention may shift to the scenery. That is impressive – huge coffered arches going back in perspective and opening on to distant blue sky. It lends a sense of occasion and grandeur to the whole scene.

For most visitors, of course, it is virtually impossible to look at the work so innocently. Some foreknowledge of it and of its author preconditions the very act of coming here at all. Like the *Mona Lisa* it is embedded in the cultural consciousness of Europe. And, as with so many works of art that carry the admiration of centuries around with them as part of their personality, the fame of *The School of Athens* makes it harder to see. Some visitors in earlier centuries even confided to their journals that it disappointed them. They were so well versed in it and moved by every aspect of it from engravings and descriptions, and their expectations of it as a masterwork of the most revered painter who had ever lived were set so high that, confronted with the actuality, they found it had little more to say than they knew already. Nowadays our response tends, if anything, to be the other way round. It is easier to admire the actuality than to be sure what it says.

Modern cleaning and restoration have probably left it looking nearer its original state than it has for centuries. Its size, the cool beauty of its colour, the grace of its movement and proportions within the room as a whole convey at the very least an aesthetic pleasure that no familiarity with reproductions can prepare one for. Its entire design is more legible, or what Baudelaire called *visible* – meaning easy on the eye – than, say, Michelangelo's frescoes in the Sistine Chapel, only a few corridors away. Yet that comparison makes us uneasy. *The School of Athens* comes to us grandly but in some way muted, its imagery less urgent, its very clarity more obscure than those enigmatic titans on the dim vault of the Sistine ceiling. Raphael cannot be approached before we have sorted out that comparison in our minds.

★*Figures at the shoulder of the text cross-refer to colour plates.*

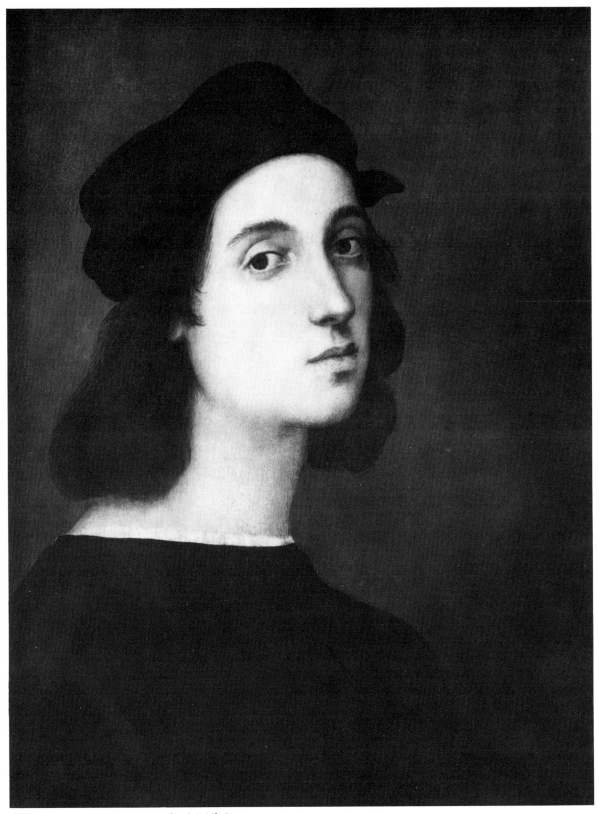

Self-portrait as a young man, Raphael (Uffizi)

He has always been set against the standards of others. In earlier centuries it was against those of Michelangelo or Titian, as a comparison of quality in a technical argument about drawing and colour. In our own it tends to be not only against Leonardo and Michelangelo, his contemporaries, but against Giotto or Masaccio or Velazquez or Rembrandt or any other in our compendious pantheon who amazes us more immediately or moves us more deeply. But these are comparisons of kind, in an argument about taste. They are not irrelevant, and we will need to examine them more closely, particularly in relation to a profound shift in cultural values which affects our own particular twentieth-century preferences. If *The School of Athens* leaves us mentally and emotionally slightly at a loss, it is because we have become unused to some of the ways it is intended to reach us. Visual eloquence of Raphael's kind is more likely nowadays to strand us in the aesthetic shallows of a painting than ease us towards its depths. Eloquence is a quality which, for no creditable reason, we resist. But in Raphael it is the first and necessary stage in the exposition of meaning.

The School of Athens is full of figures, and the most useful way in to the subject-matter of a painting is often the naming of names; people like to know about people. So guides and guide-books clamorously point out Plato and Aristotle, Socrates, Euclid, Diogenes, Alcibiades, Xenophon, Pythagoras, Heraclitus, Zoroaster and Ptolemy, let alone that some of these are portraits of Leonardo, Michelangelo, Bramante, Cardinal Bembo, Francesco Maria della Rovere, Federico II of Mantua, and that over on the right is a self-portrait of Raphael at the age of twenty-five or six next to his fellow-artist Giovanni Bazzi, known as Il Sodoma, who had previously been working on the frescoes in this room. In a sense, we are no further forward. Apart from a very few contemporary portrait-identifications, our cultural range of reference is out of its depth. 3

This room was once a Pope's library and private study. Today it is usually filled with crowds and noise, augmented from time to time by tannoy-announcements requesting quiet. It has probably been like that ever since the Papal apartments were first made accessible to public viewing. Originally the Stanza della Segnatura – the room for the signing of documents – can seldom have echoed to more than the hushed toings and froings of secretarial staff. The paintings on its walls presupposed the tone of a private room and a cultural range of reference befitting its use. That is one immediate distancing-factor between the *School of Athens* and us: its conscious scholarship has become a task instead of a pleasure of recognition.

Even if we could promptly identify every one of the eager youths and pre-occupied sages who fill the scene (and who all of them are is less certain than some of the guide-books make out), they are still distanced from us by their anonymous dress. Given that they are historical figures from different periods taking part in an allegory, their draperies clearly help the decorative unity of the gathering. They are all cast in a style of generalised Graeco-Roman classicism, and if that reference were not already clear, it is reinforced by the architecture and Graeco-Roman statues and bas-reliefs around the walls. The passion for classical antiquity which informed the

Italian Renaissance and sent its echoes down four centuries of European culture is particularly hard to recapture today. That is not because we have rejected it but because our own sense of the past is so much more diffused and compromised. Archaeology and ethnology have altered our conception of where the roots of culture lie. Aesthetically we can assimilate what would once have been called barbaric. The Renaissance view was more limited, more urgent and more moral. To dig up a previously unknown classical statue was an event fraught with emotion and significance. Each and every contact with its Graeco-Roman heritage justified a Renaissance yearning to match the best and highest of which civilisation had once proved capable.

That is largely what *The School of Athens* is about. Each folding of drapery, each turn of the body and physical gesture of its figures is calculated to raise the mind and stir the spirit with its reminder of an ennobling example. Not that classical proto-types are merely copied: that was not the point. They are relived. The painting takes place in the present. The classical statues of Apollo and Minerva in their niches are reinvented statues. Not only can Raphael's contemporaries be slipped into classical roles and garments, but, as the art historian Wölfflin pointed out, *The School of Athens* owes quite as much to animated Latin behaviour in any Renaissance piazza as to the inspiration of ancient marble.

One other ingredient of this fresco unquestionably influences our way of look-ing at it. That is Raphael himself and how we think of him. We have to contend with the knowledge of his overwhelming influence through three and a half cen-turies of European painting. We have to come to terms with a personality which is bound up with the reputation of his art. Both have inspired a love bordering on idolatry more rapturous than has been felt for any other artist in any medium. It was not accorded him for genius alone – in that respect he was less extraordinary than either Leonardo or Michelangelo – nor solely for the gifts of temperament and fortune that all added to the brilliance of his star. It is that even the barest facts about him are touched with portent. It is recorded on his tombstone, for example, that he died on 6 April 1520. It was not only his birthday, it was Good Friday. The coinci-dence was too much and too symbolic for his earliest biographer, Vasari, who declared he was born on Good Friday also, and although that would make the date of his birth 26 or 28 March rather than 6 April 1483 (depending on the method of calendar reckoning), 28 March has more than once passed into historical record as the appropriate day.

Vasari, who published his *Lives of the most eminent Painters, Sculptors and Architects* thirty years after Raphael's death but was drawing on contemporary recollections of him, records something else which already begins to glow with the halo of legend. 'One of his numerous qualities fills me with amazement,' he wrote, 'that Heaven endowed him with a disposition quite contrary to that of most painters. For all who worked with Raphael lived united and in harmony, their ill humours disappearing when they saw him, and every low or mean thought deserting their minds. Such a thing was never seen at any other time, and it arose because they were

conquered by his courtesy and tact, and still more by his good nature, so full of gentleness and love that even animals loved him, not to speak of men. We may indeed say that those who possess such gifts as Raphael are not mere mortals but rather mortal gods. Surely his soul adorns Heaven as his talent has embellished the earth.'

This clear candidate for hero-worship looks out at us from the right-hand group in *The School of Athens* – absurdly young, rather bland, slightly androgynous, 2 certainly not characterful enough to square with all we are expected to admire him for. It may be illogical or it may simply be human nature, but what we know of an artist's appearance and personality does colour our approach to his work. That this is what Raphael looked like has appealed to the sentiment of many generations. It does not appeal to ours, but unfortunately it is still how most people think of him. There are in fact other images, more persuasive but much less familiar. The most haunting is an engraving by his friend Marcantonio Raimondi – a withdrawn and solitary figure wrapped in a cloak and his own thoughts. The most forceful is the

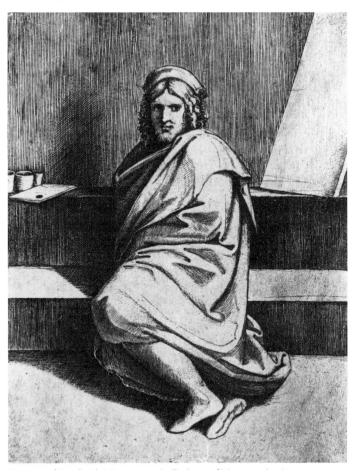

Portrait of Raphael, Marcantonio Raimondi (engraving)

13

115 one in the Louvre, part of a double portrait which used to be considered suspect but is now accepted as authentically by Raphael. It shows no consumptive darling of the gods who died tragically young, but a bearded, brooding Renaissance aristocrat in the full maturity of his powers. Both are later than *The School of Athens*, but both give us what the earlier self-portrait lacks. We are dealing with a singular personality, with a meditative intellect and a capacity for deep but contained emotion.

Armed with such an image, it is easier to concentrate on the one over-riding feature of *The School of Athens* which raises all these considerations on to another plane, and that is the space in which the whole scene has been imagined. The grandeur of that immense architectural setting, high, wide and deep, receding in stately progression through three vast archways to the open sky, is what silences you first about the painting and yet what perhaps you consciously recognise last as the clue to what it says. Nothing in art or life so lifts the spirit with a positively physical sense of heart's-ease as to let the eye feel its way towards some great distance and rest there. Nothing is so calming and yet exhilarating as to be made aware not only of space but spaciousness, of room to feel free in. If one knew nothing else about this painting, one could be sure from the setting alone that it spoke of noble and uplifting matters. When you arrive at it through claustrophobic corridors and the constriction of doorways, it suddenly pushes the walls back and lets you breathe.

Space in Raphael sets the stage for everything else he has to say. Of all the gifts showered upon him, none was greater than his fortune in having been born exactly where and when he was, in central Italy at the end of the Quattrocento. One of the most luminous apprehensions of Renaissance art in the half-century or so before his birth had been precisely this one of space. Space, in the first place, for a man to stretch in, to feel the measure of himself and his world as a physical being. But space, too, as an enlargement of the spirit, a sense of having infinity almost within visible reach. It had been achieved in the very first decades of the century, by a kind of visionary leap of pure eyesight, in the paintings of the van Eyck brothers and their successors in Flanders. In Italy it had been pursued longer and more steadily as a conscious intellectual aim, at the heart of which was the study of 'linear' perspective. *The School of Athens* is perhaps the grandest consummation of that study, with all the lines of its emphatic architectural symmetry converging on a mathematically precise central 'vanishing point' (a tiny triangle of green – perhaps of distant landscape – just where Plato's red robe touches Aristotle's blue one). It is in fact a limitation of strictly symmetrical linear perspective, a limitation Raphael later avoided or at least disguised, that in order not to distort the spatial illusion of which it is capable, the spectator must stand opposite it dead-centre.

Spatial illusion as such, however, was what Raphael's predecessors in the fifteenth century had not yet perfectly achieved, for all their eagerness to do so. Or perhaps it should not be called 'illusion' so much as that kind of pictorial confidence which allows the imagination to move around, three-dimensionally, on a large scale, in a painted world. In Flanders they could paint the feel and touch of things with

hallucinatory realism, but as though the world were a miniature one, always close-to and in vivid focus. In Italy they had an intellectual grasp of the roundness of forms and the depth of space, but not yet that ease in handling or combining them which can make one forget about the ingenuity of the whole exercise. The transition from Early Renaissance to what we now call High Renaissance – those two brief decades that inaugurate the sixteenth century in Italian art – is to some extent concerned with achieving that kind of ease. We begin, as we do in *The School of Athens*, to move in a new kind of space, more ample, more assured. The mastery of it is more taken for granted, as a natural extension of the subject-matter. But if much of the grandest fifteenth-century painting (Masaccio, for example, or Mantegna) can be seen anticipating such largeness of vision, by the 1480s there were perhaps only three painters in Italy who could show, in their very different ways, how it might ultimately come about. They were Piero della Francesca, Leonardo da Vinci and Pietro Perugino. All three are significantly involved in the story of what may be called Raphael's 'apprentice years'.

For a few years in Rome at the beginning of the sixteenth century all the aspirations of the Italian Renaissance reached a kind of consummation in what is called the High Renaissance. Four of its principal creators are represented in Raphael's most famous painting, *The School of Athens* – Leonardo da Vinci, Michelangelo, the architect Bramante, and Raphael himself. Painted in 1509/1510, the fresco occupies an entire wall of what was formerly one of the Pope's private apartments in the Vatican (1). It expresses the pride and confidence of an age which believed itself the heir of all that was noblest in human endeavour (2). Leonardo, its own universal genius, is depicted as the greatest of philosophers, Plato, conversing with Aristotle and pointing to the ever-upward reach of the mind of man (3).

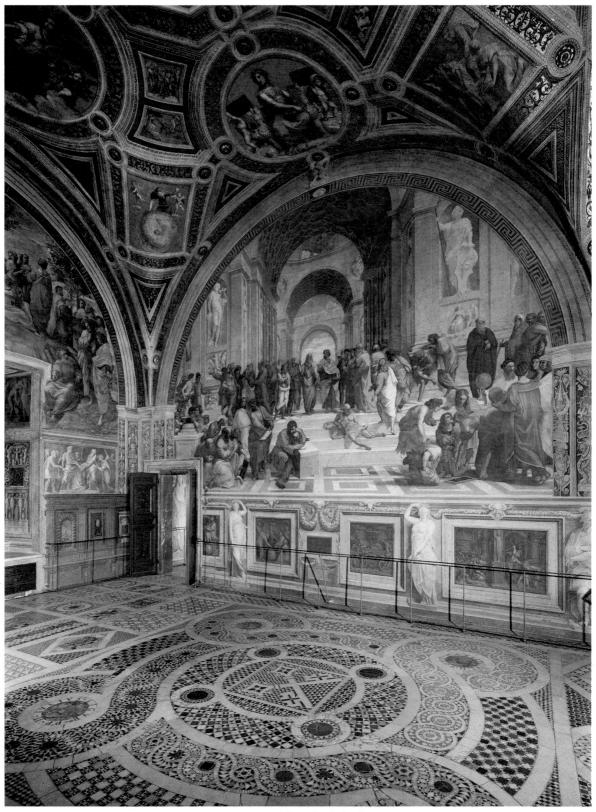

1 VATICAN, RAPHAEL ROOMS: STANZA DELLA SEGNATURA: *The School of Athens*

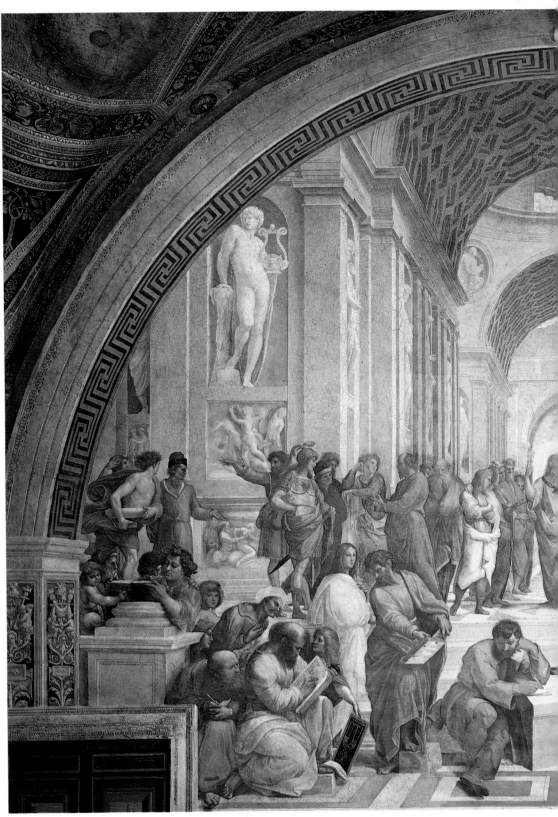

2 *The School of Athens*

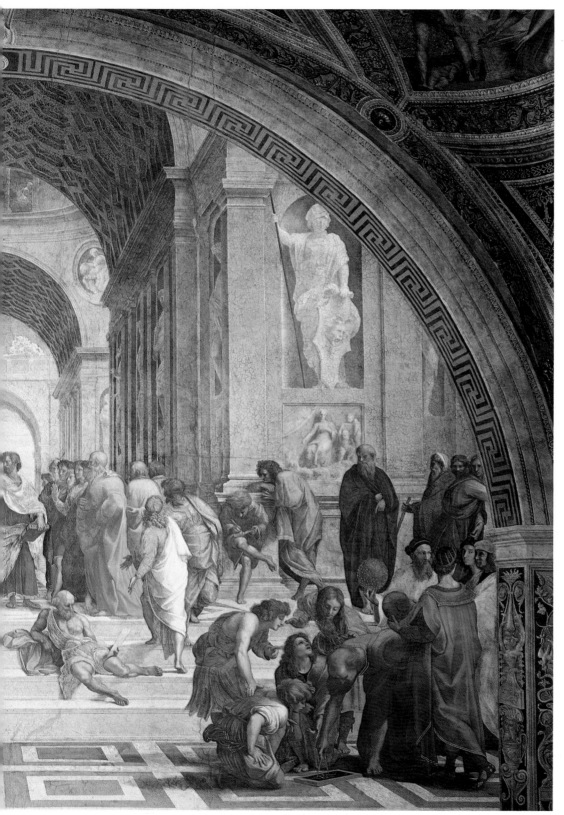

3 (overleaf) *The School of Athens*, detail of Plato and Aristotle

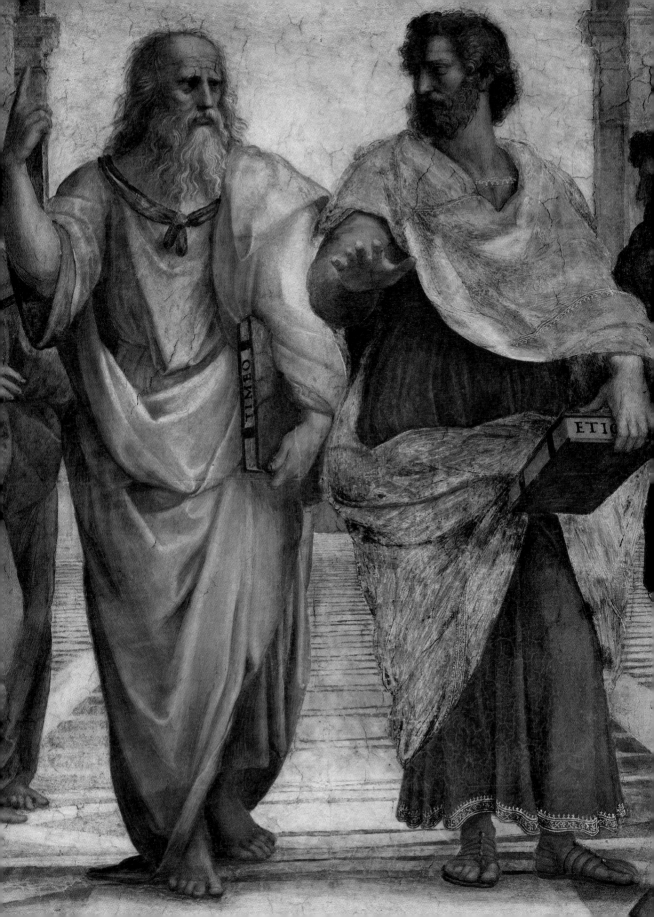

Part One
The Apprentice Years

Raphael is a painter quite recognisably in love with the landscape in which he grew 6,7,8
up. It appears again and again in his work, always as the background for figures, but
different in type and atmosphere and quality of observation from the background-
landscapes of his predecessors. But then he came from a different part of the country.
Urbino, his birthplace, is a little hill-top city of the Marches on the eastern, Adriatic
side of the Appennines: and Perugia, where he was first apprenticed, crowns another
hill-top of their western slopes, as they dip and roll towards the Umbrian plain along
the shores of Lake Trasimene. It is all a soft, lyrical, undulating countryside, still
thought by many people to be the most beautiful in Italy; essentially tranquil except
for the spice of drama from rocky spurs of mountains on the horizon. And it is soft
and lyrical as Raphael paints it. That love of nature and love of light which trans-
form the European vision of landscape in the van Eycks and the art of Giovanni
Bellini – older than Raphael by fifty years but still active in Venice – take on in
Raphael himself the more romantic character of an idealised love. His landscapes
are memories of timelessness. Full of observant detail, they are nevertheless distil-
lations of feeling, evocations of the easeful extensiveness of space.

Looking out over that countryside, dominating the city of Urbino, is a palace, 5
and it is a palace which strikes every visitor today, as it has done ever since it was
built, as one of the most enviably humane expressions of Renaissance taste and
culture ever achieved. And as you cross its famous courtyard by Laurana, or move 13
through the sequence of its rooms, you are made aware that, in this building, space
reveals another aspect of its hold on the imagination. It can be measured. It can be
made to yield visible form to intellectual ideals of clarity, order and mathematical
proportion. Space as architecture became for the Renaissance as much a symbol of
liberated mind as landscape could be of the liberated spirit: the physical setting for a
new aspiration towards human fulfilment. If there was anywhere in Italy in the last
quarter of the fifteenth century where all aspirations of such a kind met and flowered
in their purest form, it was in the Ducal Palace of Urbino, within sight of which
Raphael was born and in whose ambience he grew up.

It was the creation of one of the most successful *condottieri* of his time, Federigo
da Montefeltro. Federigo's memorably battered profile is familiar today from the
diptych of himself and his second wife, Battista, painted by Piero della Francesca 12
and now in the Uffizi: in his twenties he had lost his right eye and the bridge of his
nose in a tournament, so that he would only present the left side of his face to
portraitists. With a reputation for honour as well as military prowess, he amassed
enormous wealth largely from the retaining fees paid him by, among others, the
Pope, and he used it not only to build his palace but to raise his hereditary domain,

Urbino, to political power and administer it with exemplary benevolence. He had virtually abolished taxes and believed in fostering a relaxed personal contact with all ranks of his subjects. Asked by his court-chronicler, Vespasiano, to define the first quality of a good ruler, he had replied simply 'essere umano' – to be humane. But it was the way he fulfilled that Renaissance ideal of being simultaneously a man of action and a man of culture which made Castiglione describe him as 'the light of Italy'. He was no mean scholar in a court which attracted scholars. He had a library of finer quality even than that of the Vatican, and commissioned some of the first Renaissance translations from the Greek. At the same time, the discernment of his taste in art and architecture was embodied in every aspect of design and decoration which made the Ducal Palace so eloquent a statement of his personality.

Urbino, Ducal Palace: *The Duke's Bedroom*

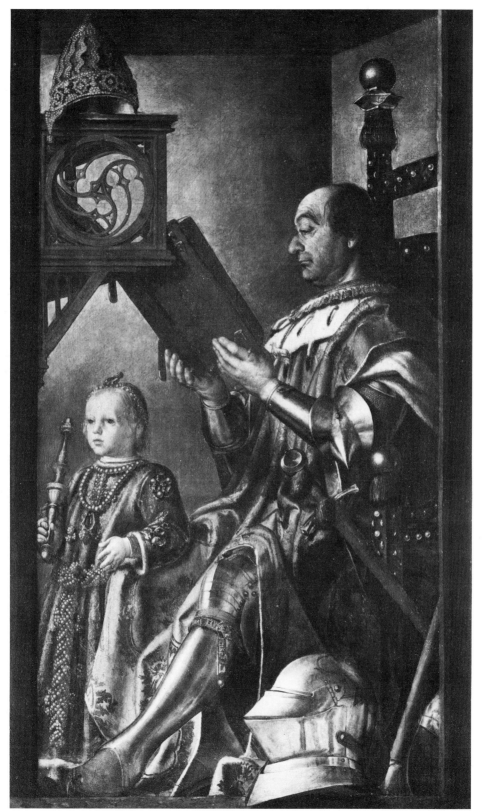

Federigo da Montefeltro and his son Guidobaldo, Pedro Berruguete (Urbino, Ducal Palace)

Federigo had died the year before Raphael was born, leaving his young and rather sickly son, Guidobaldo – only ten years Raphael's senior – as the reigning Duke. The court under Guidobaldo was to sustain for another two decades, and even refine upon, the tone which had been set for it by Federigo.

As a physical environment the Palace expressed almost palpably a marriage of mind, spirit and senses, and to the eye of a young, impressionable artist growing up in almost day-to-day contact with it, it was an object-lesson in the complementary facets of Renaissance humanism. Side by side with the Duke's private chapel was a 'chapel' to the Muses. No religious conflict was implied or even considered. On the architectural scale, there was the compelling purity of the new classicism, speaking the language of abstract harmony and thought. On a more intimate one, naturalistic detail enlivened the carving of an overmantel or the delicate panels of ornament round a window or doorway, where imagination and wit played games of skill for the delight of it. Duke Federigo, who favoured sobriety in dress and refused to clutter his state apartments with tapestries or frescoes, had created for his intellectual retreat a little *studiolo* which has become famous for the rich fantasy of its intarsia work – walls of inlaid wood giving a startling illusion of windows, shelves and half-open cupboards crammed with the apparatus of a scholar's cabinet of curiosities.

The paintings collected or commissioned by the Duke reflected a similar conjunction of taste, classical spareness on the one hand and rich realism on the other. One of them, brought from the Cathedral sacristy to the Ducal Palace where it can still be seen, was that mysterious masterpiece of silence and stillness by Piero della Francesca, the *Flagellation of Christ*. One of a different kind may have been Van Eyck's *The Bath of Women*, now lost but recorded as having been at some time in Urbino. Flemish oil-painting was much admired and a Flemish painter, Justus of Ghent, was actually employed at court. The Spaniard Pedro Berruguete was responsible for a portrait of vivid actuality, still there, of the Duke reading in his study, wearing the Order of the Garter conferred on him by Edward IV of England, and with the boy Guidobaldo at his knee. Signorelli painted a double-sided processional banner for the court, which also survives. Botticelli is believed to have designed the figures for a sumptuous pair of doors in inlaid wood.

In company like that, a rather less distinguished figure is cut by the local court-painter, Giovanni Santi. Raphael's father has been rather scorned as an artist by later critics from Vasari onwards. But in fact, given a certain provincial dryness, his paintings are not without personal charm and feeling. Certainly he was not without local success. His position at court was more firmly established after Duke Federigo's death – that is to say, when the greater artists had departed – and competent frescoes and altarpieces by him are to be found in several neighbouring towns.

The family house in Urbino, the Casa Santi where Raphael was born, shows him to have been a man of considerable substance. It is a surprisingly large house even for a court functionary, with rooms beyond the inner courtyard where he ran an evidently thriving *atelier*. Nor were his artistic horizons provincial. On Duke Federigo's death he wrote a 'chronicle' in verse, basically a loyal tribute to his late

master's perceptiveness in matters artistic, which has often occasioned some surprise at his own. He charts the course of a new art according to developments in perspective, tracing accurate connections between Flanders, Florence and the artists of central and northern Italy with whom he was most in touch. Nor has history seriously faulted the list of contemporaries he singled out for praise in 1482, including Ghirlandaio, Botticelli, Signorelli, Verrocchio, Mantegna, Leonardo and Perugino.

Giovanni Santi died when Raphael was eleven, leaving the boy until at least the age of seventeen, when we first have documentary evidence of him, as the ward of an uncle, Don Bartolommeo. Apart from some muddled chronology, we have to trust Vasari's *Life* for our few glimpses of that boyhood. Raphael's mother, Giovanni's first wife who died in 1491, had suckled the child herself so that no peasant wet-nurse should imbue him with 'the rough manners of people of low condition'. From his father he had learned the rudiments of art and even, according to Vasari, 'assisted him', although that can hardly have meant much more than helping to grind colours in the workshop. Tradition inevitably adds that the beautiful child appeared in some of his father's pictures, but that is beyond proof apart from one tantalising possibility in the Casa Santi itself. A small fresco there of a Madonna and Child is claimed by some scholars as Raphael's own work, painted on a later 11 return to his birthplace from Perugia. But others support the well-established tradition that it is by Giovanni, in which case it must surely be modelled on his own young wife and son. It is an attractive thought. Behind the general guesswork about Raphael's childhood, though, lies an important question. His father was an official at the Ducal Palace. How much could the boy himself have been influenced by its atmosphere and culture, by the physical setting and intellectual ideals of that celebrated enclave of civilised values?

It was not only as a child that he experienced them. He returned to Urbino more than once as an artist of growing repute. In all probability he painted the portraits (now in the Uffizi) of Duke Guidobaldo, his childhood contemporary, and of his Duchess. Several others of his early paintings have direct or indirect associations with the ducal court. His personality and his art were to be marked throughout his life by a certain grace and ease of manner, and also by a highly literate intelligence, which bear all the imprint of that court. Two men, moreover, whom he counted among his closest friends, were as familiar with it as he was – the architect Bramante, himself a native of Urbino: and the writer and diplomat, Baldassare Castiglione. Bramante, from whom Raphael acquired much of his own knowledge of architecture, may actually have had some hand in the later details of the design of the Ducal Palace. Castiglione, for his part, chose it as the setting for a famous 'portrait' of the perfect Renaissance gentleman. More than just a book 17 of manners, *The Courtier* takes the form of a lively discussion between historical members of the court itself (two of them suggested to Shakespeare the characters of Beatrice and Benedick) about certain ideals of human behaviour. It is about 'civilised' conduct as the mark of sensitive minds, about seemliness and care for the feelings

of others in personal relations, about the outward expression of innate nobility. Everything we know about Raphael confirms that Castiglione's book reflects qualities and values he himself grew up with, tried to live by and to express in his art.

There is one further question about what he may have absorbed from Urbino and its artistic tradition. The Ducal Palace is so imbued with the spirit of Piero della Francesca that it is thought he may even have advised on its design. There are details of classical construction, for example, in his *Flagellation of Christ* which perfectly match those of the palace, though the latter was mainly carried out by the architect Laurana. Urbino is not, in spite of Vasari's suggestion, where Piero first made his reputation. But he himself states in his dedication of a treatise on mathematics to Duke Guidobaldo that it was to Federigo, the Duke's father, that he had 'given of his best'. We know it was to Federigo that he dedicated an earlier and more substantial treatise *On Perspective in Painting*, and that he shared with him an interest in Flemish painting and the Flemish technique of oil-colour. One particular picture in the palace which Raphael could have known is a perspective-study nowadays ascribed to Piero's 'circle' (the word itself implies that his ideas were influential). It is a long, horizontal panel, originally one of a pair, showing a city-square in cool morning light. It is not an actual city, but a perfectionist's dream of the 'ideal' city, lucid, humanly proportioned in pure classical style, waiting to be inhabited. At the centre is a perfectly circular building. Idealist thought always comes back to the mystery of the circle. Renaissance philosophy, Renaissance religion, Renaissance

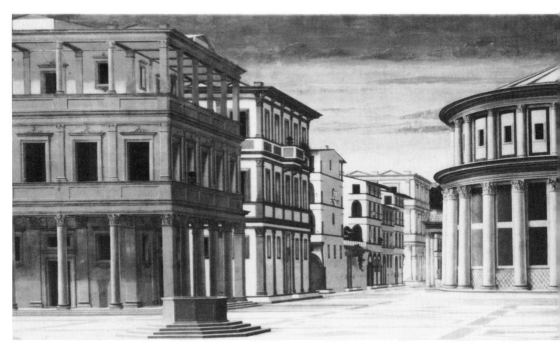

An Ideal City; Piero della Francesca (?); (Urbino, Ducal Palace)

26

mathematics each find satisfaction in it as symbol and image, while circular buildings suggested both classical and Christian precedents in the *tempietto* and the *martyrium*. It is a theme we shall meet again.

Piero may have become blind in his old age and is not known to have been at work during Raphael's lifetime. His art involved a rigorous intellectualisation of spatial ideas to serve a majestic conception of humanity. At best we can only surmise what it may have meant to the younger artist. But there is a further coincidence which, however tenuously, links their names. The painter to whom Raphael was ultimately apprenticed, with whom he learned to master the techniques of perspective and pictorial space, is believed to have served his own first apprenticeship in the workshop of Piero.

Continued on page 37

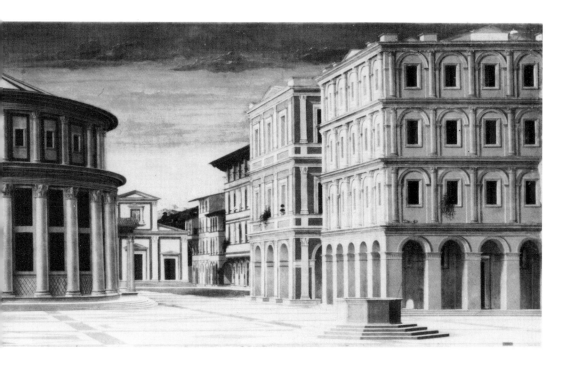

orn in 1483 in Urbino, Raphael was brought up in an exceptional city and a particularly beautiful part of Central Italy (5–8). The family house reflects the prosperity of his father, Giovanni Santi, who was court-painter to the Dukes of Urbino (9–11), and from his earliest years Raphael would have been familiar with the Ducal Palace built by Federigo da Montefeltro (12–14). Federigo had made it one of the most distinguished centres of the age for art and classical scholarship (15, 16). In Raphael's own day the court of Urbino remained a byword for refinement, culture and grace, and his great friend Castiglione (17) made it the setting for a famous book, *The Courtier*.

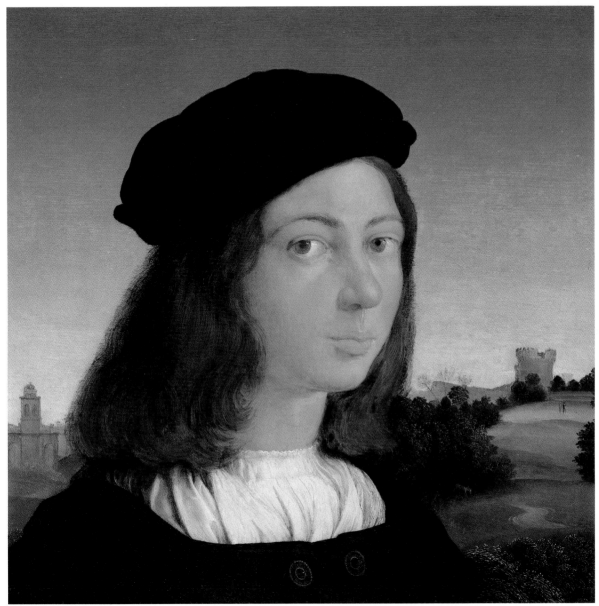

4 *Early self-portrait*, Raphael (Hampton Court)

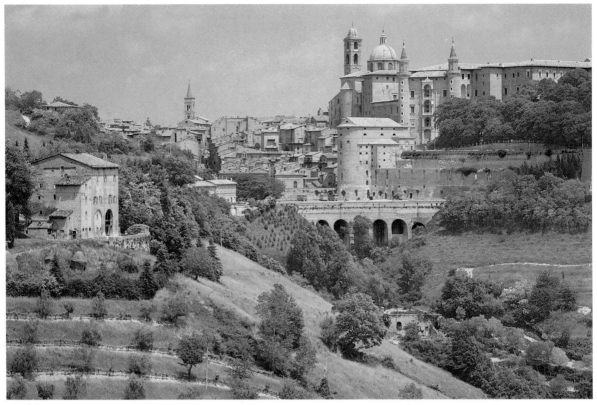

5 Urbino

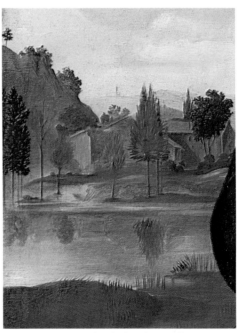

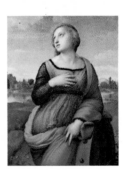

6 *St Catherine*, Raphael: detail (London)

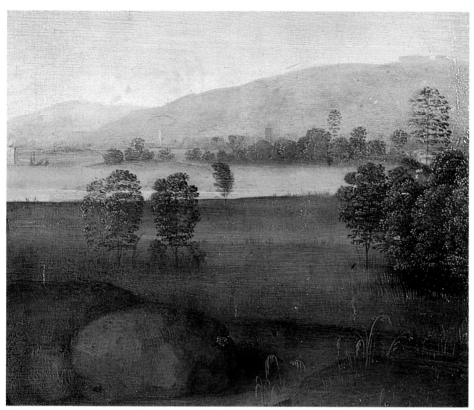
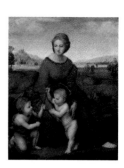

7 *Madonna of the Meadows*, Raphael; detail (Vienna)

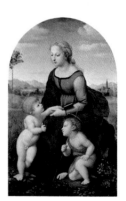

8 *La Belle Jardinière*, Raphael: detail (Louvre)

9 Urbino, Casa Santi: *Sala Grande*

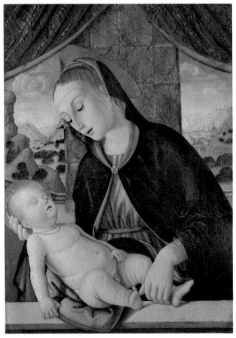

10 *Madonna and Child*, Giovanni Santi
(London, National Gallery)

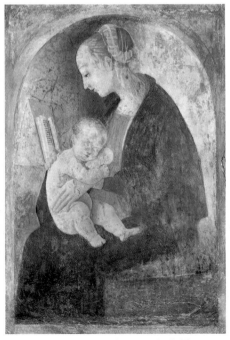

11 *The Casa Santi Madonna and Child*,
attr. Raphael or his father

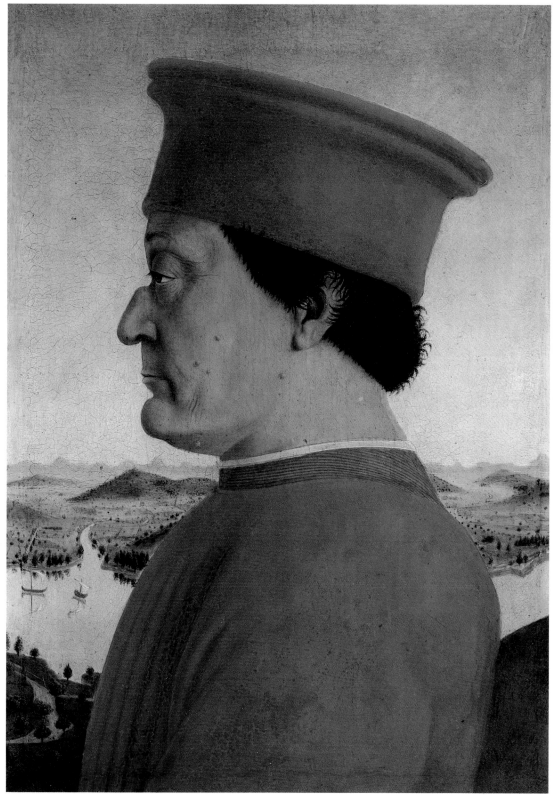

12 *Federigo da Montefeltro*, *Duke of Urbino*, Piero della Francesca (Florence, Uffizi)

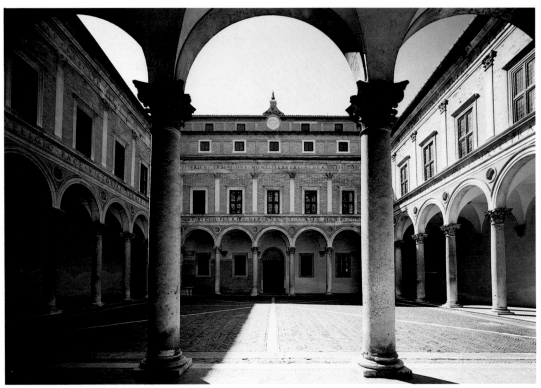

13 Urbino, Ducal Palace: *Courtyard* by Laurana

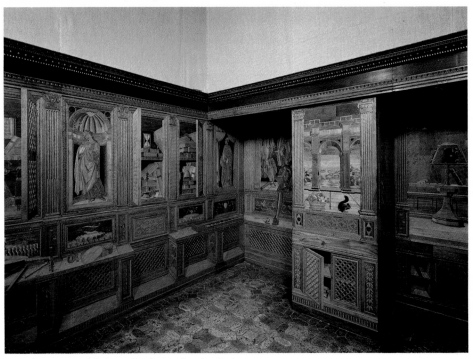

14 Urbino, Ducal Palace: *Studiolo* of Duke Federigo

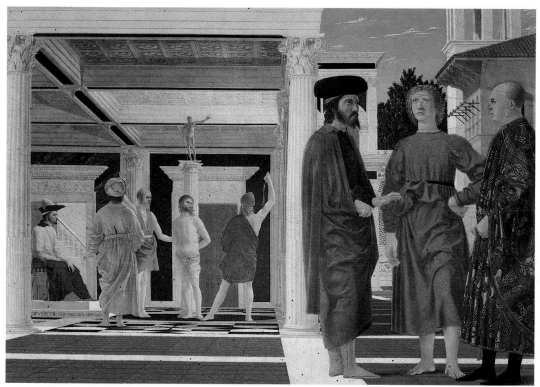

15 *The Flagellation of Christ*, Piero della Francesca (Urbino, Ducal Palace)

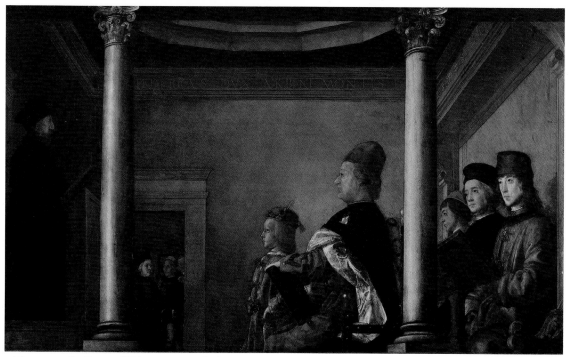

16 *Lecture at the Court of Urbino*, Justus of Ghent (Hampton Court)

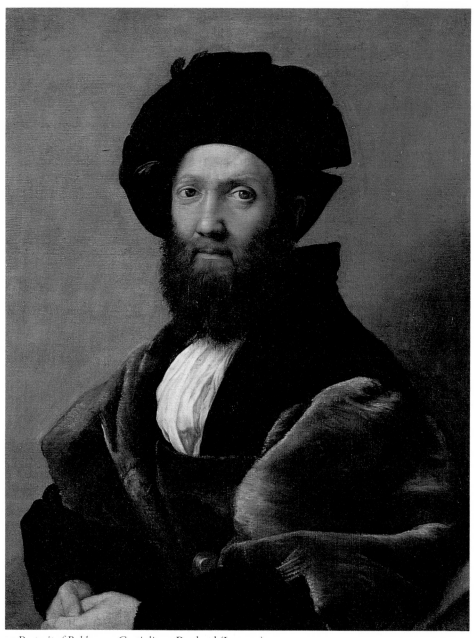

17 *Portrait of Baldassare Castiglione*, Raphael (Louvre)

The main street of Perugia, the Corso Vannucci, bears the actual surname of the painter who is better remembered by the name of the city. Perugino was not a native-born citizen (he came from nearby Città della Pieve) but he was made an honorary one in 1485 for having conferred some of his own renown on Perugia when he made it the centre of his widespread activities and set up his workshop there. Most established painters followed the practice of founding an art-factory where apprentices could be trained in the crafts of the studio and then graduate to assisting the master in keeping abreast of his commissions: if unusually talented, they might become junior partners within the 'firm', carrying out their own commissions as independent artists. This was the course followed by Raphael. 'Charming Pietro by clever drawing, amiability and polished manners,' as Vasari tells us, he may have been taken first into Perugino's household as an adoptive member of the family – that is, if he was really as young at the time as Vasari implies. Obviously a favoured pupil, he must have travelled widely and observed the artistic climate in many other centres than his own long before he was twenty, for Perugino's work kept him constantly on the move. On the other hand, he kept within Perugino's orbit for surprisingly long. He was still using the Perugia workshop as an operational base for some years after he had started signing commissions of his own, and even after his removal to Florence. Few pupils have modelled themselves more closely on their masters, certainly few of Raphael's quality. Even fewer have been able to assume the master's identity and at the same time find their own personality within it, not by rebellion but by empathy.

Perugino himself is not now the most admired of painters. To modern eyes he falls between two stools: too sophisticated to look as innocently charming as earlier religious artists, and not sophisticated enough to rank with the best of his contemporaries. In his own day it looked different. When Raphael's father in his rhymed Chronicle links him 'equal in age and endeavour' with Leonardo, the judgement is a shrewder one for the 1480s than it appears now. The two artists had studied together in Florence under Verrocchio, and both seemed to be aiming at a unity of effect and largeness of vision which heralded a new awareness in painting. Perugino even at his most mannered is strikingly different from the rather garrulous kind of Quattrocento art which beguiles with its wealth of incident and the sharp observation of contemporary life. His angels, saints and Madonnas are removed from all anecdotal bustle and set apart in a world of timeless reverie. They too easily become a formula with him, posed gracefully with the weight on one hip, their small-featured faces almost identical in expression. But it is a formula he invented, and remarkably potent for conveying calm and lyrical spirituality in a racked and secular age. Above all, no one before him had so effectively related figures to the landscape or architecture they inhabit. The broad spatial planning of his compositions had depth, stillness and unity, combined with a quality of feeling which – in spite of a rather too languid soulfulness – breathes for the first time the air of a purer classical art which was still to be perfected. In all Italy, Raphael could not have been apprenticed to a painter better suited to point him to his future.

For those who believe that art reflects its society, Perugia offered a very different picture from Urbino of the kind of circumstances which produce art. Here there had been no soldier-statesman of Duke Federigo's calibre to ensure political stability or foster the pursuits of peace. The steep, ancient city with its Etruscan gates and narrow climbing alleys was 'distinguished' (in the bitter words of a contemporary chronicler), 'by men of infamous habits and iniquitous conduct'. Two families, the Oddi and Baglioni, were locked in a perpetual power-struggle over it, and the Guelphs and Ghibellines of Florence, or Shakespeare's Montagus and Capulets, pale beside them for the scenes of violence and bloodshed with which they filled its streets. Some of those streets survive today in a curious cellarage below Sangallo's Rocca Paolina fortress which was built over the top of them, and their subterranean silence is like a memory too grim to be left above ground. When one plot against the Baglioni was broken in 1491, 130 conspirators were strung up in the Palazzo Communale and a three-day mass was held at thirty-five altars in the square to purge the place of its curse. Conspiracies erupted even within the family itself. On the night of 15 July 1500, four of them were murdered during a wedding celebration, and the next day their nephew Grifone, who had led the plot, was in his turn slaughtered in the open piazza. Raphael would then have been eighteen, and could have witnessed another ritual of penitence in which the Cathedral had to be washed with wine and reconsecrated. Like the protesting but helpless citizens, a painter trying to pursue his art in such circumstances doubtless tried to remain neutral: a few years later he painted one altarpiece for the Oddi family and a second for the mother of Grifone Baglione. Such conditions were not merely local, though Perugia's may have been a shade worse than most. Art around 1500 was all produced against a background of 'the common calamities of the wars in Italy', as Castiglione called them. Most major cities were either tenuously held by military despots feuding between themselves or else being attacked by the forces of larger powers who laid claim to them. Raphael arrived in Perugia at a time when Cesare Borgia was subduing central Italy for the Pope and leaving a trail of atrocities in his wake. Florence had barely escaped being sacked by the French armies of Charles VIII. In April 1500 Leonardo had written some observations about the flight of hawks in his notebook, and then added an extra line. He had just heard that the French had toppled the regime in Milan of his recent patron, Lodovico Sforza.

Problems of spatial harmony or the graceful posing of angels seem to bear no relation to such turmoil, unless as escape, reaction or protest. The hushed devotion so apparent in Umbrian art was possibly all these things, possibly the necessary alternative. From the walls of Perugia you can just see Assisi, and the message of St Francis was as familiar in the city as the violence of its rulers. The most famous of Franciscan wandering preachers, Bernardino of Siena, had come here often. In 1425 they had built an outdoor pulpit beside the main door of the Cathedral for him to preach from. Canonised soon after his death, he was to appear in painting after painting of the late fifteenth century, his instantly recognisable features obviously a living memory. Perugia raised an Oratory to him in 1461, designed in the classical

style of Alberti by Agostino di Duccio and embellished by him with exquisite carvings of smiling angels bearing the saint to Heaven among swirls of blown drapery. Perugino, in one of his earliest altarpieces about ten years later, had painted scenes from his life.

The tone of religious art in this troubled city retained an urgent piety which was very much its own. It seemed to echo the keen, sweet fervour of Gothic spirituality for longer than the sentiment persisted in more cosmopolitan centres like Florence or Siena. Perugino himself had both sensed it and enlarged upon it, and through Perugino it is picked up by the young Raphael. Raphael is so much the central channel through whom religious feeling of a certain readily accessible type is transmitted from one stage of the Renaissance to another, that one cannot stress too early in his career the gift he had for expressing it. He was to express it in changing terms, emotionally and stylistically, as his aesthetic concerns themselves changed. It is a feature of his art which may have less to do with personal faith than with sensitivity to the tone and atmosphere of faith, but what was first demanded of him here in Perugia was a tone he caught with remarkably sure sympathy – that intense, lyrical devotion which a more sophisticated context like Florence might never have given him the time to explore.

It is around 1500 that his presence in Perugino's workshop starts to make itself 24,25 felt. That is the date recorded in the frescoed decorations for the Audience Hall of Perugia's Chamber of Commerce, the Cambio, for which Perugino had been commissioned four years earlier and which was carried out with the help of his assistants. Vasari says the master 'would have gone to any lengths for money' (he actually began life in great poverty). So perhaps he took sly pleasure in devising for this room devoted to finance, a scheme calculated to raise its moral tone. The birth and transfiguration of Christ occupy the end wall, the side walls are lined with figures exemplifying virtue, heroism and wisdom, while the ceiling proliferates with astrological and allegorical allusions along similarly elevated lines. Perugino signed the ensemble with a self-portrait, but Raphael is generally credited with parts of the ceiling and some of the figures, particularly those of Fortitude, the Cumaean Sibyl, Solomon, and the warrior-heroes Leonidas, Horatius Cocles and Lucius Sicinius. That of Daniel is supposed to carry his own features.

What singles them out is a trace of extra vivacity in the detail and of alertness in their bearing and pose. The idiom, the types, even the mannerisms of Perugino are assimilated so thoroughly they fit like a second skin. But they are flexed and sensitised by a more youthful eagerness. Perugino in 1500 was aged fifty or slightly 20 more. For twenty years he had been at the height of his powers. He had worked for three Popes, making his name in 1481 with frescoes for the chapel named after Sixtus IV, the Sistine, when he had headed a team which included Botticelli, Signorelli and Ghirlandaio. He had been in Rome again to provide decorations for the coronation of Innocent VIII and then that of Alexander VI. He maintained a household in Florence as well as Perugia, and most central Italian cities could by now boast of a major work by him. But such pressures had also produced a tendency

to cliché and a slackening of style. Having that style rejuvenated by his ablest pupil served to revitalise him. One of the great difficulties in identifying Raphael's hand in works upon which they almost certainly collaborated is that the liveliest passages are not necessarily the younger man's. The assistant was having his own effect upon the master.

Raphael is himself called *magister* in a contract he signed that same year – on 10 December 1500 – to paint an altarpiece for the neighbouring town of Città di Castello. The title may be no more than a legal nicety, for he contracted to share the work with a friend of his father's who had kept open the old *atelier* in Urbino, of which Raphael was the heir and legal owner. But the inference is that, at eighteen, he was prepared to accept a commission away from Perugia and use his father's studio to do so. Only two fragments of the altarpiece survive, but they are enough to confirm what rapidly becomes self-evident: that he now considered himself, within the terms of his obligation to Perugino, independent. What follow are four works which earn him the professional as distinct from a purely legalistic right to call himself *magister*. Three of them are again for Città di Castello, but one which he painted for Perugia is the altarpiece for a member of the Oddi family, currently in the ascendant over the Baglioni.

26 It is a double scene. Below is an empty tomb from which the Virgin has risen bodily to Heaven, but which blossoms now with her attributes, the lily and the rose. Around it stand the awe-struck Apostles, among whom Thomas holds the girdle she dropped to him as she went. Above, she is crowned Queen of Heaven by Christ to the sound of music-making angels and a sort of firework display of cherubim in the sky – the first of Raphael's chubby and sometimes roguish babies. It is a work of solid competence and individual felicities, like the breeze blowing outwards from the Coronation which sets the angels' dresses tossing. The division into halves is awkward, merely two storeys of a house in spite of the outdoor set-ting, but this is Raphael's first attempt to articulate upper and lower groups of figures spatially on a large scale. In fact it is the scale which defeats him, not the details. Ease with large-scale group-compositions was one of Perugino's notable skills, but it is natural to expect a very young man's powers of invention to be more piecemeal and best in concentration. And in the three small predella panels intended
27–29 to run along the base of the painting, Raphael's do indeed burst into flower like window-boxes in bloom. Based on Perugino designs, but painted with the precision of miniatures, they glow with colour more subtle and full-bodied than Perugino's. Each diminutive scene poses a different spatial arrangement, constructed with intri-cate grace but observed and imagined whole, in breathable air and space-filling light. Of the three, the *Presentation in the Temple* is the most forward-looking: it moves towards the large-gestured grandeur of a circular ground-plan.

In Città di Castello, in a rather forlorn palazzo whose garden elevation was decorated by Vasari, there hangs a more touching reminder of Raphael's early efforts at independence. Patches of bare canvas show through where the paint has dropped off all over it. But the wonder is that it has survived at all, for it is the two

sides of a banner for carrying in street processions, probably made in connection with a pestilence which struck the town in 1499. Through the damage, two features stand out. Both the *Trinity* on the front and the *Creation of Adam* on the reverse have low-set horizons below a sky of Italian blue paling to white where it meets the haze of distant landscape; and the face of the sleeping Adam is not a bland Perugino face, but a youthful, bearded Christ of a more thoughtfully imagined type.

Both features are repeated in the brilliant *Crucifixion with Saints*, the first painting 31
to be signed by Raphael, with which he rewarded Città di Castello's demands for yet another work by him. It is brilliant in the sense that it shines out. Even today it tells with extraordinary clarity across a room in London's National Gallery where it is surrounded by masterpieces. The blue-to-white of the sky glitters, sharpened by angels' ribbons etched across it, together with the thin dark line of the Cross, and the thin pale body of Christ. A limpid transition of landscape darkens to the fore-ground, in order to outline the contours of two kneeling saints. If it were not done by colour, it would still be a *tour-de-force* of tonal contrast, using reversals of dark and light to give each form its fullest significance within the painting as a whole. Raphael is already improving on Perugino in subtleties of space-composition. The painting is arched in a half-circle at the top, but the four figures at the bottom are ranged in a matching half-circle in perspective on the ground, the standing ones splayed slightly outwards to emphasise the effect. And then, last but most tellingly, the eye reverts to the emotional centre of the subject, the face of Christ. It is a refinement on the Adam of the Città di Castello banner, but painted with a shadowy, romantic delicacy which is tremulous with the kind of emotion one gets from very young poets. Raphael was to be praised for four centuries as the 'wordless poet' among painters: in this face one begins to appreciate why. Is it purely a product of his own temperament, or some manifestation of the Zeitgeist, or something this most intelligently impressionable of painters had seen or sensed on his travels around the country with Perugino? For the quality of feeling in this face was to become the hallmark of an artist in Venice only a year or two older than Raphael himself whose name was Giorgione.

Città di Castello had no great wealth of art, but it did possess two altarpieces by Luca Signorelli, that tough, wiry master of the nude who was to influence Michel-angelo. Raphael had seen his work in Orvieto, and he was an old associate of Perugino's. And if Raphael's so-called *Venetian Sketchbook* is to be trusted (fifty-three pages of assorted landscape drawings and motifs sketched from other artists, which may or may not be in Raphael's own hand) Signorelli was a painter he took note of. He may have thought of him now, for when he painted his fourth work for Città di Castello, he introduced a figure posed like none that could have come from Perugino's studio-stock, but breaking a stick across his knee in the way archers bend their cross-bows in Signorelli's own Città di Castello painting of The Martyrdom of St Sebastian. He is the rejected suitor on the right of Raphael's *Marriage of the* 32
Virgin, the 'Sposalizio'.

This picture Raphael not only signs but dates prominently, 1504, over the entrance-arch of the temple. He is twenty-one, and in every sense come of age. As a pictorial idea, the *Sposalizio* is still indebted to Perugino, not merely to the precedent of his *Christ Giving the Keys to Peter* in the Sistine Chapel, which Raphael had probably never seen, but to another *Marriage of the Virgin* which had passed through the Perugia workshop five years earlier. Both have figures along the front, a sunlit piazza behind to set them off, and a temple to close the rush of perspective. But the idea has not only been re-thought but re-felt. Instead of the traditional Quattrocento line-up, Raphael has cut an upright slice into a huge dynamic vista. The figures are curved along the front edge of a vast wheel in space whose far edge disappears into a magical distance and whose hub is an eye-catching circular temple with a passage opening straight through it from front to back. Even with two slight flaws on either side of the pavement perspective, the effect is of an exhilarating conquest of expression in the name of intellect. The marriage celebrated in the foreground by the slipping of a ring on Mary's finger is a marriage also between sacred drama and Renaissance humanism, a wedding of spirit and mind which had always been the ultimate aim in mastering three-dimensional space. The mystic symbol of it is the circle, centred but infinite – the form of the temple in Piero's ideal city, the form of Pisano's great three-tiered fountain in front of Perugia's Cathedral, the form of Perugia's oldest Christian church, San Michele, all of them resonant with echoes from classical antiquity. Raphael's temple is said to have been designed for him by Bramante. The style is characteristic of him, though Vasari implies that Bramante, who was in Rome, had not yet met his young fellow-townsman. It was in any case shared by a good deal of new religious architecture which had a common source in the Florentine domes and circular chapels of Brunelleschi. It would have been common currency among the progressively-minded, and it had one feature which seems especially to have seized Raphael's imagination – the piercing of circular forms by eyes of light, like the eye which lets infinity pierce through the centre of his temple in the *Sposalizio*.

At the end of this same year, 1504, he was in Florence. It is the beginning of the second and more momentous stage of his formative period, but it is far from being a clear-cut beginning. What he needed from Florence was to be at the centre of things. For more than a century, the city had been Italy's powerhouse of new ideas and speculative thought; a combative, competitive, abrasive city with a history as turbulent with political experiment as it was distinguished for its innovative art. No one seems agreed on how often or how closely Raphael may already have been in touch with it. Perugino had studied there, married there and set up house there even while keeping Perugia as his base. Some scholars see in his pupil's early grasp of aesthetic ideas wider-ranging than his own, evidence of early and possibly independent knowledge of Florentine art. Florence was not far from Perugia, and Raphael was an experienced traveller even around that war-infested countryside. But if his aim was to settle there, it was not without much restless activity first.

In a contract of 1506 he stated that enquiries would always reach him either at Assisi, Gubbio, Siena, Urbino, Florence or even (surprisingly) Rome or Venice. That may have been youthful boasting rather than fact, but it shows a desire to be at least considered busily cosmopolitan. There is no proof of his visiting Venice, but some evidence suggests he knew Bologna, which is half-way there. We know he returned to Urbino, while in 1502 the whole Perugia workshop would appear to have descended on Siena. Not only was Perugino frescoing a palace there for the future Pope Pius III, but his colleague and one-time pupil, Pintoricchio, was designing a fresco-cycle for the Cathedral Library and asked for Raphael's assistance with it. If Raphael was in Siena in 1502 (the help he gave Pintoricchio seems to have been confined to solving some problems of space-composition in the preparatory drawings: by now he was clearly the workshop's resident expert on such matters) he would have seen Michelangelo there. The twenty-seven-year-old sculptor was working for the same patron in Siena as Perugino, but it was known he had just landed an unusually important commission in Florence, to carve the statue of *David* for that city. Leonardo had also recently returned there after several years in the service of Milan and Cesare Borgia, and Florence was anxious to secure a major commission from him too. If Raphael was to ensure a ringside seat at such exciting developments, he needed an official excuse to be present. He got one with a letter of introduction from the court of Urbino. Duke Guidobaldo's sister wrote for him what reads now as a curiously condescending recommendation to the head of the Florentine Republic. He was a 'discreet and gentle youth', son of an excellent painter much-lamented by her, who 'thought to stay some time in Florence in order to learn'. The letter may have ignored Raphael's own growing reputation and the fact that he had just painted a portrait of the writer's brother, but it gave him his entrée. He could take up residence in Florence.

As Rome was later to be, and then Paris, and in our own time New York, Florence was the artistic nerve-centre of its age not just because of what was produced there and could be seen there, but because of the level of aesthetic debate there. It was where artists talked art, where experiment generated theory and theory bred experiment. The aims of a 'new art' had been explored there in a progressive cross-fertilisation of ideas between painting, sculpture and architecture. Artists who practised all three were as often scholars, philosophers and writers also, and the shop-talk of the studios became the foundation of treatises and manifestos which combined technical instruction with wide-ranging analysis of cultural issues. Nowhere had the Renaissance consciousness of witnessing a 'rebirth' in all branches of knowledge been more assiduously studied than in Florence, with all its attendant expectancy that even greater things were still to be achieved.

Lorenzo Ghiberti, for example, who was an inordinately self-glorifying but nevertheless brilliant goldsmith-cum-painter turned sculptor-architect, had brought out his three *Commentarii* in the 1450s. They had taken it as axiomatic that, since the time of Giotto over a century before, Florence had led a European-wide advance

Continued on page 54

43

Raphael served his apprenticeship in the ancient university-city of Perugia (18, 19) as pupil and then assistant to a painter much in demand all over Italy, Perugino (20). Around 1500 Perugino was working on frescoes for Perugia's money-mart, the Cambio (25), parts of which are attributed to the seventeen-year-old Raphael (24). Drawings of this period are often of fellow-apprentices (21–23) who posed for his earliest independent paintings. Modelling himself closely on Perugino's lyrical, devotional style (30), he developed his own gift for colour (27–29), expressive rhythm (31) and space (32). The *Sposalizio*, dated 1504, when Raphael was just 21, is based on Perugino's design for *Christ's Charge to Peter* (33).

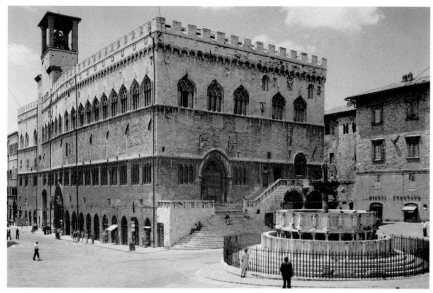

18 Perugia, *Palazzo dei Priori*

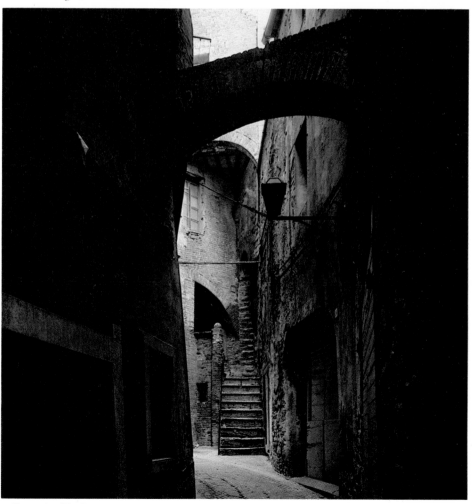

19 Perugia, *Via Ritorta*

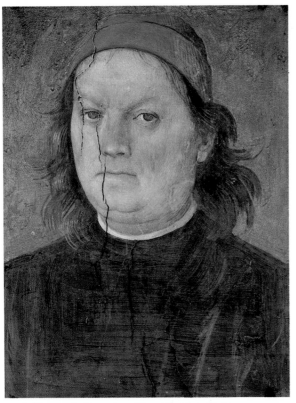

20 *Self-portrait*, Perugino (Perugia, Cambio)

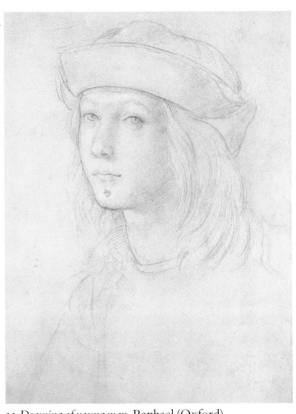

21 *Drawing of young man*, Raphael (Oxford)

22 *Study for Oddi Altarpiece*, Raphael (Oxford)

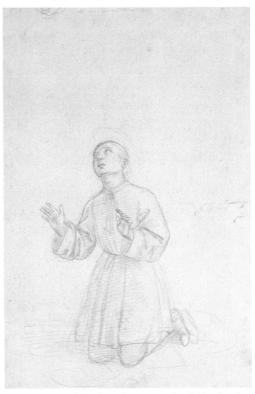

23 *Drawing of kneeling figure*, Raphael (Oxford)

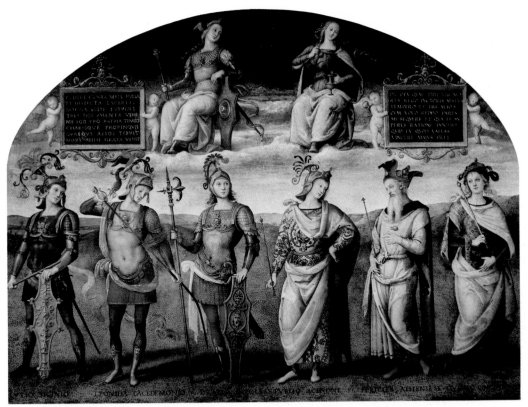

24 *Fortezza e Temperanza*, the left-hand figures attr. Raphael (Perugia, Cambio)

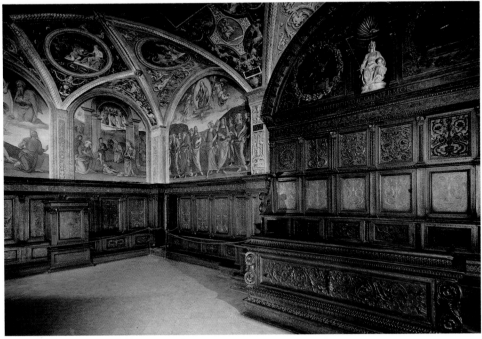

25 *Sala dell'Udienza* (Perugia, Cambio)

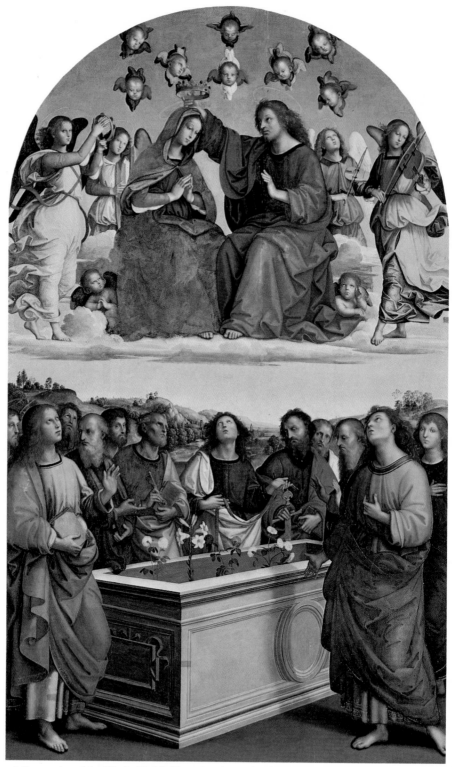

26 Coronation of the Virgin (Oddi Altarpiece), Raphael (Vatican, Pinacoteca)

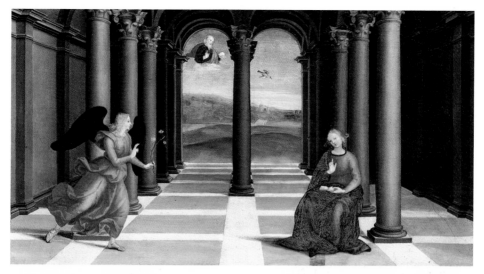

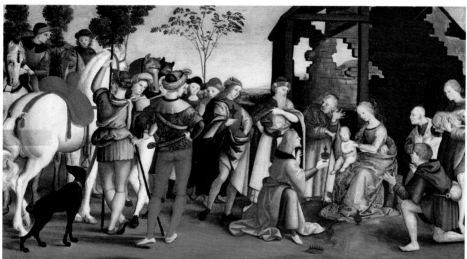

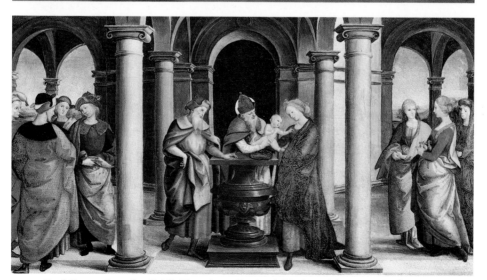

27–29 *Predella panels* to the Oddi Altarpiece, Raphael (Vatican, Pinacoteca)

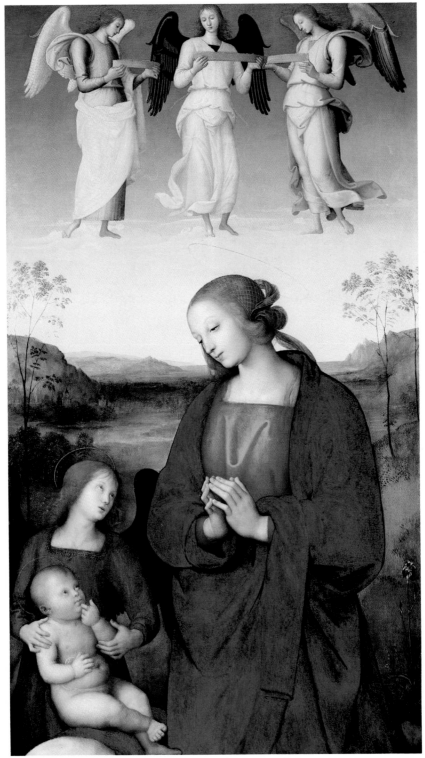

30 *Madonna and Child*, Perugino (London, National Gallery)

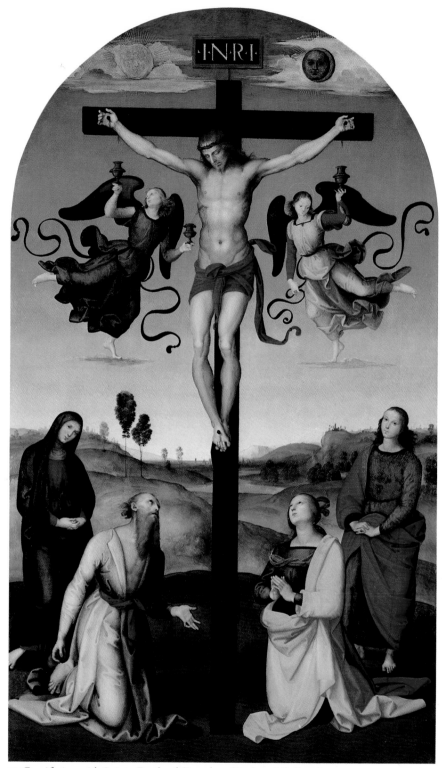

31 *Crucifixion with Saints*, Raphael (London, National Gallery)

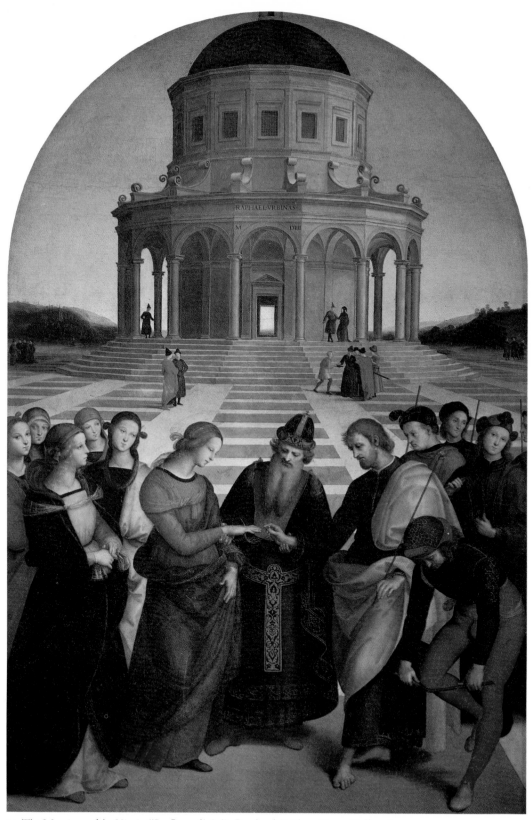

32 *The Marriage of the Virgin* ('Lo Sposalizio'), Raphael (Milan, Brera Gallery)

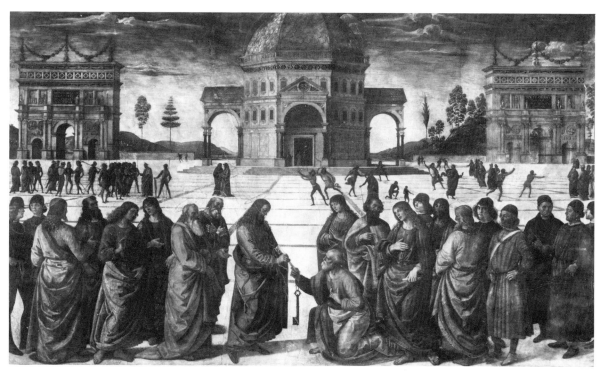

33 *Christ's Charge to Peter*, Perugino (Sistine Chapel)

towards rational, humanistic and classically-based values. For art itself he had proposed the objectives of *gentilezza* – a concept of beauty activated by grace – combined with the greatest possible naturalness of expression. The most influential theorist to follow him was that astounding Renaissance all-rounder, Leon Battista Alberti. 'Men can do all things if they will', said Alberti, and almost as an aside to his own practical concerns with architecture, music, physics, mathematics, civil and canonical law, poetry, the writing of novels in Latin and perfecting his horsemanship, he had set out guidelines for what painting should accomplish in his *Della Pittura*. His treatise stressed the dynamic integration of disciplines. Painting should pursue the study of space through perspective, of movement 'which is the vital principle of all life', and above all what he called *storia* – descriptive purpose. Further researches were brought into play in the 1470s by the congregation of talents attracted to Verrocchio's workshop. There the talk and the experiment had been about three-dimensional form and the role of modelling in light and shade: about the expressiveness of the nude in art, and the study of anatomy: about the interrelationship of light and colour which recent Flemish painting so intriguingly demonstrated: about how both these could contribute to Florentine *disegno* in a new concept of pictorial unity.

By the beginning of the 1500s, 'many young Florentines and foreigners', says Vasari, met regularly for the discussion of ideas at the studio of an architect called Baccio d'Agnolo. Even Michelangelo was occasionally to be seen there, but 'among the foremost was Raphael of Urbino, then a young man'.

There is a quality about Raphael which allowed him to set out and do, during the next few years, what many artists were still theorising about. One imagines him at Baccio's studio-gatherings, alert to the accumulated experience of Florence but coming to it from his own, with an observer's independence of judgement. The whole Quattrocento had been striving to make its painting express life in the round, in its fullest meaning. It had taken the mechanism of the art to pieces, redesigned most of its working parts and invented others, but was still not satisfied that it had achieved an organically functioning whole. Florence had supplied the engineering flair which tuned the machine to its own favourite tempo, bringing that spring to the step and lift to the mind which were *vivacità* and *prontezza* – life lived keenly. Elsewhere in Italy separate traditions had been founded and powerful individual artists had realised one or other aspect of the Renaissance vision according to stylistic variations of their own. But the problem throughout Italy now seemed to be how to develop a style which would bring the whole vision into coherent focus. It was as though some dream of absolute beauty still just eluded expression, hovering almost within reach of every conquest already achieved in design, form, movement, perspective and the illusion of living reality, but waiting for a moment when they would all breathe together as one.

In this respect Raphael must have been aware that he started with a singular advantage. Whatever he lacked of Florentine virtues, he had been trained to think in terms of visual coherence – of unified rhythm, of unified space, of space made

coherent by light and of form made coherent by colour. Vasari, a true-born son of Florence, was to write that Raphael had to unlearn his provincial ways in order to profit by what Florentine art had to teach him – 'another man would have lost heart to have wasted so much time'. The opposite is true. It was because he had profited so intelligently from the best Perugino could give him that he became the first painter to profit intelligently from Leonardo. He understood a vital link between the one pupil of Verrocchio and the other, and that ultimately it concerned the language of visual unity, that elusive *bellezza nuova e più viva* which would usher in a new consummation.

Florence was a great city for gladiatorial combats between its leading artists. One reason for being there in 1504 was that it was just settling down to enjoy its biggest battle of artistic giants since Ghiberti had beaten Brunelleschi and five other competitors for the commission to design the bronze doors of the Baptistery. The republican Council of the city (its secretary was at that time a certain Niccolò Machiavelli) was still drawing breath from a series of traumatic political upheavals from which Florence had barely rescued its much-prized independence. For the Great Council Chamber of its City Hall, the Palazzo Vecchio, it wanted two large new frescoes of battle-scenes to celebrate Florentine victories over the city's past and present enemies. The Council had vacillated for some time over the commission, but with their greatest asset, Leonardo, among them again, they ordered one of the battle-scenes from him in the autumn of 1503. Characteristically, he had been spending his time in the hospital of Santa Maria Novella dissecting corpses. He was now given the keys of the Papal suite at Santa Maria to prepare his full-scale cartoon, and is said to have begun by inventing a mobile scaffolding to raise and lower him while he worked on it.

A year later the Council ordered the second battle-piece, from Michelangelo. The two were to occupy adjoining halves of the Great Chamber's main wall, 60 feet long by 24 feet high. Unfortunately even these dimensions are no longer accessible to us, for in the 1550s the whole room was heightened, enlarged and smothered in new and tiresomely Mannerist frescoes by the indefatigable Vasari. But in the event the originals themselves were never completed. There was no love lost between Leonardo and Michelangelo, and their being publicly pitched against each other probably became intolerable for both. Leonardo started his fresco, but could not resist experimenting with the technique, just as he had done in Milan with the *Last Supper*. The experiment failed, the paint ran and fell off, and he abandoned it. Only the central section of his *Battle of Anghiari*, the Fight for the Standard, is now known from studies and reconstructions, one of them by Rubens. A pyrotechnic design of plunging horses, violent action and fantasticated details of armour, scimitars and helmets, it looks as though it may have been Leonardo's way of working out of his system a curiosity about war and its savagery which he had indulged in the service of Cesare Borgia. Michelangelo for his part seems never to have got beyond his preparatory cartoon. The excuse for his tumultuous study of the male nude in action was that it represented Florentine soldiers at the battle of

Cascina caught off guard by the enemy while they were bathing. Again we know it only from his own figure-studies and copies of the whole design, but Florence was struck dumb by it, even more than by Leonardo's. To artists privileged to enter the maestro's sanctum in the back-streets of his native quarter behind Santa Croce, it seemed the 'scuola del mondo', a revolutionary statement of the Florentine belief that all vital energy in art could be expressed through the human body.

It would have been out of character for Raphael to react immediately to these tours-de-force. He did sketch a thumbnail memorandum of Leonardo's and experiment with some drawings of men fighting, but he would never push himself beyond what he could absorb without distortion and on a scale he could control. Nor would any 'borrowed' idea resurface in a painting of his without first being so thoroughly filtered through his own temperament that 'borrowed' is a mere word of convenience. But there is a group of very small, squarish pictures, rich in colour

Study for The Battle of Anghiari, Leonardo da Vinci (Budapest)

and almost Flemish in technique, which could be said to echo at several removes the flourish of the Florentine battle-pieces. They are all concerned with young knights in armour engaged in or preparing for encounters in the cause of virtue.

Three of them were done for Urbino, and all four are couched in the courtly language of chivalry rather than anything smacking of Florentine realism. But Florence already gives the forms a more sturdy roundness, and the action a more determined energy. One is of *St Michael*, sword aloft, treading down Satan in the shape of a dragon at its last gasp. Other fantasy-devils stand around and a city goes up in flame in the distance. The atmosphere is oddly reminiscent of Hieronymus Bosch, though it may be a courtesy-tribute to a friend nearer at hand, the painter Francesco Francia of Bologna. But why, for Urbino, this scarlet-skied symbol of hell overthrown? In Raphael's absence, Cesare Borgia had stormed through the duchy, briefly dispossessing Guidobaldo and spreading his usual terror. After the restoration, the Duchess Elisabetta had a pageant-play staged at Carnival time to celebrate Urbino's deliverance, and Raphael may be alluding to the same happy outcome, in similar allegorical terms.

Guidobaldo himself was now much more strongly placed, for the Borgia Pope, Cesare's father, had at last been succeeded by an anti-Borgia one, the great Julius II, who had family connections with Urbino. In a special ceremony at the Papal Court in Rome, Guidobaldo received at the hand of ambassadors sent from Henry VII of England the same honour that had been conferred on his father before him.

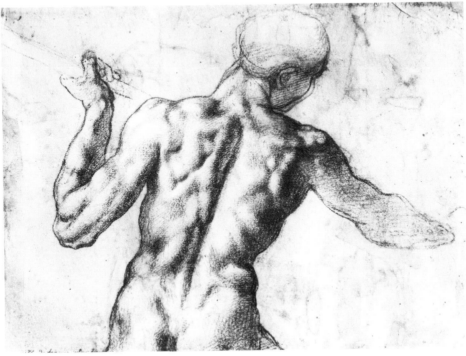

Study for The Battle of Cascina, Michelangelo (Vienna, Albertina)

57

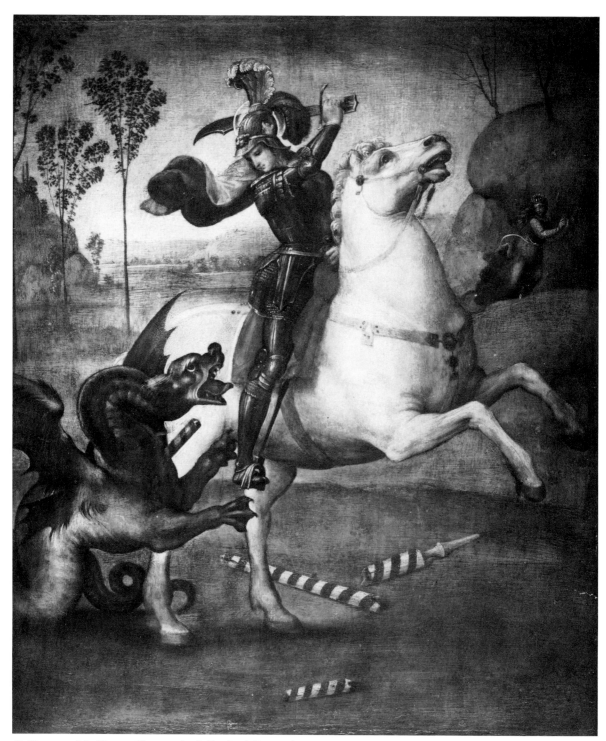

St George and the Dragon (first version), Raphael (Louvre)

On 22 May 1504 he was invested as a Knight of the Order of the Garter, and Raphael's next two small paintings of knights in armour are of *St George and the Dragon*. The earlier may be a pair to St Michael, and shows St George on horseback facing to the right, sweeping an oriental scimitar round his head in a spiralling twist of movement: the echoes from Leonardo's battle-design are unmistakable. The later version turns him to face left, perhaps because that way it can be seen that he now wears the Garter below his left knee. This version too introduces Leonardesque coils in the saint's flying cloak and the tails of both horse and dragon. But it has a cleaner thrust of energy than the first picture, and its Flemish detailing is wedded to a more memorably compact image. The painter's friend Castiglione headed an embassy from Urbino which bore the picture to England and presented it to Henry VII.

47

One further work is of the same unusual square format, but even smaller and even more redolent of romance and chivalry. The battle this time is no more than a moral one of choice, and that between alternatives which Raphael makes equally attractive. The protagonist is again a young knight and the allegory concerns his dream. Minerva and Venus appear to him, urging him to decide between the claims of duty or pleasure. Or it could be between wisdom and beauty, both desirable. Or, as this is Renaissance allegory, it is even more likely to be between alternative definitions of virtue. The knight's armour is Roman because he is Scipione Borghese acting the role of his classical namesake in the *Somnium Scipionis* by Cicero, and as Raphael is turning a graceful compliment to the scion of a powerful family, he is unlikely to be offering the young man a distinction between simple right and wrong. Interpretation is not made any easier by the fact that a second painting, depicting *The Three Graces*, is almost certainly the pair to this one, making them a diptych. The Graces, whatever their charms stand for, must represent the reward of the knight's choice.

46

Precise meaning apart, however, Raphael has poured into these two tiny panels all his youthful passion for beauty, grace and, be it said, sexual romance. The Borghese family he would have met in Siena, and it is in Siena that he probably saw a famous antique fragment of three female nudes interlinked in the way he has amplified in his painting. For the first time we see him fully in the spell of classical sculpture, recognising in his blood how it moved in forms and rhythms answering some ultimate ideal. Previously, when they are recognisable at all, classical motifs inform his figure-composition apologetically, as required exercises in taste or in the watered-down adaptations of Perugino. Here one of them takes centre stage, suddenly realised with warm conviction, like a heaven-sent guide to how an enduring image could be given to adorable flesh.

We cannot know if Raphael ever met Leonardo, who was now into his fifties and a secretive worker. But he pondered deeply the implications of that mind, and pored over every example of its thought that would have been accessible. Leonardo had several epoch-making paintings behind him: from the 1480s, the unfinished

Continued on page 77

From 1504 to 1508 Raphael based himself in Florence, which for 200 years had been the intellectual and artistic powerhouse of the Italian Renaissance (34). He studied its architecture (35), its paintings and its sculpture (36), but was most profoundly influenced by Leonardo da Vinci and Michelangelo, who were both working there. Leonardo's influence can be traced in a series of brilliantly perceptive portraits (37–44) and even in a group of very small, romantic allegories painted for the powerful Borghese family (45, 46) and for the court of Urbino (47). But it was as a painter of Madonnas that Raphael found his personal vision. He explored the theme in numerous variations, assimilating the lessons of Perugino (49), Leonardo (52) and Michelangelo (54) and arriving at his two most famous interpretations of the Mother of God a few years after he had left Florence – one in her most human aspect, the other at her most divine (53, 55).

34 Florence

35 Florence, Pazzi Chapel *Cupola* by Brunelleschi

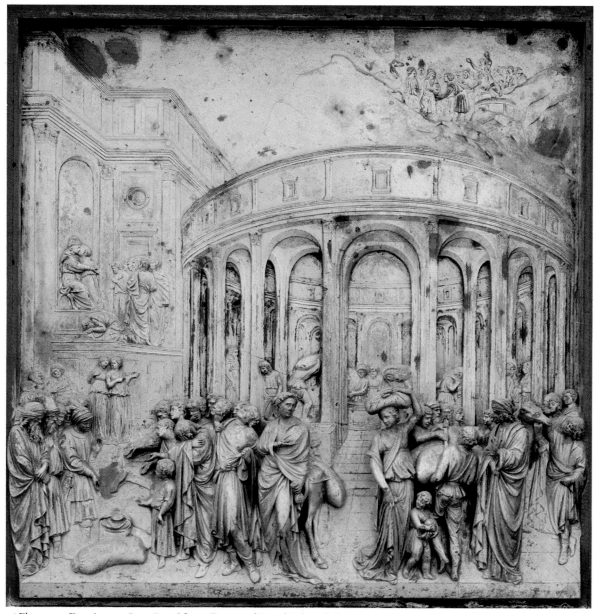

36 Florence, Baptistery: *Isaac Panel* from Doors of Paradise by Ghiberti

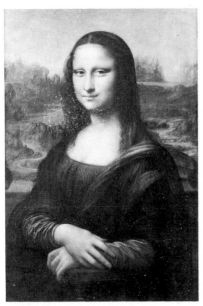

37 *Mona Lisa*, Leonardo da Vinci

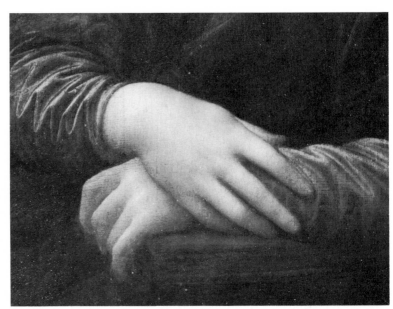

38 Detail of hands from *Mona Lisa*

39 Detail of hands from *La Donna Muta*, Raphael

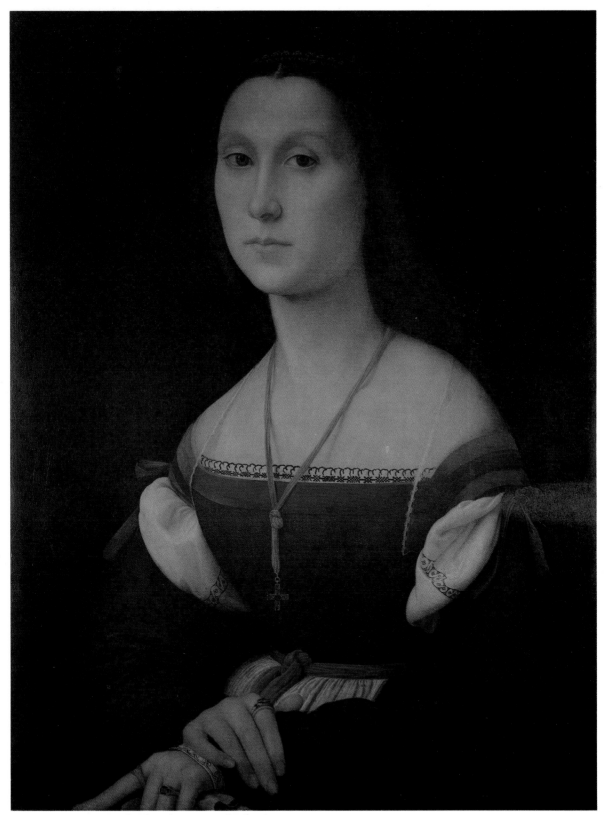

40 *La Donna Muta*, Raphael (Urbino, Ducal Palace)

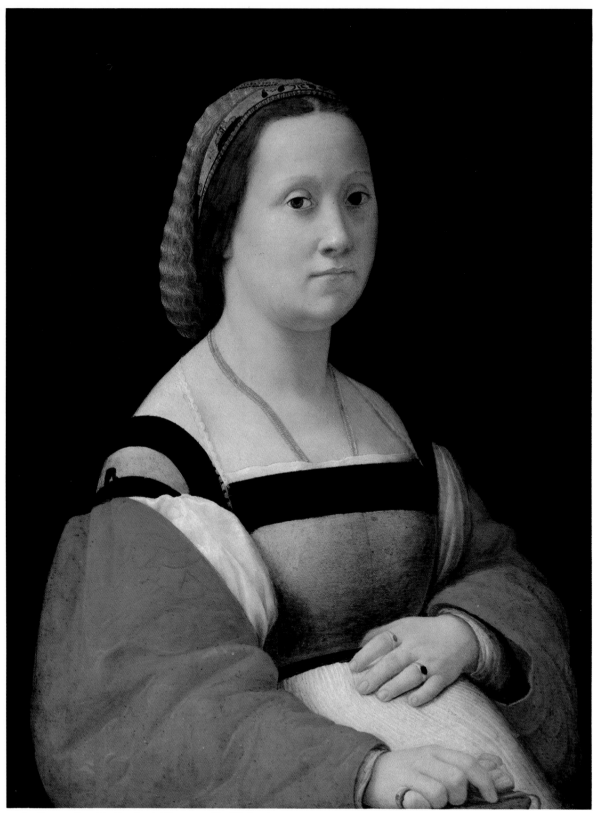

41 *La Donna Gravida*, Raphael (Florence, Pitti Palace)

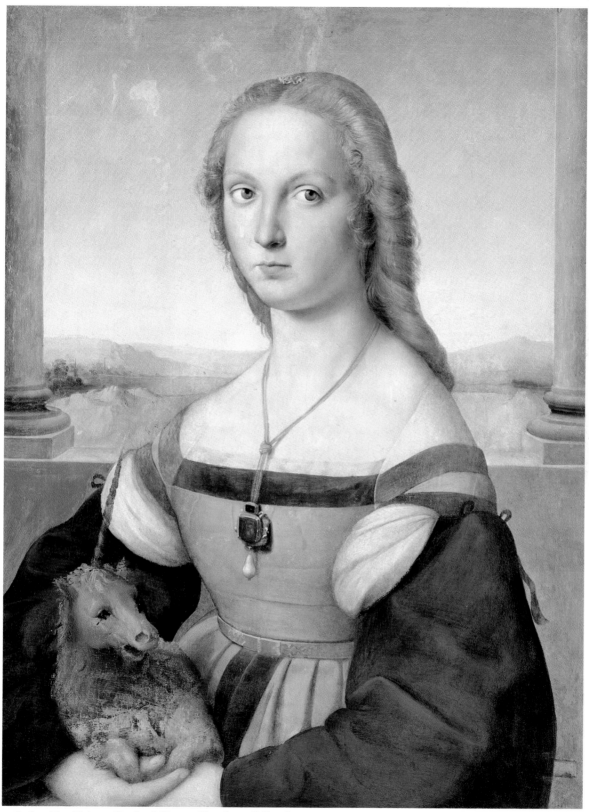

42 *Lady with a Unicorn*, Raphael (Rome, Borghese Gallery)

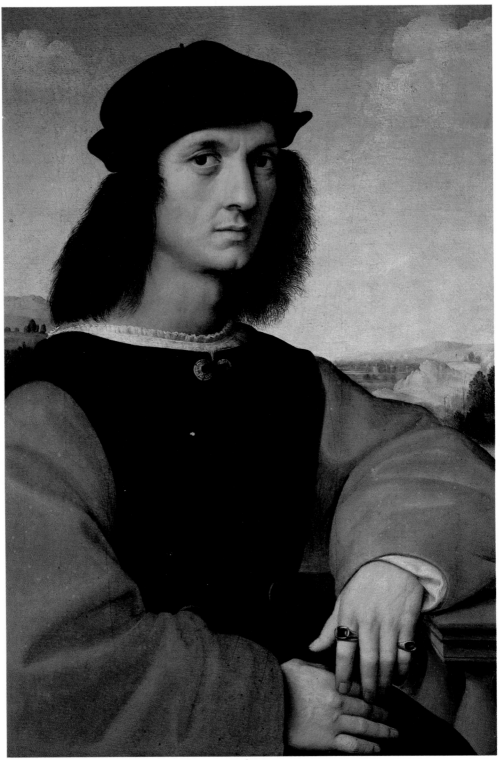

43 *Agnolo Doni*, Raphael (Florence, Pitti Palace)

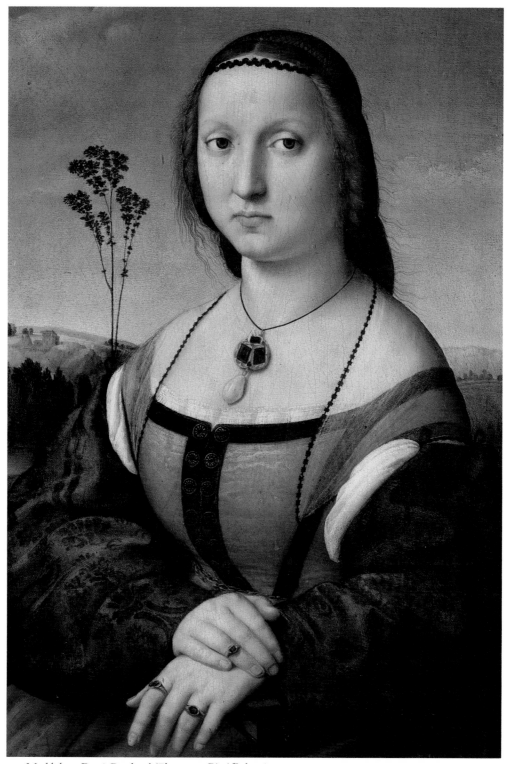

44 *Maddalena Doni*, Raphael (Florence, Pitti Palace)

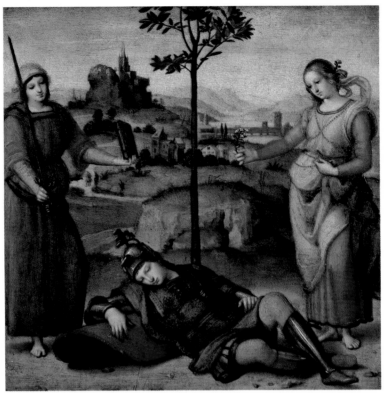

45 *The Knight's Vision*, Raphael (London, National Gallery)

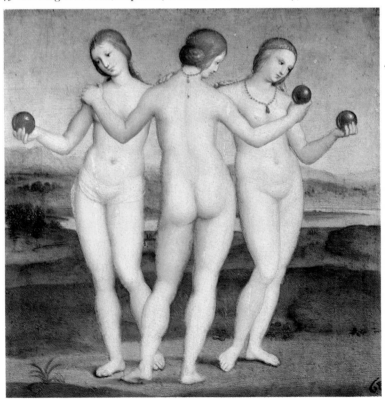

46 *The Three Graces*, Raphael (Chantilly, Condé Museum)

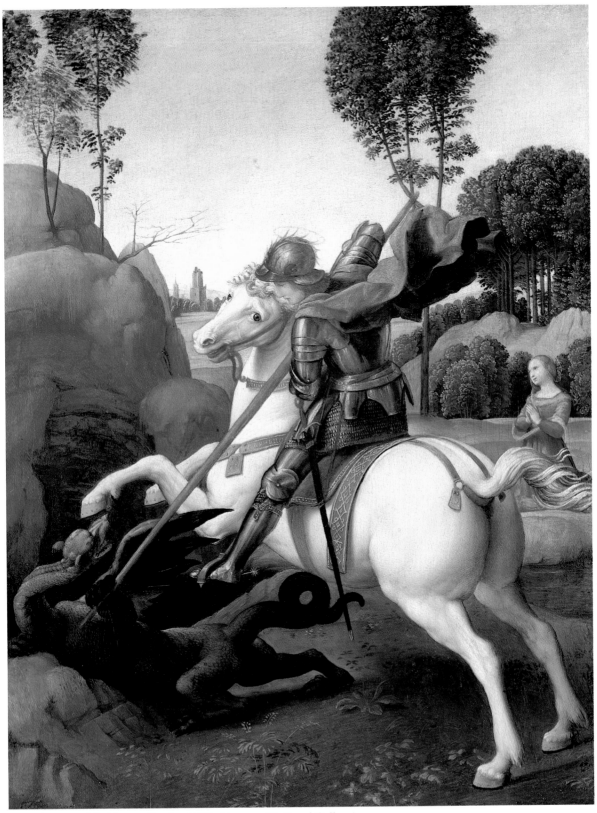

47 *St George and the Dragon*, Raphael (Washington, National Gallery)

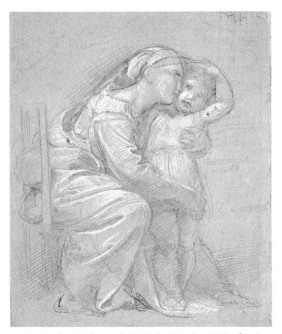

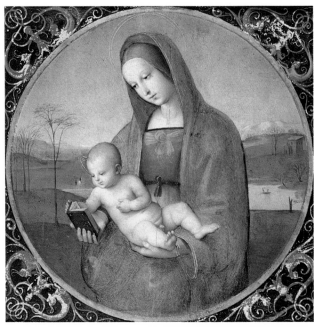

48 *Study for Madonna della Sedia*, Raphael (Oxford)

49 *Connestabile Madonna and Child*, Raphael (Leningrad)

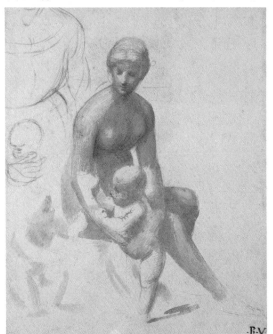

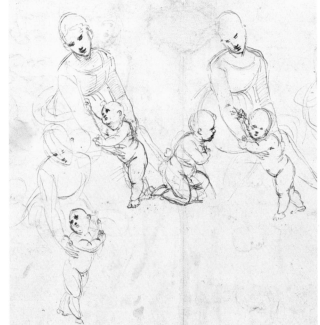

50, 51 *Studies for Madonna of the Meadows*, Raphael (Oxford and Vienna, Albertina)

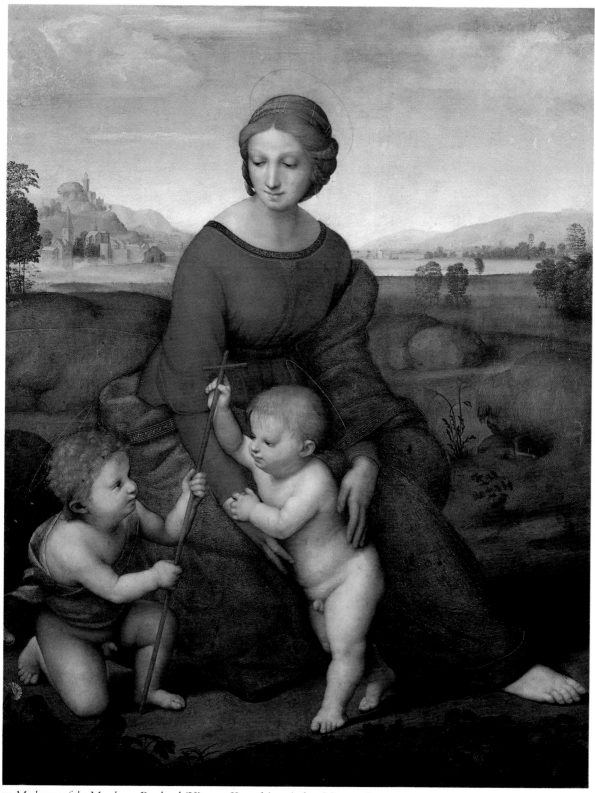

52 *Madonna of the Meadows*, Raphael (Vienna, Kunsthistorisches Museum)

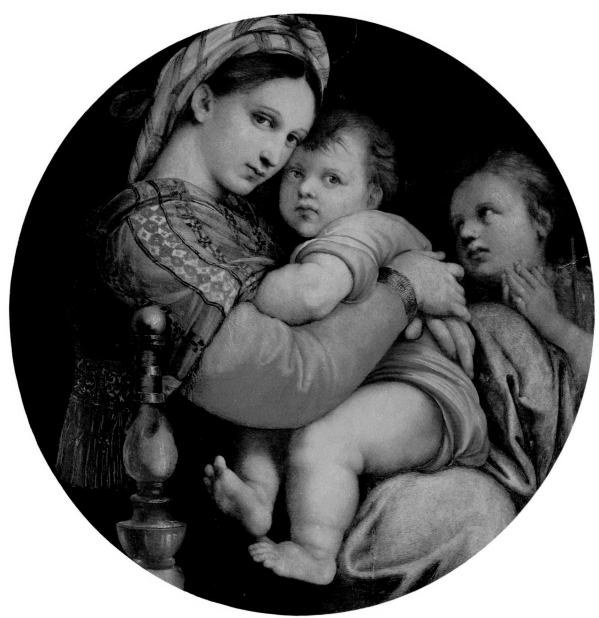

53 *Madonna della Sedia*, Raphael (Florence, Pitti Palace)

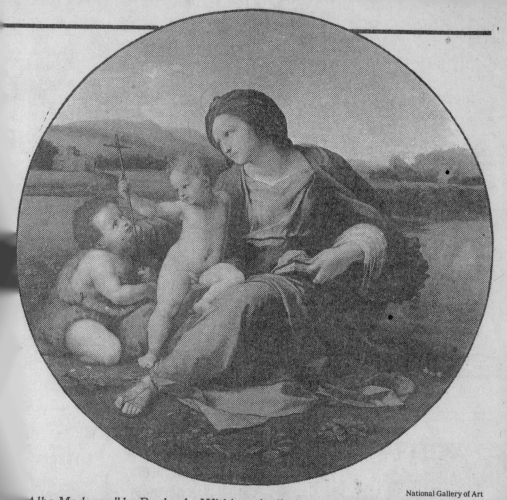

"Alba Madonna" by Raphael—Within strict limits, amazing work was done.

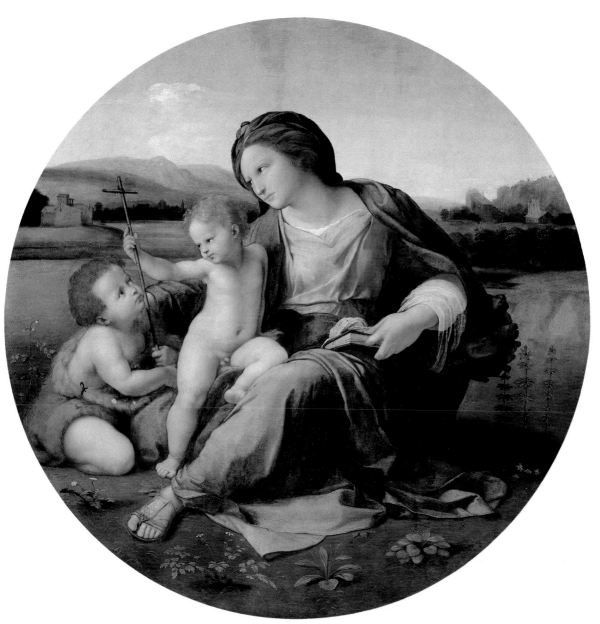

54 *Alba Madonna*, Raphael (Washington, National Gallery)

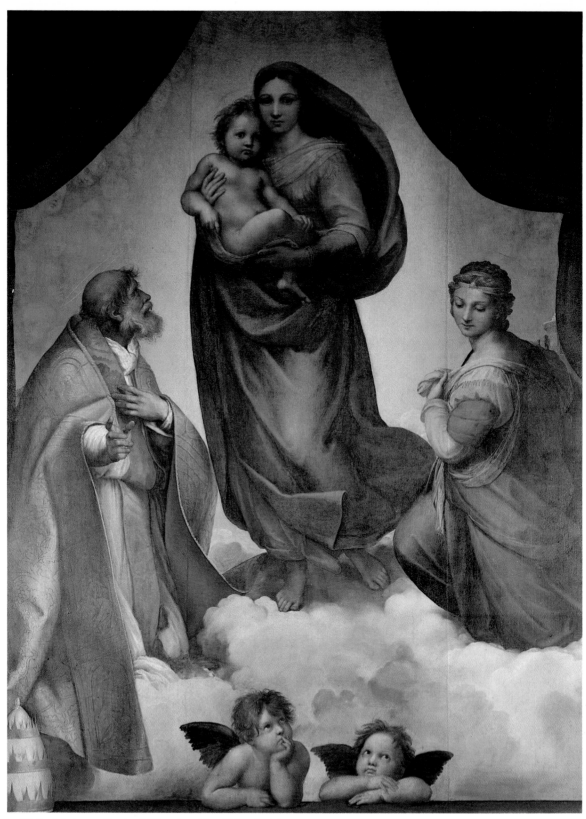

55 *Sistine Madonna*, Raphael (Dresden, Gemäldegalerie)

Adoration of the Magi and the first *Madonna of the Rocks*; from the 1490s, the *Last Supper* in Milan and the great charcoal drawing now in London of the *Virgin and Child with St Anne*. In Florence he was not only exploring the snarling fury of soldiers fighting, but meditating erotic twists and turns of the female nude for a projected *Leda and the Swan*. One of the studies for this design was available to Raphael long enough for him to make a close and detailed copy of it. Leonardo's sense of mystery would always be beyond him. But his sense of beauty, feminine in a way that was not Raphael's but filled with a remote and ethereal sweetness, must have lured and profoundly moved him: it went so far beyond Perugino's. There were technical lessons also to be learned from Leonardo's famous *sfumato* – his shadowy subtlety of modelling that followed round every nuance of a form as it receded through infinite gradations of twilight to blend at length into the surrounding atmosphere. This was a control of substance in space beyond anything the Quattrocento had so far managed. There was Leonardo's ceaseless curiosity too about human behaviour and expression – how, without words, to develop what is happening psychologically in a painting, the inner narrative of situation. 'A good painter,' Leonardo confided to his notebook, 'has two subjects of primary importance: man, and the state of man's mind. The first is easy. The second is difficult, for it has to be conveyed by gestures and movements of various parts of the body. One should learn from deaf-mutes: they express themselves better in this way than any other group of human beings.'

Most of Leonardo's effect on Raphael was slow-working, too deep to be obvious, but very persistent. The face of an old man close to the Madonna in Leonardo's *Adoration of the Magi* reappears in the centre of Raphael's *Transfiguration* nearly twenty years later, like an invocation to the master's spirit to be with him as he breaks through to new conquests of expression in his last painting. But Leonardo's interest in faces and psychology conveyed itself to Raphael in one subject-area he could grasp immediately, the portrait. It concentrated his youthful appetite for observation and realism while more abstract problems matured in his mind. Between 1500 and 1504 Leonardo was working in Florence on the portrait which has become Europe's most familiar work of art, the *Mona Lisa*. The painting owes its popularity to a mood, a teasing effect of *sfumato*, and an enigmatic landscape. But in a more technical sense, its authority comes from a masterly disposition of the half-length within its frame, allowing for maximum internal movement within the minimum of gesture. The stillness and centredness of the whole image, so essential to its effect, can accommodate a surprising range of variations as long as the right set of inner dynamics is preserved. Raphael understood it at once, for he reproduces its essentials in a series of portraits which are externally as unlike it as they are different from one another, yet all clearly derived from the same structural proposition.

Closest to it is a portrait of *Maddalena Doni*, buxom, bourgeoise and sulky-faced, without a shred of poetry about her, but in terms of colour, texture, detail and fullness of form, visually resplendent. As a character she looks blank but challenging, which may be why Raphael lavishes such care on her clothes: it is character-

44

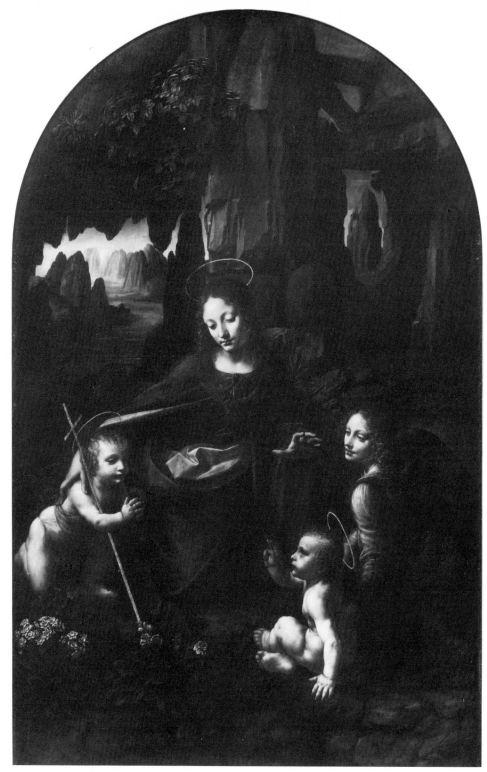

The Virgin of the Rocks, Leonardo da Vinci (London, National Gallery)

comment in itself. He invents a beautifully sophisticated colour-chord between their blue and pink, the paleness of her skin and the translucency of the sky, for his Umbrian colour-sense is now a fully developed instrument of expression. But even apologists for Maddalena turn with some relief to the portrait of her husband, *Agnolo Doni*. With sure virtuosity, Raphael frames him commandingly in red and black to concentrate on the watchful intelligence of the face. The pose is basically Maddalena's in reverse, except for a slight but significant shift of the hands. The *Mona Lisa* pattern had brought hands into the overall revelation of character, and Raphael says as much about Agnolo in the light brushing of fingers against each other as he does about Maddalena in the composed relaxation of hers. Agnolo was a patron of both Raphael and Michelangelo (Michelangelo's 'Doni tondo' in the Uffizi was painted for his marriage to Maddalena), but reputedly money-loving as well as art-loving. His expression could be read either way, both shrewd and sensitive. The *Mona Lisa* had made a conscious, timeless enigma of the human presence. Raphael particularises a personality, leaving a shadow of doubt to play around it as part of its human reality. The guarded silence of his sitters is a measure of his respect for them, and of his understanding.

43

Study for Mary Magdalene, Raphael, pen and ink (Uffizi)

Florentine art was always good at male portraits, but never as good as Raphael
42 at women. The *Lady with a Unicorn* has some connection with Urbino, for the
unicorn was an Urbino emblem as well as the time-honoured attribute of virgins.
The contained presence, the half-turn of the shoulders, the straight gaze, the far
distance all acknowledge Leonardo. But Raphael's light-filled clarity centres on the
wide-eyed appeal of youth striving to look grown-up. Perhaps a lady-in-waiting at
court, she is allowed a proper seriousness, but it melts at the edges in the reflections
under her chin, the filigree treatment of gold hair round her face, and the baby-blue
40 of the far landscape. No landscape at all modifies the image of *La Donna Muta*. She
too may be a lady of the Urbino court (her portrait hangs in the Ducal Palace there)
although some critics see her as a member of the semi-aristocratic Florentine middle-
class. Whatever her rank, Raphael has ennobled her as a sentient being. Her acquired
title could as well refer to the muted colours he has reserved for her as to the slight
lift of her head which seems to enjoin silence. The physical detail spells out precise
and immaculate refinement: one exquisite passage of observation traces the shadow
of her gold chain defining the shape of her collar-bone. The painting is a man's
tribute to the opposite sex without the involvement of sexuality. For all its insight
and sympathy, it is not touched with quite the masculine tenderness which makes
41 *La Donna Gravida* the most moving of the *Mona Lisa* derivatives. Again the back-
ground is dark, an interior. Again the sitter is unknown. One hand is moved up to
rest lightly on her pregnancy. The pose is slightly more oblique. But the whole
image has been shorn of ornament without losing its realism, and conceived with a
sculptural simplicity and weight which softens it instead of making it more austere.
The face in particular is softened with deeper shadows. It seems to be the face of an
older woman, and the portrait possibly holds some hidden emotional significance.
But for the work of a twenty-three-year-old it is felt with the certainty and depth
of maturity.

Michelangelo's example was more difficult for Raphael to come to terms with
than Leonardo's, though it had been no less an inducement for his move to Florence.
On 25 January 1504, Perugino had sat on the commission of artists appointed to
decide a suitable location for Michelangelo's *David*. The work had been intended to
stand in or by the Cathedral, but the place finally chosen was in front of the Palazzo
Vecchio, a building more representative of that civic pride it was supposed to sym-
bolise; David had scattered the oppressors of Israel as the Florentine republic (for
the moment, anyhow) had repelled invasions from without and dictatorships within.
Raphael may even have been present at the unveiling of the statue that autumn, on
8 September. Promptly dubbed 'Il Gigante' and hotly resented as well as admired –
for it was stoned and had to be put under guard – it flaunted itself with a kind of
arrogance which was as much aesthetic as politically called for. It has remained to
this day a controversial image, the Greek god looking like an adolescent bravo
'with the hands of a killer', as one critic has described him. One imagines Raphael's
hating it, even if there was no denying its power. He made his own quietly specu-
lative analysis of the piece in the same way he had often explored Perugino's

figurative inventions. He got a model to adopt the same pose and studied that, from the life. And he drew it from the back, not the front. It was not Michelangelo's *terribilità* he wanted to know about, but the management of that negligent weight-shift across the hips, the casual menace of that hanging right arm and bent wrist. This was virtuosity in a field where he lacked experience.

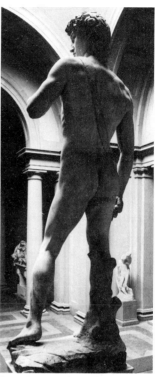

David, Michelangelo, marble (Florence, Accademia di Belle Arti)

Study of male nude, Raphael, pen and ink (British Museum)

At twenty-eight Michelangelo was virtually half Leonardo's age and temperamentally his opposite. Where Leonardo probed, ranged and questioned, Michelangelo enunciated a faith with all the force of the single-minded. For him the human body was the one sufficient vehicle for those sublime truths that art and the spirit should strive for. He was not remotely interested in realism, portraiture, landscape or even space as Raphael understood space. But he was a master of what could be called the body's space – its inner tensions and torsions, the space it can fill with its own striving. Michelangelo's art and personality were to dog Raphael all his life. It is the one professional relationship of his we ever hear about which rankles, because Michelangelo, as quick to suspect rivalry as Raphael was innocent of it, could never understand the younger man's derivations from him as sincere tribute. His lonely struggles with the ultimate must to him have seemed belittled when accommodated to a more temperate art. Even that passionate admirer of his, Delacroix, recognised that the Titan's sense of tragic rebellion led him into 'affectations of strength or of the unexpected', and those would have been anathema to an artist governed by Castiglione's code of restraint. It is significant that even while he studied Michelangelo, Raphael kept turning back to the humanism of his greatest precursor in sculpture, Donatello. He drew Donatello's St George several times, and even based his second *St George and the Dragon* on Donatello's small relief-carving of the subject below his famous portrait-statue of the ideal Christian warrior. On the other hand, Michelangelo's inventiveness with the human figure was a superb corrective to Perugino's static, non-dramatic way of visualising human encounters, and had a more sinewy substance even than Leonardo's. That was because it gave new impetus to an entire tradition of Florentine sculpture. 'I say,' Michelangelo pronounced, 'that painting seems to me all the better the more it tends towards relief, and relief all the worse the more it tends towards the condition of painting.' That was the kind of dictum Raphael could build on: it appealed to his pictorial instinct.

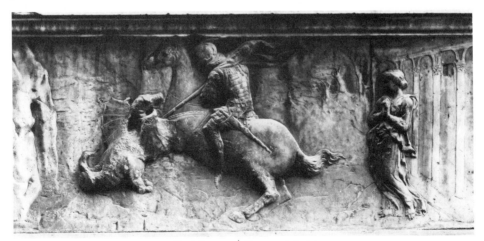

St George and the Dragon, Donatello (Florence, Orsanmichele)

Apart from the battle-cartoon and the *David* (Michelangelo had already carved his *Pietà* for St Peter's in Rome but Raphael is unlikely to have seen it), Raphael would have been most aware in Florence of his progress on various motifs of the Madonna and Child. There was the 'Bruges' Madonna completed around 1504 and despatched to the Netherlands two years later; a frontal, seated image with a brilliant solution of how to carve into one clenched design the child standing between his mother's knees. There was the circular painting for Agnolo and Maddalena Doni, with an idea for the woman's figure kneeling and turning round with lifted arms which haunted Raphael for years, not to mention a boy's head with springing curls which he drew immediately and stored for future reference. There were also two circular reliefs in marble which owe much of their nobility to the fact that, despite taut design and technical virtuosity, they avoid the sightest 'affectation of strength'. But the special value of all these works to Raphael was their theme. Everything that

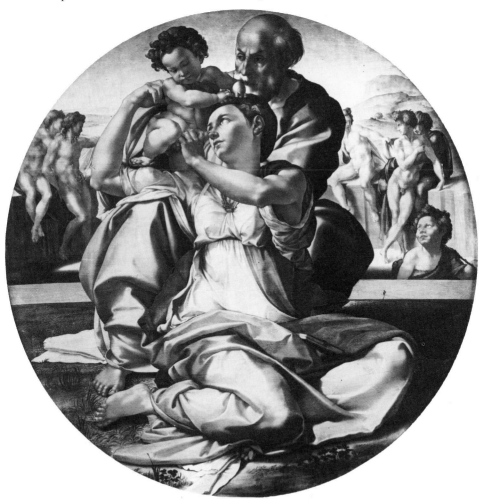

The Holy Family ('Doni tondo'), Michelangelo (Uffizi)

83

diligence could do to enlarge his style was pointless without material suited to his temperament on which to practise it, and his four years in Florence come logically into focus on the subject for which his name is still a by-word. He became a *madonniere*, a Madonna-painter. It has even been suggested that he explored the subject so thoroughly over the course of his brief career that he left little more for classical painting to say about it.

Study for a cherub, Raphael: adapted from Michelangelo, black chalk (British Museum)

By the end of his life Raphael had left around forty completed variations on the theme of the mother and child, if we count those where the central two-figure motif becomes part of a Holy Family or is supported by attendant saints. Almost half that number is crowded into his Florentine period. The Madonnas tell us many things about Raphael and not least is the amount of work he could get through. The quantities of drawings for them confirm that, just as they reveal the energy of his thought and creativity. They range from those marvellous sheets swarming with mothers and babies in impetuous swirls of the pen, to very precise studies of a single figure or head. Into them go all he was learning from other artists, endlessly adapted to ideas of his own which are often evolving into separate designs all being pursued at the same time; the order in which they are realised as paintings is almost incidental. Solutions are reached when a design emerges which can be made to look as though there had never been any problem. But if part of the success of Raphael's Madonnas is their skilfully prepared ease as designs, it is only a part. The more delicate problems he was tackling were questions of interpretation, expression and sentiment.

The Madonna in art inhabits a border-territory which is part sacred, part secular. She can be an icon or an idealised mistress. Beauty is essential to her, and the Madonna-painter searches for his image somewhere between the claims of religion, art and fashions in femininity. Florentine artists had never been afraid to make the holy mother adorable in the most human sense, but as the 'new art' of the incoming century became more recognisably classical in its aims, so did the need to idealise its types of beauty become more conscious. Raphael's Madonnas evolve gradually from Perugino's model, already an idealised type, and in his Florentine period they seldom lose entirely that slight primness of small features in an oval face, characterised particularly by the small, neat mouth. Raphael lengthens the nose, develops a downcast, crescent-shaped glance of the eyes, but the purity of that oval remains the dominant idealising form even when the whole head is revealed. The demure blue hood of Byzantine tradition, still worn by the *Solly*, *Connestabile* and *Ansidei* 49 Madonnas, is thrown back in the Madonnas of around 1506 to show the full line of the neck and shoulders, the gold hair looped back or braided round the head or 51 bound in a wisp of veil as it is in the *Belle Jardinière*. It is a move towards more sensuous beauty, keeping pace with a more sculptural modelling of the whole figure, and done with infinite tact.

At the same time, Raphael humanises the ideal. Leonardo and Michelangelo both conceived Madonna-images of a loveliness which can make Raphael's look homely. But neither had the temperament to express that love for the woman within the goddess by which Raphael edged his Madonnas so close to the secular. Theirs could never be called sentimental images: Raphael's might. Some are very nearly idealised portraits, and varied enough to suggest more than one model or at least a constant injection of observation from the life. The drawings show evidence of that, and so particularly do those paintings of mother-love which centre on images of embracing, supporting or guarding the child. The *Small Cowper* Madonna, which was almost certainly painted for the court of Urbino: the *Colonna* and the *Large Cowper* Madonnas: the magically simple *Granduca* – all use gestures of the 138,114 child's hand against the mother's neck which appeal straight to domestic experience. Most appealing of all is probably the *Tempi* Madonna, where the human charm of the embrace is warmed still further by one of Raphael's most sonorous colour-chords of red, green and golden yellow.

Humanising the Divine Child in a Madonna-painting is more of a problem than humanising the mother. Traditional iconography made him a miniature adult, conscious of his destiny, his hand raised in blessing. Raphael's prolonged exploration of how to marry that concept with the artistic demands of *naturalezza* produced many babies which are not to the taste of the literal-minded. But if some of them are too arch in their self-awareness, the problem tends to be connected with the by-play surrounding symbols like the book, the goldfinch, the lamb or the cross. All are prophetic of Christ's ultimate sacrifice, though sometimes they are introduced like toys for the children and only the Madonna's face betrays sorrowful fore-knowledge of their meaning. Raphael's instinct is to give as little prominence to

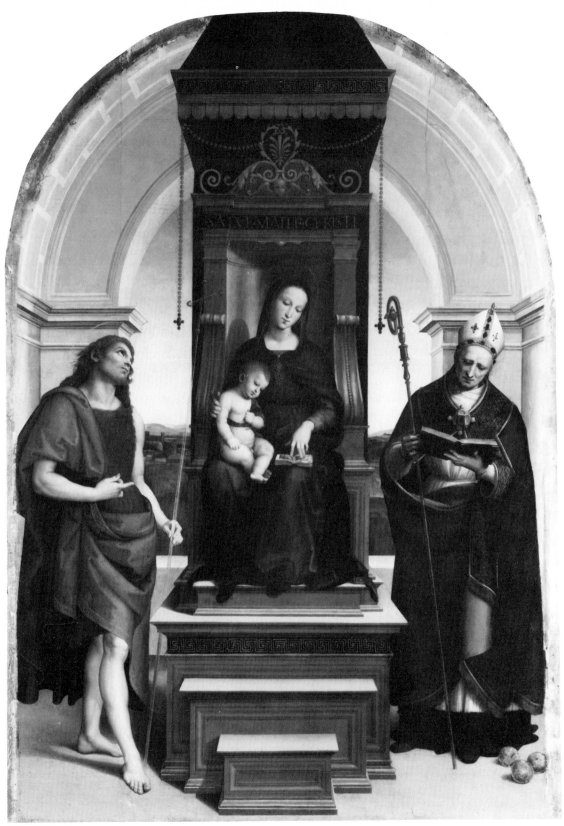

Ansidei Madonna, Raphael (London, National Gallery)

symbols as he does to haloes, while developing the psychological implications of the scene and avoiding disruptive drama. He was tempted to drama once by an invention of Michelangelo's. In the *Taddei tondo*, Michelangelo carved the child twisting across his mother's knees in fright at the goldfinch proferred by the infant John the Baptist. In the *Bridgewater Madonna*, Raphael adapted the pose but changed the motivation to one of playfulness: the action is too extreme for it, and the painting is artificial. At the same time he tried out the original motivation in a drawing for the Canigiani *Holy Family*, but with the child standing and recoiling in 113 fear against his mother. For the painting he again avoided it, but transferred its emotion to the face of St Elizabeth. She has seen the two children meet, and turns to look up at Joseph with a sudden cry of premonition. Her expression may even be borrowed from the antique, from a Hellenistic statue known as the 'Old woman crying out in fear'.

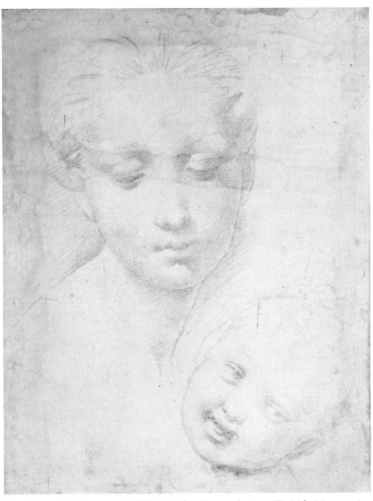

Study for a Madonna and Child, Raphael, metalpoint (British Museum)

Landscape is the characteristic setting for the Madonnas as it is for the Canigiani *Holy Family*. That in itself was not new in Madonna-painting, but Raphael's own spririt-easing sense of calm distance transforms what had been a background device to an enhancement of the physical reality of his figures. Leonardo's *Virgin of the Rocks* had initiated a Florentine speciality in paintings of the Madonna with a baby St John as well as the Christ-child. But it was Raphael who first fully understood that this was not an invention about iconography but about pictorial space, and about building an image which occupied that space as firmly as sculpture. Three figures compose themselves in depth more easily than two, on a broad base rising to a natural apex. It is the famous pyramid-form which Raphael announces in the great trio of full-length Madonnas all painted in little more than a year – the *Madonna of the Meadows*, the *Madonna of the Goldfinch*, and the *Belle Jardiniere*. Landscape in all three begins with the ground at their feet, rooting them in a real world, confirming their presence and their scale, and then dissolving into infinity beyond them.

Some of the more complex Madonnas belong to the second phase of Raphael's career, the years in Rome. Absorbed in larger projects, he returned to the subject at rarer intervals, and then in ways which tend to be related to design-problems of 54 other current work. The superbly assured *Alba Madonna*, for example, has lost a certain charm but gained a certain grandeur from his experience with *The School of Athens*. Gradually, also, the Roman ambience and its pressures relegated Madonna-paintings to the kind of production his able team of assistants could carry out from designs without too close an involvement from himself. As designs they have been influential but command little love today. Yet two of the Roman Madonnas belong here rather than later because everything Raphael managed to say on the subject in Florence seems to lead up to them. They date from three or four years after the *School of Athens* and are, along with the *Granduca*, the most revered of them all – the *Sistine Madonna* and the *Madonna della Sedia*.

They have one feature in common which none of the Florentine Madonnas shares – both mother and child look straight out at you and hold your gaze. Otherwise they are at opposite poles of that sacred-secular duality inherent in the 53 theme. The *Madonna della Sedia* is brought as physically close as the tondo format will allow. The rounded limbs press forward, the child's elbow is like the boss of a shield leading the whole image gently outward, following the direction of the eyes towards the spectator. Everything is concentrated on sensing the touch and warmth and nearness of that protective embrace. A drawing connected with it shows that the picture gets its name from what was originally a humble household chair. And the mood is indeed so private and domestic that, were it not framed in a kind of halo, this need hardly be a religious painting at all. That of course is its appeal. A devotional image could scarcely be made more humanly accessible.

55 The *Sistine Madonna*, by contrast, is both public and divine. She sails towards us from another world, wafted through clouds of cherubim (the white radiance behind her is entirely made up of them) as though entering through a bright window into

our darkness, ushered into the presence of the congregation by a Pope on one side and St Barbara on the other. Ostensibly she comes to bless and to reward, for she takes her name from the convent of San Sisto in Piacenza for which she was painted in celebration of a political pact. Piacenza had been an independent city, but chose prudently to side with Pope Julius II when he was fighting to regain territories which had once belonged to the Papacy. The painting was a gift to the city, and in it St Sixtus is represented with the features and papal attributes of Julius. To compare the mother and child Raphael conceived for such a role with those of the *Madonna della Sedia* (which is perhaps later by a year) is to be struck less by obvious and necessary differences than by the consistent honesty of his imagination. The models for both must be the same. Ultimately they had to be, in order to attempt the spiritual mystery at the heart of the subject. For here the child is already the Redeemer and the Sacrifice, and the mother already the Madonna of the Sorrows. Raphael provides no symbols now to tell us so. We can read it in the vulnerability of two of the most beautiful faces he ever painted.

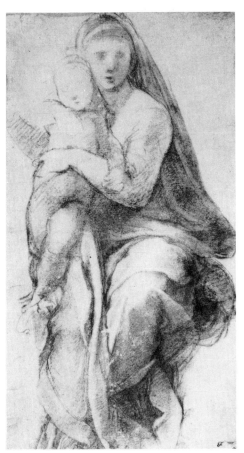

Study for a Madonna and Child, Raphael,
black chalk (Chatsworth)

Raphael is thought to have reached Rome somewhere between May and September 1508. The summons came from Pope Julius and may have had to be obeyed precipitately, for Raphael left one or two commissions behind him uncompleted or to be finished by lesser hands in the Perugia workshop. That, at any rate, is one explanation put forward for the uneasiness many critics have felt about a painting in which Raphael seemed at special pains to exploit the lessons he had learned in four years' study of Florentine art. It is the altarpiece he undertook for Atalanta Baglione, the mother of Grifone killed in the Baglione slaughter of 1500. It hangs now in the Borghese Gallery in Rome, an *Entombment of Christ* which had started out referring

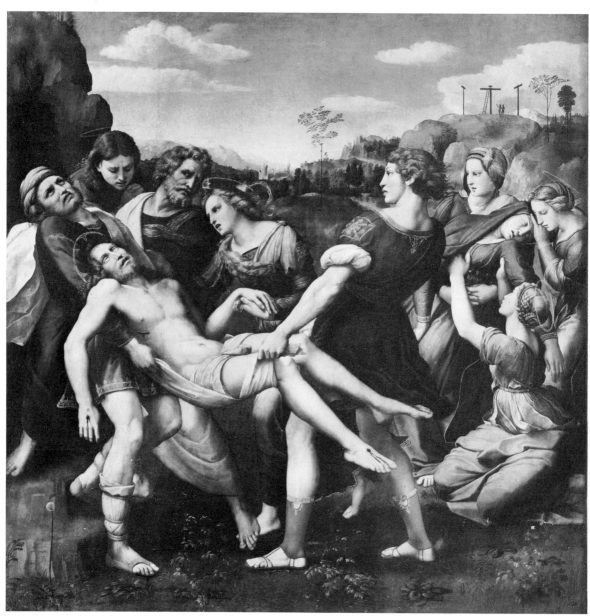

The Entombment of Christ, Raphael (Rome, Borghese Gallery)

more directly to Atalanta's grief, as a *Lamentation of the Virgin* over her dead son. In a long sequence of studies Raphael wrestled with the grouping of ten figures overwhelmed by tragedy. As a 'Lamentation' it began quietly enough from a composition of Perugino's, but then a change of thought shifted the emotional centre to the dead Christ being carried rather than lying on the ground. It was more dramatic, it allowed for more Florentine cross-rhythms of character and muscular action, and it introduced a telling classical motif for the dead body, adapted from a *Burial of Meleager* known in more than one antique sarcophagus relief.

The grief of the Virgin was now secondary and moved over to the right, where it is still the most poignant episode in the painting. One drawing for it even studies the swooning action of the Virgin in terms of a skeleton, a curiously touching image to be thrown up by the process of research. But for once the thought Raphael put into the design as a whole leaves the solution looking unnatural. By the very

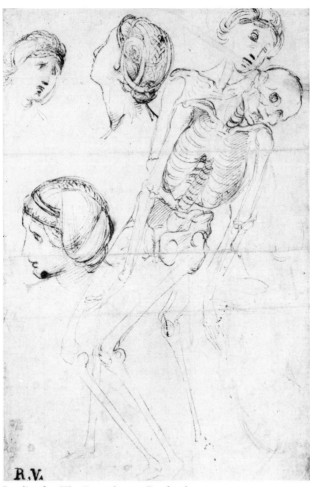

Studies for *The Entombment*, Raphael,
pen and ink (British Museum)

standards he invokes, which are largely Michelangelo's, he lays himself open to criticism, above all where he tries to be tragic and strenuous at the same time. The distribution of weight between the straining Apostles fails to convince: there is an uncomfortable clutter of legs: Nicodemus breaks the concentration by looking towards us out of the picture-space, and there is doubt about where his arms are. Even Raphael's usual gift for colour and landscape is compromised by the effort to resolve difficulties of his own choosing. It is an ambitious effort, the kind of exercise which had to be attempted. What is astonishing is that barely a year later he is planning frescoes in Rome far exceeding the complexity and scale of the *Entombment* or anything else he had undertaken, and mastering their problems as though no effort had ever been entailed. But he never again attempted the subject of Christ's death.

Charity, Raphael; one of three predella panels for *The Entombment* (Vatican)

Part Two
The Prince of Painters

The piazza before St Peter's in Rome is one of the most dramatic forecourts in the world. It is not, like most great squares, a natural hub of urban life. It gathers its audience together only to prepare them for what lies beyond. As we know it now, it is a piece of very grand Baroque theatre, spectacularly stage-managed by Bernini. His two enclosing colonnades are like a drum-roll before the curtain rises on the central shrine of Catholicism and the seat of the Church's temporal and spiritual power, the Papal City of the Vatican.

In the summer of 1508, Raphael would have crossed this space for his first meeting with Pope Julius II, and he crossed it almost daily for the rest of his life. Although its appearance has vastly changed, it was not then very different in size, and one gets a reliable impression of it from Martin van Heemskerk's sketches of the 1530s. Instantly recognisable is the Vatican Palace itself, affording much the same glimpse of the south-east complex as it offers today, with the galleries built by Bramante,

St Peter's Square with the Vatican, Martin van Heemskerk (Chatsworth)

93

but known now as Raphael's *Logge*, looking out over Rome. This part of the Palace was the centre of Raphael's career and work for the twelve years remaining to him. Even when the physical labour on its decorations had been largely delegated to assistants, he was required to attend daily at the Papal court in one or other of the official capacities to which he was steadily appointed.

His own house and studio were on the opposite side of the piazza, in the ancient quarter between it and the Tiber known as the Borgo. The famous obelisk in the middle of the square was not moved there (a task which took four months) till later in the century, but Raphael could still have caught sight of it in passing, because since the days of Caligula it had stood just to the south of the present St Peter's: he was, as it happens, one of the first to recommend that what the piazza needed was an obelisk. The Borgo's two main streets, the Borgo Vecchio and the Borgo Nuovo, were finally swept away between 1936 and 1950 with the construction of a vast ceremonial way, the Via della Conciliazione. With them went almost every trace of the district as Raphael might have known it. From Bramante, reputedly for 3000 ducats, he bought not merely a house but a *palazzo*, which means that within five years of his arrival in Rome he was beginning to live already 'not like a painter, but as a prince'. The words are Vasari's, describing Raphael at the height of his career making an almost royal progress across the piazza surrounded by his entourage. 'For,' says his biographer, 'he never went to court without having fifty painters at his heels, all good and skilful, who accompanied him to do him honour.'

Drawings of Raphael's palazzo in Rome, Andrea Palladio (London, RIBA)

But the most surprising aspect of the square, as he knew it, was its western side. To many people it must have been the most controversial, not to say the most disconcerting, spectacle in Rome. Christendom's most venerable basilica, erected by Constantine more than a millennium before to hallow the site of St Peter's burial, was no longer there. With a self-confidence which was breath-taking even for the Renaissance, the old building had been pulled down in order to rebuild it in finer and grander style. In charge of the whole operation was Bramante. Two years before Raphael arrived, he had got the Pope to lay a new foundation-stone, and five years later, with 2500 workmen on the site, had raised the corner piers for a projected dome and built arches to connect them. There the work more or less stuck. Funds kept running out and van Heemskerk's drawings give an idea of the ensuing chaos even three decades later. Papal ceremonies were conducted virtually *al fresco* between the four piers, amongst temporary hoardings covered with flapping draperies, and surrounded by the huge disruption of a mason's yard. Only the entrance-façade to the forecourt of the old basilica remained to face the piazza like a discreet veil in front of the proceedings.

The upheaval was symptomatic of what tended to happen anywhere within the orbit of Julius II, for the Papacy had acquired one of the most dynamic forces for change in its history. No Vicar of Christ was ever a more ambitious prince of this world. He was sixty when he became Pope in 1503 and had only ten years given him, but in that time he earned his title of *il pontifice terribile* – the awe-inspiring

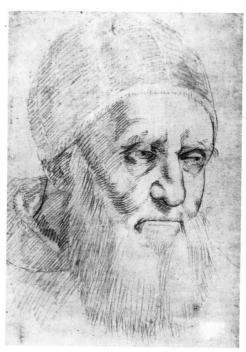

Pope Julius II, a study for the painting, Raphael, red chalk (Chatsworth)

95

pontiff. Driven by the Renaissance lust for fame as well as a genuine sense of spiritual mission, he was determined to leave his stamp on history, on the Church and on the city of Rome, which were in effect all one and the same. He manoeuvred an alliance of European powers under the name of the Holy League and, sword in hand at the head of his own troops, he welded the Papal States together again, forced the French to stop meddling in Italian politics, and made them at last withdraw their armies from Italian soil. By able reorganisation at the Vatican after the ruinous regime of the Borgias, he restored a credibility to the Papacy which had been all but squandered. He completed the physical transformation of Rome to make it, in Tommaso Inghirami's words, 'at last worthy of the name it bears'. He swept away whole neighbourhoods by driving streets like the Via Giulia through them, straight as his own ambition.

But he did so at frightening cost. His wars kept crippling his own exchequer and were often only sustained on *ad hoc* fund-raising and bank-loans. His forceful methods and none too scrupulous diplomacy raised opposition to him in one direction as fast as he secured his cause in another – his fortunes were never more desperate than in the year before he died, and he only lived just long enough to know he had triumphed. And like the central act of *hubris* in a Greek tragedy, the greatest monument he planned to his pontificate, his symbol of the Church restored to unity and power, was in the end the undoing of everything he achieved. For it was Julius who tore down the old St Peter's, intent on raising a new one which would give outward and visible form to the coherence of his grand design. The building was not completed till a century after his death, but by then the Church's efforts to make the rest of Christendom finance it had precipitated the Reformation and led on to the Sack of Rome by Imperial mercenaries in 1527. He had been dead only fourteen years.

His features are more familiar than those of any other Pope, not only because of Raphael. He is seen as a cardinal in his mid-thirties in a famous group-portrait in the Vatican by Melozzo da Forlì which shows him with his uncle, the first della Rovere Pope, Sixtus IV. Sixtus was a ruthless and scheming despot who bequeathed the practice of nepotism to Papal politics, but who was also a major promoter of Renaissance humanism and classical learning. He began the architectural rescue of Rome from its dilapidated mediaeval muddle, he collected antique marbles and bronzes, and he built the Sistine Chapel. Julius inherited his ruthlessness and his love of art, but in spite of beginning his own career as the Pope's favourite nephew, he stamped as firmly on nepotism as he did on simony when he came to power. That kind of integrity made him formidable in a court grown used to corruption: it was a source of inspiration and loyalty to his followers, just as his capricious temper, impatience and domineering will were a source of trial. Michelangelo's relations with him were a stormy saga of quarrels and attempted rebellion, but out of them came the achievement of the Sistine ceiling. Julius had first loaded him with the impossible commission for a tomb which would have taken twenty years to complete, and then tempted and bullied him into deserting sculpture for painting when

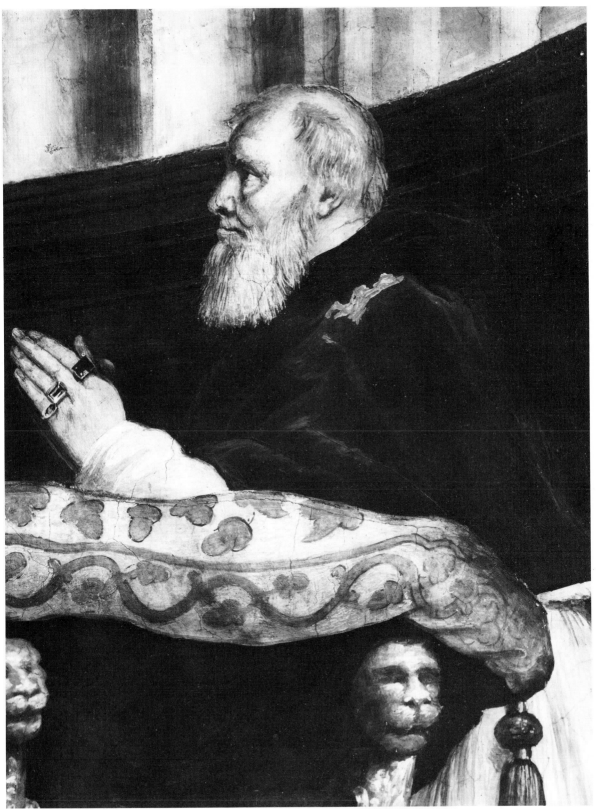

Pope Julius II, Raphael; a detail from *The Mass at Bolsena*

he least desired to. But the task-master knew his artist, and the artist recognised a kindred spirit as visionary as his own. Michelangelo did not stoop to portraiture, but in the force of his *Moses* for the abandoned Julius tomb, and even in his conception of God the Father on the Sistine ceiling, he was almost certainly reflecting something of the Pope's towering personality.

Raphael, on the other hand, portrayed him seven times in the first two of the Vatican apartments and, for the della Rovere chapel in S. Maria del Popolo, painted a searching portrait which is unlike any other image we have of him. Done within a year of the Pope's death, it shows a weary Titan whose body was weakened by gout and venereal disease but whose spirit also, at that moment, was subdued by the possibility of failure. It is a portrait painted with evident sympathy. Though at other times Raphael shows the piercing glance and the inflexible line of the mouth with a full appreciation of the man's pride, this is a reminder that he probably understood his humility also. For five years Julius guided his young painter through the most personal exposition of his thought, as he never guided Michelangelo, explaining what he wished to have expressed on the walls of the Papal apartments. In that close association, Raphael's own temperament would have made him see beyond the politician and the autocrat to the priest beneath both of them, whose most imperious ambition was for the sacred office he filled.

The link that brought the Pope and his painter together was Urbino. Julius had paid the city two memorable visits in 1506 and 1507. Raphael may not actually have been present, though his reputation at the court can hardly have gone unnoticed by so keen a collector of talent as his future employer. Castiglione was certainly there, because the second occasion supplied his *dramatis personae* for *The Courtier*, and one of them was not only Julius's nephew but Duke Guidobaldo's heir, the seventeen-year-old Francesco Maria della Rovere: he is the young man in white who looks out at us from the foreground group on the left of the *School of Athens*. Guidobaldo was already dying of tuberculosis, and Francesco Maria's succession only a year later brought Urbino and its court very much into the Papal orbit. It was at this point, in 1508, that Bramante neatly knotted the strands of circumstance together. He came from near Urbino himself, and saw an opportunity of strengthening his personal faction in Rome against his much-distrusted rival for Julius's attention, Michelangelo. Vasari tells us he wrote to Raphael 'on account of a slight relationship, and because they were of the same country, saying that he had induced the Pope to have certain apartments done, and that Raphael might have a chance of showing his powers there.'

The apartments in question were a suite of rooms being prepared for Julius's personal occupation because he refused to inhabit those, one floor lower down, which had been used by his hated Borgia predecessor, Alexander VI. They were already well under way, and Bramante may have had no greater objective in mind than to install his young protégé among the team of artists working on them: they included Raphael's own teacher, Perugino. On the other hand, he may have been more ambitious. No one has ever been quite sure when he first took his distant

relative under his wing and realised that he could become the ideal complement in painting to his own vision as an architect: one recalls that he is often credited with designing for Raphael the circular temple in the *Sposalizio*. When Vasari makes 32 him claim that 'he had induced the Pope to have certain apartments done,' the implication may be 're-done' – on the basis of more modern, that is to say more Bramantesque, ideas than the current team of painters were proposing. If so, he was a very successful schemer. Raphael's trial-piece for the commission is said to be the not over-familiar panel on the ceiling of the Stanza della Segnatura variously described as *Astronomy*, the principle of *primum mobile*, or *The Creation of the Universe*. A figure calling the unity of all things into being stretches her hand over a huge globe which, in the preparatory drawing, is clearly an astronomical model of the celestial spheres. Whoever or whatever prompted Raphael to choose the subject, it could not have been better calculated to flatter Julius: it was an allegory of the Pope's own creative ambitions at their grandest. He dismissed the entire team already at work and gave Raphael *carte blanche* to destroy what had been started and begin all over again. The decision was a credit to them both. They were both launching into the unknown.

Julius not only had an instinct for talent; he inspired it because he trusted it. Perhaps because he was a man of action rather than a scholar or an intellectual, he had realised better than any of the cultured minds with which he surrounded himself that the best of Renaissance thought was beginning to drown in a sea of words. Philosophies like Humanism and Neo-Platonism, which had been in intellectual favour for a century, needed redefining if they were not to sink under their own pedantry. We owe it to Julius more than anyone that the loftiest ideals of that brief peak of culture, the High Renaissance, were expressed in forms beyond words. In Bramante he had already annexed the services of the most forward-thinking architect of the age. In Michelangelo he had seized on its most brilliantly promising young sculptor and recognised the spiritual range of his vision. He had entrusted both with projects of daunting proportions. Now, with unerring faith, he chose his painter. Raphael had no experience whatsoever of so complex a commission, he had only once before worked without supervision on a fresco-painting, and he had never worked on the physical scale that now confronted him. But he rose to the occasion as artists backed by Julius always did. There is a receipt dated 13 January 1509 for an initial payment of 200 ducats to show that work on frescoing the first apartment was either contracted for or just begun. On 4 October of that year Raphael was appointed Writer of Apostolic Briefs, a sinecure to provide him with a permanent stipend and a position at court.

The first room, the Stanza della Segnatura, took two and a half years to complete. Four interlinked themes are announced in roundels towards the centre of the ceiling, developed through four panels below them, and fully expanded on the four walls. The two largest frescoes are about man's search for truth – the so-called *Disputa* (or solemn colloquy) on the meaning of the Christian sacrament: and the 58 so-called *School of Athens*, which is likewise a colloquy, on the significance of 2

speculative thought. They are 'so-called' because their traditional titles are not, so far as we know, Raphael's. On the other walls, the *Parnassus* depicts the kingdom of imagination and art, and a lunette facing it represents the *Cardinal Virtues*. That the whole room expresses a closely-knit thematic unity is generally agreed, even if the shelvesful of literature on the subject tend to read it in widely different ways. The idiom is allegory and it moves with conscious freedom between varying modes of reference and allusion. But like all great allegory, its central imagery is grounded in the kind of universals from which every age will draw its own interpretation. It has been seen as a religious document and as a secular manifesto, but the main point is always the same – that it is an attempt, at a highly developed cultural moment, to give a coherent view of man's spiritual and intellectual range. St Thomas Aquinas appears in the *Disputa* as a reminder that he too had attempted a *Summa* on that theme. Dante's appearance in the same fresco and again in the *Parnassus* recalls another thinker who reached for an all-embracing vision. Leonardo also appears twice (as King David in the *Disputa* and Plato in the *School of Athens*) in homage to a contemporary mind which above all others of the age seemed universal in its grasp.

The task of giving pictorial expression to this synthesis of ideas was enormous enough, but it needed an intellectual framework before it could even be approached. Who devised the programme has never been certain, though Julius clearly gave the initial impulse and outlined the structure on which it was to be built. Raphael was not himself the kind of abstract thinker to undertake it, even if it would have been allowed. That is not to underrate the quality of his mind, but only to say that his intelligence did not work that way. Unlike Leonardo with his notebooks or Michelangelo with his poetry and self-revealing correspondence, Raphael has left us next to nothing in words to show that he thought verbally. His few extant letters rarely discuss anything but business, and are curiously unpolished in style. Among the studies for the *Disputa* one suddenly comes across five drafts for sonnets, complete with a rather touching attempt to marshall his rhyme-scheme: they reveal that he was in love, but not any gift as a poet. Contrary to all precedent, Michelangelo is believed to have been left free to work out his own programme for the Sistine Chapel. But Raphael's commission required him to draw on wider resources of scholarship than any one mind could have supplied. They included theology, philosophy, history, literature and at least some guidance about scientific and mathematical thought. All those resources were to hand within his own immediate circle, and to them he could add one area of expertise in which he was growing more of an authority with every day that passed: his knowledge of Roman antiquities and classical imagery.

His advisers can be generally deduced if not certainly identified. There is an indication that he consulted Ariosto about the *Disputa*, but Ariosto was no theologian and would have been more helpful on points of literary tradition for the *Parnassus*, where his portrait duly appears. The *Disputa* is about the interpreters of Christian doctrine, and Raphael seems here to have turned to the Church's leading authorities on orthodoxy, the Dominicans. St Dominic himself is represented, and Thomas

Aquinas was a Dominican. St Francis, to be sure, is there also (for Julius was a member of his order) supported by the Franciscan Duns Scotus who contested Aquinas's interpretation of Aristotle. But the Dominican connection is reinforced by what looks like Raphael's own partiality. He had been well acquainted with the monastery of San Marco in Florence, which was Dominican: and to represent San Marco he included, not only Fra Angelico and St Antoninus (later a famous Bishop of Florence) but also, half-hidden in a black cowl on the far right and redeemed from the charge of heresy for which he had been burned only ten years earlier, San Marco's most famous Prior, Savonarola.

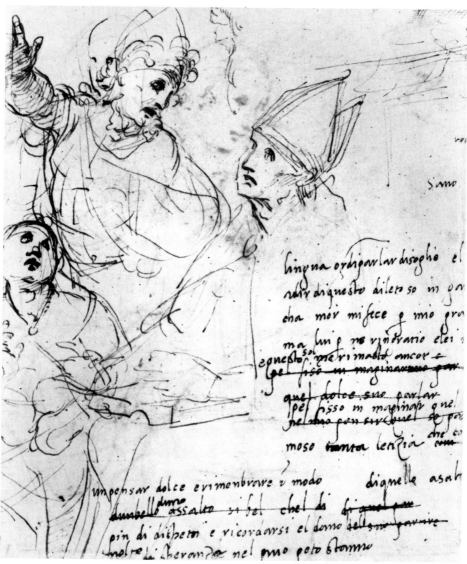

Studies for the Disputa, Raphael, with drafts for a sonnet (Vienna, Albertina)

For the *School of Athens*, on the other hand, Raphael required a guide to the history of philosophy. The Papal court could have supplied several, but a natural choice for him would have been Pietro Bembo. Bembo was a skilled classicist, a Venetian who gravitated to Urbino and thence to Rome, where he was to become Papal Secretary and a cardinal. But above all, he belonged to that circle of intimates which Raphael shared with Castiglione, and is another of those who take part in *The Courtier*. Castiglione himself, for that matter, could well have been involved, if only as a widely read and knowledgeable friend. The figure of Zoroaster immediately to the left of Raphael's own portrait, looking at him, has been identified both as Castiglione and as Bembo.

Although Julius now dismissed the earlier plans for the room as out of date, parts of the ceiling were at least adaptable to Raphael's new scheme. At its very 57 centre is a painted *oculus*, possibly by Bramantino or Sodoma, in which the escutcheon of the humanist Pope who built the Stanze, Nicholas V, is seen in a perspective of circling cherubs against the open sky. Raphael could never disregard the sky, that symbol of man's spiritual reach which he had brought with him from Umbria. He made it give air and space to all four walls, and he left the *oculus* intact overhead. Around it had been placed symbols of the four elements. The idea was apt, but needed expanding. In their stead, but absorbing their symbolism, Raphael placed four presiding genii of human endeavour – above the *Disputa* reigns the figure of Theology: above the *School of Athens*, that of Philosophy: above the *Parnassus*, Poetry: and above the *Cardinal Virtues*, that concept of order which sanctions virtue in human affairs, Justice.

But when it came to planning the two great walls that face each other across the room, one further mentor and guide was present to Raphael's mind. In the foreground of both of them are portraits of Bramante, the only figure apart from Julius, Dante and Leonardo (and just possibly Francesco Maria della Rovere) to be represented twice. If it was indeed he who had suggested a grander spatial configuration for the room, Raphael expressed the idea on a Bramantesque scale. The perspectives of the two frescoes lie on a single axis, complementing one another. To the spectator standing between them, beneath the dome of the ceiling with its *oculus* of sky, they circumscribe a space like the central crossing of a great church. What is clearly intended is an allusion to St Peter's. The coffered arches which dominate the *School of Athens* can be seen from van Heemskerk's drawings to represent Bramante's hoped-for vision of the new basilica. The *Disputa*, on the other hand, is set symbolically on the foundation of a church not yet completed. A scene of building operations 60 is shown on the left beyond Bramante himself, who leans on the balustrade. The Fathers of the Church are gathered on an open pavement while on the right, which allegorically denotes it as the cornerstone, there stands a huge truncated pier of white marble. The plan of St Peter's was to be a centralised space, the circle of the dome within the square of the piers. Given that Raphael's room is not square, he disposes his great concourse of figures to suggest a space which is circular. It is the shape he painted for Julius in his trial-piece of the *Creation of the Universe*.

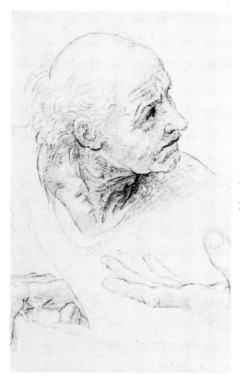

Study of Bramante for the Disputa,
Raphael, silverpoint (Louvre)

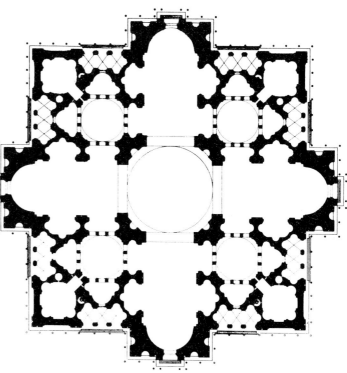

One of Bramante's early designs for the new St Peter's

Interior of St Peter's, with Bramante's crossing half-built, Martin van Heemskerk (London, Soane Museum)

Thematically, the *Disputa* begins the main cycle, for first in man's understanding of Truth must come his understanding of God. It is also, after parts of the ceiling, where Raphael began. It shows him relying on past experience while he finds his feet stylistically on this unprecedented scale and only gradually, in the course of seeing his work evolve, discovering his idiom and gaining confidence with it. The angels in the sky, for instance, and the figures on either side of Christ are much more tentatively handled than the groups at ground-level. Needing, as he must at this stage, all the reassurance he could muster, he also relies on a partial self-quote in designing the great arcs of the heavenly vision. The previous year, shortly before coming to Rome, he had painted a fresco in the tiny side-chapel to the church of S. Severo in Perugia. It had been his only previous experience with the medium since working as Perugino's assistant, and though far less ambitious than what he was attempting now, it was a similar scheme of Christ flanked by saints, all supported on layers of cloud and seen slightly from below. At the same time, he seems to have called to his aid his memories of a *Last Judgement* in Florence by Fra Bartolommeo. It is in the monastery of San Marco, much damaged now, but showing the same approach to a perspective rendering of sweeping arcs of figures. The painter-monk is one of those transitional, slightly soft-grained artists whose merits tend to be overlooked when more powerful talents are close by. He is in fact an important link between Leonardo and Raphael's developed classical style in Rome. One of the first Florentine painters to abandon contemporary costume for religious scenes in favour of a more idealised impression of classic draperies, he was also one of the first to enlarge on Leonardo's feeling for volume in space. About ten years Raphael's senior, he was moving in a direction close to Raphael's own and, until the *Disputa*, with more experience. It is hardly a coincidence that the echo of his *Last Judgement* in that work is reinforced by the other reminders of San Marco – the presence of Fra Angelico, Antoninus and Savonarola.

The *Disputa* drawings provide even clearer evidence than the fresco itself that not only Raphael's ideas, but his style, were changing course radically in the process of it. Fresco is a medium that forces decision and demands clarity. It has to be painted on quick-drying plaster which fuses the pigment with the wall-surface – which is why the medium is so durable and why, also, it refuses to lend itself to slow working methods or to second thoughts: it proved a disastrous medium for Leonardo. In its technical difficulties Raphael was professionally trained – in the need, for example, to control tonality and colour-balance when each day's patch of plaster has to be completed on that day. It probably took longer to attune his eye to the scale on which his spatial effects would work. The sensitive, impressionistic touch with brush and washes of ink in the earlier studies yields to more wiry drawing with the pen and then to that broad but utterly precise delineation of form with chalk or charcoal which never again, however soft or delicate, becomes impressionistic.

His first idea was apparently to close in the sides of the composition with architecture like a stage set, to give him perspective. An early study for the figures

Study for the left-hand side of the Disputa, Raphael, pen and wash (British Museum)

in the sky is concerned with keeping them afloat, well spaced out and almost weightless. Both ideas gave way to bolder ones. A group of several drawings develops the movement of figures at ground-level on the left-hand side, pressing forward up the steps – one of them a detailed life-study of posed nudes. On the wall, it must have looked too impetuous or not motivated sufficiently in depth, for the standing figure in blue with his back turned has been added. Stylistically he seems to have crossed over from the later *School of Athens*, but the effect of his presence is crucial. Both by his colour and his position he halts the rush to the right, directs the eye further inward, and makes it pause like the caesura in a line of verse, just before it reaches the all-important figure of Julius in the role of Pope Gregory the Great. Opposite Julius, on the right, is another Father of the Church, St Augustine, turning to his amanuensis on the steps. At his feet lie the volumes of his influential writings on Christian doctrine, the title of the most famous of them, *The City of God*, clearly legible. He is one of an assembly of figures representing those who, throughout history, have guided the spiritual wisdom of the Church. But his seated figure is such a superb invention of heraldic colour and sculptural form that it seems hardly to belong to the same stage of Raphael's development as most figures in the fresco. It may be, in fact, that Raphael returned to this whole right-hand grouping of the *Disputa* only when he was well into the more assured idiom of the *School of Athens*. He could even have done so after he had experienced the next decisive influence on his style. That was when he became aware of what Michelangelo was doing, only the distance of a courtyard away, in the Sistine Chapel.

The Prophet Jeremiah, Michelangelo (Sistine Chapel)

Michelangelo was working behind locked doors in an atmosphere of secrecy and paranoia which even the Pope found it difficult to penetrate. The secrecy was that of any artist needing to be alone to concentrate. But he seemed also desperately conscious that his ideas were vulnerable to theft before he had even finished expressing them. He had engaged assistants only to dismiss them almost immediately, and had been toiling in isolation on his ceiling for some months before Raphael arrived in Rome. It is difficult to be sure what he thought of Raphael. One story says he gave Julius Raphael's name when he was trying to avoid the Sistine commission himself. There is a later anecdote of his praising Raphael's *Isaiah* in spite of – or perhaps because of – its obvious dependence on his own style. Both artists had partisans able and willing to make a cold war out of what may have been no more than rather luke-warm personal relations. On the other hand, Bramante did give

occasion, quite deliberately, to justify much of Michelangelo's suspicion and resentment. As the Papal architect, he had keys to the Sistine Chapel, and he let Raphael in to look. The effect of those giant Sibyls and brooding Prophets is apparent in a variety of figures throughout the Stanza della Segnatura who turn with a nobler gesture and grander rhythm because of them. The finest by far is Raphael's outright gesture of homage. He added Michelangelo's portrait to the central foreground of an already completed *School of Athens*. The portrait of a mood, a temperament, a powerful and tragic presence rather than a personality, it represents Heraclitus, the philosopher for whom all matter partook of the element of fire, all things flowed, the spirit of the world was a perpetual state of becoming. It is the noblest Michelangelo creation ever invented by another mind than his.

Memorable as the figure is in himself, he gives weight in every sense to the atmosphere and rhythm of the whole fresco. Slightly out of proportion (standing up, he would dwarf the figure beside him), his dark bulk in the foreground underlines the already strong sense of recession beyond. His purples and browns sound out the soft resonances of blue and red scattered through the colour-texture of the painting and play them together as a single richer and deeper chord: without it the four strong notes of yellow, the one on the right of Aristotle particularly, would ring out almost too loud. What one might call the corporate psychology of the whole gathering is also enriched by this darker, more sombre element of introspection. Given so much by an unscheduled addition, what can the fresco have felt like without it? Unlike the *Disputa*, hardly any studies survive for the *School of Athens*, but what does survive is something rarer: it is the full-scale working-cartoon for the whole of the lower half of the composition – that is to say, as originally painted. When the central area of steps was opened up, the feeling of a wide semi-circle of figures, pulled well forward at the sides and far back in the centre, must have echoed much more self-consciously that of the *Disputa*. Just as the *Disputa*'s theme is divided between a lower half and an upper, so that of the *School of Athens* is balanced between its left-hand side and its right: this too is a more self-conscious effect in the cartoon. If anything, the Michelangelo figure has disguised a more schematic exposition.

The balance between left and right stands for complementary aspects of thought. As the *Disputa* is about spiritual wisdom and the knowledge revealed by faith, so this celebrates the wisdom attainable by human reason. Not only philosophy, but logic, mathematics, even grammar and rhetoric are among the disciplines represented. Nor are the participants all Greek or even Athenian. They include an Arab philosopher and a Persian mystic. The first is a twelfth-century writer from Moorish Spain, Averroes, whose texts were translated into Latin and taught in Christian universities: he is bending over the foreground group on the left, in a white turban. The second is Zoroaster, or Zarathustra, on the far right holding a blue globe, who had argued the opposition of good and evil in a dualistic universe. Plato, with his hand pointing to heaven, presides over the left-hand side of the painting, which

Continued on page 121

Raphael was summoned to Rome in 1508 by Pope Julius II (56) and from then until the Pope's death in 1513 was occupied almost exclusively on frescoes for the Papal Apartments (the 'Stanze') in the Vatican. The first room was the Pope's library, and celebrates the greatness of human thought in allegories of religion (58), ethics, philosophy (59 and plates 1–3 above) and art (61–63). The second is strikingly different. Painted at a time of great political uncertainty, it illustrates examples of God's miraculous intervention in answer to prayer. Three of the frescoes (65, 67, 70) include portraits of Julius II. The fourth, not completed till after his death, substitutes his successor, Pope Leo X (73).

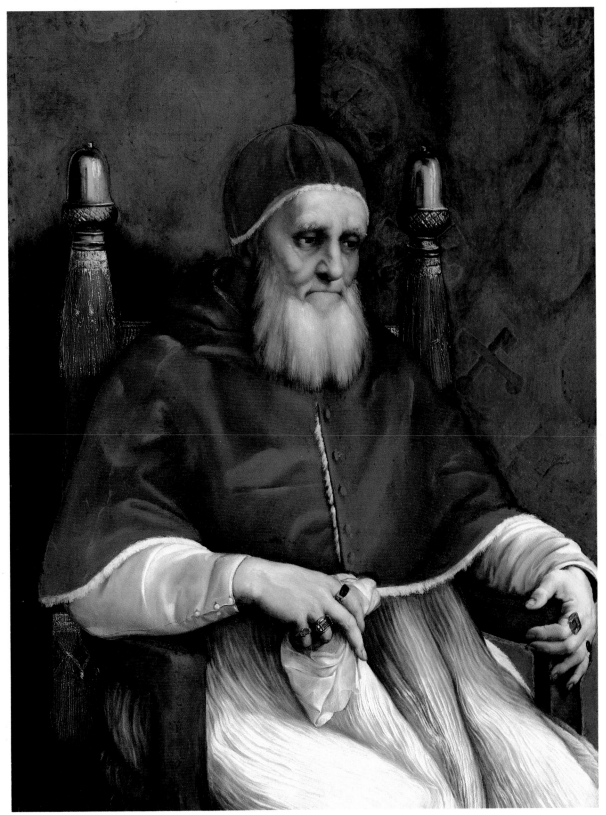

56 Pope Julius II, Raphael (London, National Gallery)

VATICAN, RAPHAEL ROOMS: STANZA DELLA SEGNATURA 57 *Ceiling* 58 (below) *Disputation on the Sacrament* (*Disputa*)

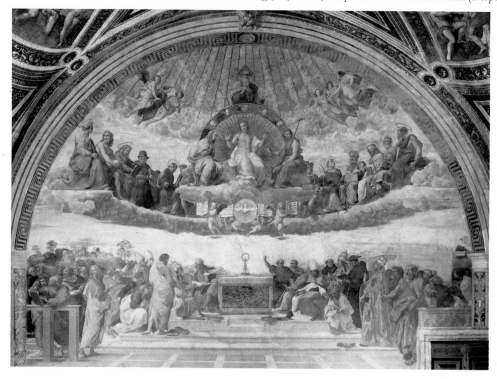

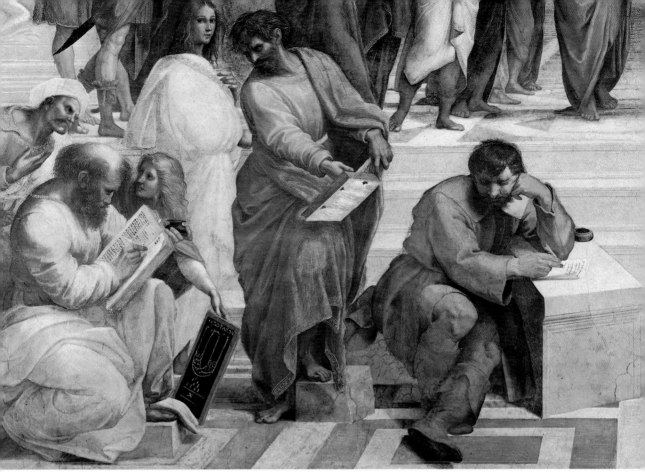

59 *The School of Athens*, detail of left foreground figures 60 (below) *Disputa*, detail

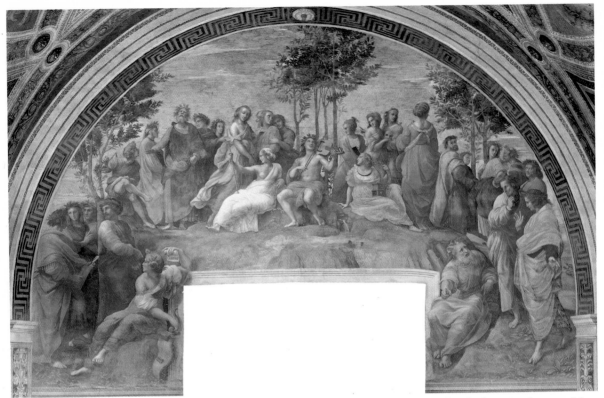

VATICAN, RAPHAEL ROOMS: STANZA DELLA SEGNATURA 61 *Parnassus* 62 (below) *Parnassus*, detail of group of poets with Apollo 63 (opposite) *Parnassus*, detail from right

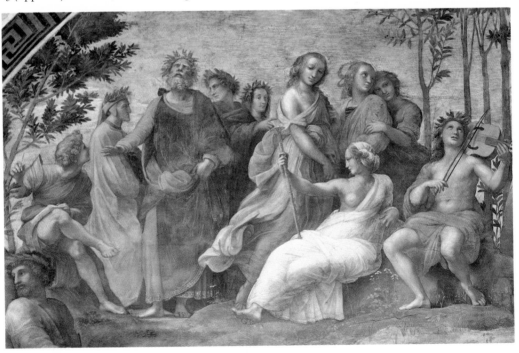

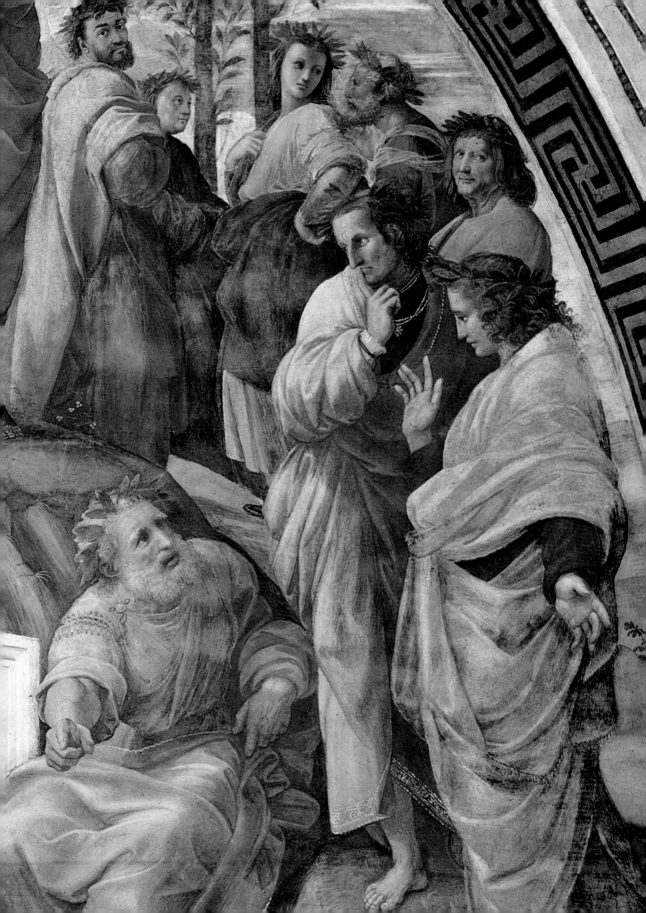

VATICAN, RAPHAEL ROOMS: STANZA DI ELIODORO 64 *The Burning Bush*, detail from ceiling 65 (below) *Expulsion of Heliodorus* 66 (opposite) *Expulsion of Heliodorus*, detail from right

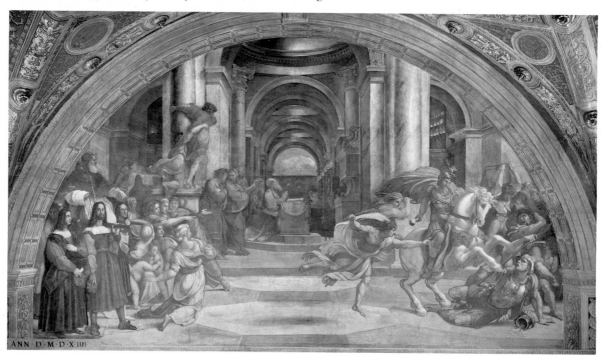

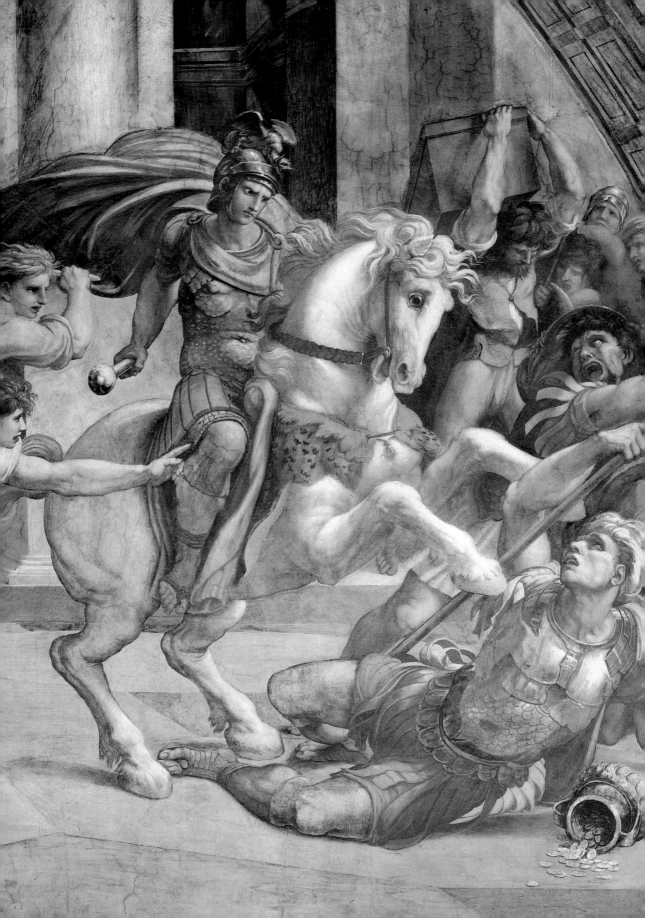

VATICAN, RAPHAEL ROOMS: STANZA DI ELIODORO 67 *Liberation of St Peter* 68 (below) *Liberation of St Peter*, detail from right 69 (opposite) *Liberation of St Peter*, detail from centre

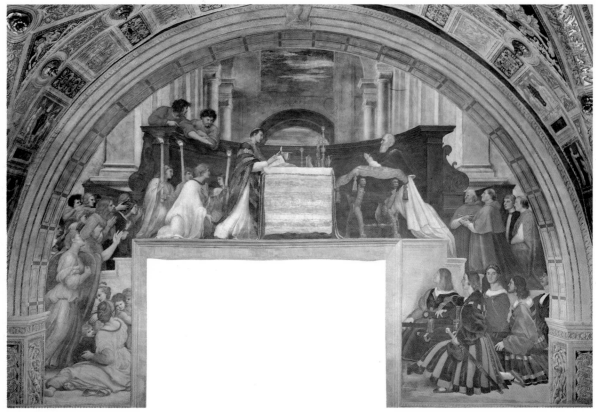

VATICAN, RAPHAEL ROOMS: STANZA DI ELIODORO 70 *The Mass of Bolsena* 71 (below) *The Mass of Bolsena*, detail
72 (opposite) *The Mass of Bolsena*, detail of Swiss Guards

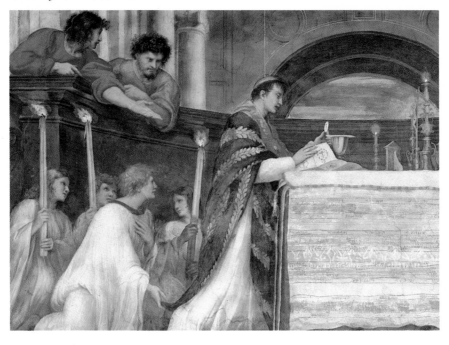

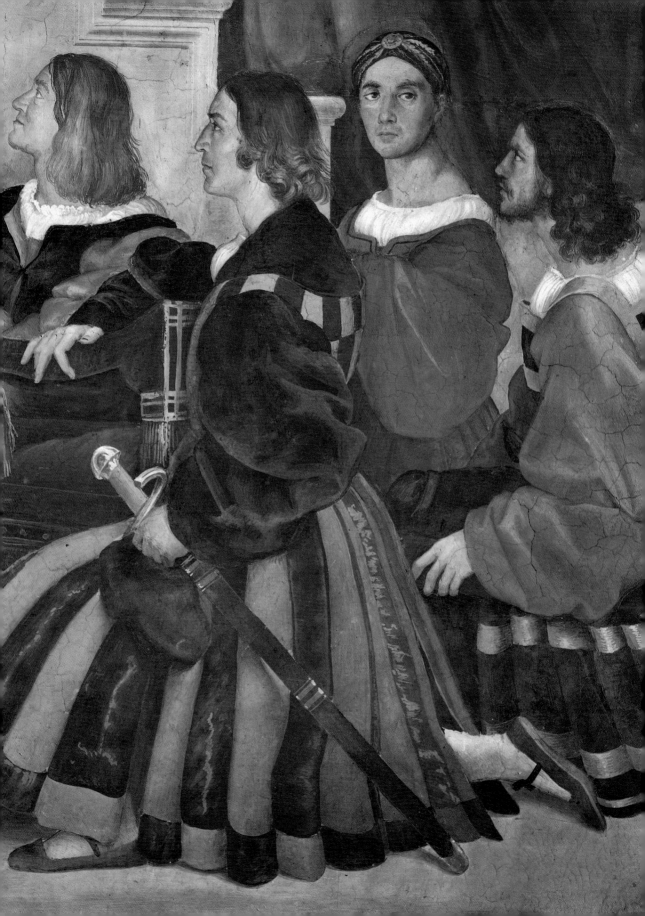

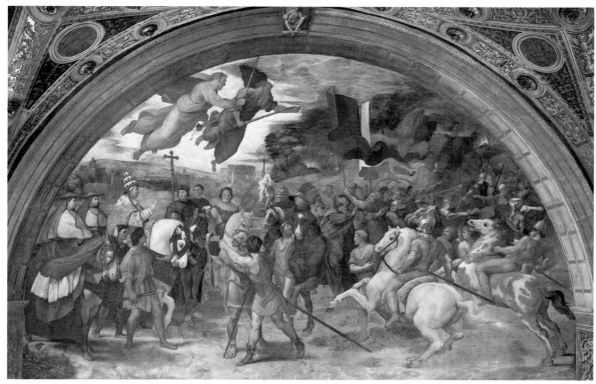

VATICAN, RAPHAEL ROOMS: STANZA DI ELIODORO 73 *Meeting of Leo I and Attila*
74 (below) *Meeting of Leo I and Attila*, detail

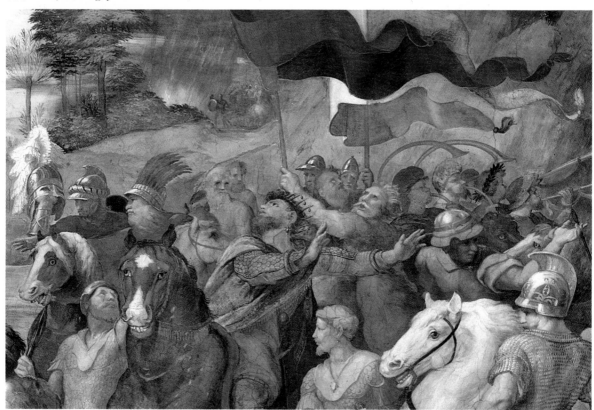

stands for intuitive intellect and idealist or abstract thought. The statue of Apollo, who is the light of reason, looks down on this half. It includes Socrates, who searched for ethical values rather than scientific certainties, and in the foreground, writing in a book, sits Pythagoras. Before him is a slate recording his mathematical 59 researches into the laws of harmony. But he is, as it were, of Plato's faction because he taught the immortality of the soul: even, in fact, the transmigration of souls. On this left-hand side, philosophy is thought of as akin to the faculty of imagination, and on the neighbouring wall it leads into Apollo's other realm, the world of artistic imagination, the *Parnassus*.

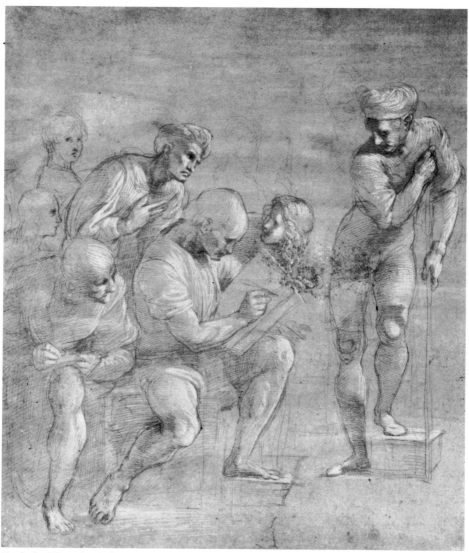

Study for The School of Athens *with Pythagoras, Raphael, chalk heightened with white (Vienna, Albertina)*

3 Of all Raphael's triumphs of expressive and meaningful gesture, perhaps the
most famous is the exchange between Plato and Aristotle. Plato's hand pointing to
things invisible is countered by Aristotle's open one stretched over the world of
ascertainable fact. The right-hand side of the fresco is the side of pragmatic thought
rather than intuition, the reason that deduces from hard evidence. And from her
niche above, it is watched over by Athene, goddess of wisdom. Not every detail in
such a programme can be too pedantic, perhaps. One does wonder, for example,
if there is any significance, as apart from convenience, in Raphael's having painted
himself on this side rather than the left. The figure beside him, on the extreme right,
is thought to be the artist Sodoma, who cannot have relished being dismissed from
the work he had already been doing in this room and who may be included as a
typically graceful and conciliatory gesture on the part of his successor. But the two
painters, one suspects, do not stand here as representatives of art but simply to get
Raphael as near as possible to Bramante. For Bramante is the focus here, playing the
role of Euclid and balancing Pythagoras as Aristotle balances Plato: the great geo-
metrician, the codifier of mathematics, the practical teacher surrounded by eager
acolytes as Bramante was by every young artist who came to Rome. On the neck of
his tunic Raphael acknowledges his own debt by inscribing his initials and the date:
1509. Again there are thematic links through to the wall on the right, which carries
the lunette of the *Cardinal Virtues* (Prudence, Temperance and Strength of Purpose)
presided over by the roundel of Justice in the ceiling. Athene is the goddess of
justice as she is of wisdom, and the theme is one of reason leading to good govern-
ment, those qualities by which man governs himself and the world of temporal
affairs.

 The *Virtues* lunette is a graceful decoration rather than a full-fledged pictorial
61 allegory, but the *Parnassus* opens the fourth wall to the sky, sunlight, trees and the
murmur of voices. Perhaps because it is a more specialised expression of Renaissance
taste, it tends to appeal less directly nowadays than the *Disputa* and the *School of
Athens*. Few works of art slip from fashion more easily than those which set out to
charm their contemporary audience with its current notion of art. Here the king-
62 dom of the creative imagination is duly personified by Apollo and all nine Muses,
63 but the rest of the company consists entirely of poets past and present. Music is
alluded to in a supportive role; there is not a visual artist in sight. The order of
priorities may not be quite our own, but then to the Renaissance art in any medium
was first and foremost 'poetry'. The gift for which Raphael himself was most ad-
mired was that he gave form to a 'poetic' quality of thought. Indeed that was what
he continued to be valued for until late into the nineteenth century: his 'expressive-
ness' set him above all other artists until a revolution in aesthetics, of which we are
still the heirs, reversed the priority of content over form. It was in the 'poetic'
content of heightened allusion and graceful cultural reference that Raphael made
himself particularly adept. For his audience, steeped in the culture of antiquity,
a hint here and a reminder there set the delighted imagination winging among
remembered beauties.

Raphael could have loaded the *Parnassus* with such allusions. Most artists of his time with such a subject did. But in his usual way of re-creating rather than quoting his sources, he suggests an atmosphere of classical reference without specifying it. Some scholars of iconography have been particularly teased by his Apollo. There is a vivid life-study for this figure, but the pose seems so authentically antique that hope still abounds that some day an antique source will be rediscovered for it. Where a reference is precise and unmistakable, Raphael is usually making an allegorical or archaeological point rather than an artistic one. Three of the musical instruments in the *Parnassus*, for example, are closely studied from sarcophagus reliefs – Calliope's flute, Sappho's tortoise-shell lyre and Erato's lyre with a boxed sounding-board. On the other hand, music is perennial and timeless: Apollo plays a Renaissance treble-viol.

At other times, the allusion can be more complex. Members of the Papal court would instantly have recognised the likeness of Raphael's head of Homer to that of the *Laocoön*, the famous marble group which is still in the Vatican collections. It

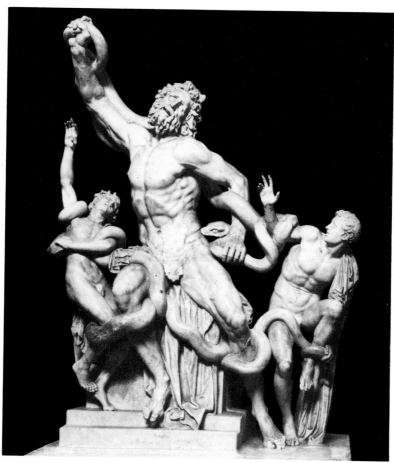

Laocoön, as first restored (Vatican)

123

would have recalled all the excitement of that day three years before when the work was first dug up. The news had spread like wildfire across Rome on 14 January 1506, and the architect Giuliano da Sangallo had hurried with Michelangelo to see it. From his own classical reading he had known immediately what it must be. Pliny the Younger, the friend of the Emperor Trajan, had left a description of it as the most estimable work of art in the Imperial Palace. Pope Julius fully intended that the Papacy should own by far the finest collection of antique works in Rome. Over-riding some stiff competition, he bought the *Laocoön*.

His collection was partly a status-symbol, partly the garnering of a Roman heritage, and partly a quite genuine homage to beauty. Bramante's extensive additions to the Vatican Palace had included, to Julius's specifications, an open-air sculpture-court to display the most choice pieces. A kind of shrine to antique art, its selective arrangement and attractive formal setting complete with fountains and orange-trees were at that time unprecedented, and the Belvedere collection made a deep impression on contemporary taste. Besides the *Laocoön*, it included the 'Belvedere' Apollo, which remained for centuries the most admired statue in the world, and the 'Belvedere' Torso, which profoundly influenced Michelangelo. It seems not to have included, at the time Raphael painted the *Parnassus*, another much admired piece known then as the *Dying Cleopatra*. Her title nowadays is the *Sleeping Ariadne*, the Renaissance having romantically mistaken a snake-bracelet on her arm for Cleopatra's asp. Castiglione was the first of many who wrote sonnets to her, fashionable collectors like Isabella d'Este had miniature copies of her, and Raphael used the pose of her legs and drapery for the Muse Calliope, who is prominent in white to the immediate left of Apollo. Whether or not he intended rather pointedly to show Julius his aesthetic interest in the statue, a year later we hear of her as having just been acquired by the Pope. Bramante designed a special fountain-setting for her in the sculpture-court of the Belvedere.

Raphael formally signed the *Parnassus* as completed 'in the eighth year of the pontificate of Julius II, AD 1511'. He was probably signing the formal completion of the Stanza della Segnatura also. But towards the end of his work on it there had been a lull at the Vatican. This tended to occur whenever Julius left Rome for any length of time, because the cost of his campaigns prevented his employees at home getting paid. The Papal tiara was already in pawn to the Papal banker. 'I have not received as much as three pence,' moaned Michelangelo to his brother, and on this occasion he stormed his way to Bologna to expostulate to Julius in person. Raphael may not have been as financially hard-pressed: he had his stipend as Writer of Apostolic Briefs, but payment even of that may not have been regular. It was in this lull that he was approached by the Papal banker. Agostino Chigi, the 'great merchant of Christianity', was to be Raphael's most important patron after the Pope himself. He came of an influential Sienese family which a hundred years later supplied its own candidate for the throne of St Peter, and in 1511 he was much concerned with completing an elegant house which Baldassare Peruzzi had designed for him on the expensive west bank of the Tiber. After his death it was bought by

The 'Belvedere' Torso (Vatican)

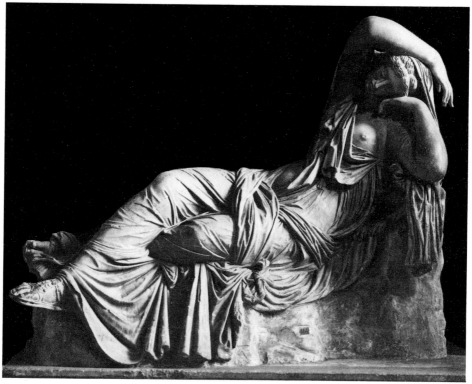

The Sleeping Ariadne, formerly called 'The Dying Cleopatra' (Vatican)

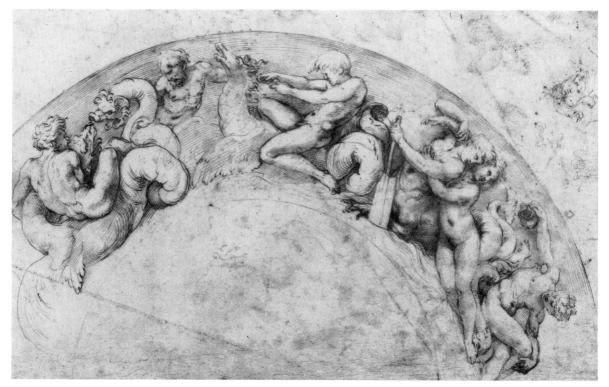

Design for the border of a salver, Raphael, pen and ink (Oxford, Ashmolean Museum)

the Farnese, and is known today as the Villa Farnesina. He approached Raphael first to provide designs for two bronze vases, in classical taste, with earth-creatures – centaurs and nymphs – on one, and sea-creatures – tritons and naiads – on the other. Chigi then asked him to join the team of artists busy frescoing the loggias of his new villa.

80-82 The result was only one painting – the Pope's imminent return to Rome may not have allowed for more – but it is the most joyous of all Raphael's evocations of classical mythology: the triumph of the sea-nymph Galatea riding her dolphin-drawn scallop-shell among sporting Nereids, Tritons and Cupids. The fresco was originally seen beyond an arcade that opened on to the garden, and a cool summer breeze still seems to blow through this open-air water-frolic. Raphael was working alongside Perruzzi, who was a virtuoso of fresco-technique besides being an architect and a colleague of Bramante's: and also with the painter Sebastiano del Piombo, who came from Venice. The two of them together seem to have inspired him to superb freshness of handling and adventurous forays in colour. Greens he had not used before, subtle transitions across the flesh-tones, the iridescence of the cupids' wings are among the technical triumphs of the *Galatea*, and as an added bonus, there still survive on the unpainted plasterwork below it some of his work-in-progress jottings including a girl's face and the profile of an old man. From a letter we also get a rare glimpse into Raphael's mind. Writing to Castiglione he says: 'In order to paint a beautiful woman, I must see women of even greater beauty. You

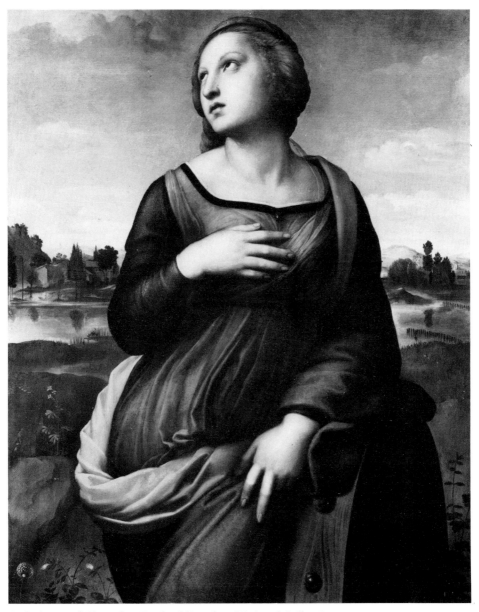

St Catherine of Alexandria, Raphael (London, National Gallery)

must help me to find the best. If I lack good judges and beautiful women, then I follow what I have in my mind. I have a certain Ideal in my mind.' His Galatea is a synthesis of ideals. Those from art include a twist of the body from Leonardo's *Leda and the Swan*. The gesture of the arms over the raised left knee is a reminiscence of an antique Venus of what is known as the 'Capua-type': a Venus who is holding the shield of her lover, Mars. But the head is that of one of his own Madonna-like female saints, like the *Catherine of Alexandria*. And yet they are all transformed with a physical zest which can only be taken from life.

Raphael's *Galatea*, surrounded by amorous rompings and the target of three arrow-happy Cupids, is a hymn to the pleasures of love. Artists' love-lives are not usually much discussed in art-history, but Raphael's is part of the legend and part of the image. Vasari is rather tight-lipped about it. Having reported that Raphael drew portraits of various ladies, 'including his mistress', he goes on: 'Raphael was very amorous, and fond of women, and was always swift to serve them. Possibly his friends showed him too much complaisance in the matter.' Posterity was happy to amplify the hint, and the divine Raphael was humanised with a love-story. All of it is apocryphal, and even the title of his mistress and favourite model – 'La Fornarina', the baker's daughter – is a later invention. The *Galatea* may or may not be an idealised image of her, but the Villa Farnesina directly borders on the Santa Caterina district of Trastevere from which she is reputed to have come. They will even show you at the end of the street the garden of the local restaurant where Raphael is said to have courted her.

117 A striking portrait in the Borghese Gallery in Rome which acquired much of its fame because it was presumed to represent her, shows a lustrous bold-eyed beauty naked to the waist. It is not by Raphael but by Giulio Romano, and is thought now to be possibly a likeness of the great courtesan Imperia, who numbered Agostino Chigi among her admirers. But La Fornarina is almost certainly the model for the
55,53 softer and more moving beauty of the *Sistine Madonna*, the *Madonna della Sedia* and the lovingly painted symphony in cream and gold, Raphael's most sumptuous
86 female portrait, known as *La Donna Velata*. Attempts to identify her historically concentrate on an entry for 8 August 1520 in the records of the Conservatorio di Sant' Apollonia, a home in the Trastevere quarter for women in trouble: 'today was received madonna Margarita, widow, daughter of Francesco Luti of Siena, deceased'. The date is just four months after Raphael's death, and the word 'widow' could be a euphemism. There is also a house in the Via del Governo Vecchio which is known to have belonged in 1518 to a baker from Siena, who might be Margarita's father. How early or late La Fornarina entered Raphael's life can only be guessed at. Some authorities suggest that the five stumbling love-sonnets among his drawings for the *Disputa* are addressed to her. But she is clearly more than a romantic anecdote or merely one of Raphael's 'secret pleasures' (Vasari's phrase). One of the reasons her legend has stuck is because she fits the role of Raphael's Muse. As soon as she comes to mind as the possible model for one painting, the likeness echoes again and again through others, not as an identifiable portrait but as a recognisable type. No less than classical antiquity, the influence of Leonardo or of Michelangelo, or that earlier type of beauty he had derived from Perugino, she supplied a particular standard around which to conceive of an ideal.

At the Vatican, the Stanza della Segnatura is completed, and the scene changes. It is only to the room next door, but the transition is dramatic. You walk through a door in the wall of the *School of Athens*, and beyond it you see first the Pope in state, being carried aloft on his gestatorial chair. As the whole wall comes into view, you realise he has been brought in to witness from time present, like yourself, a scene of

exemplary drama from time past. It is the *Expulsion of Heliodorus from the Temple*, 65
the first of the frescoes to be started in this room and the one from which it takes its
name, the Stanza di Eliodoro. The change of mood is disturbing. It has darkened,
fragmented, become more claustrophobic. The lofty calm of the Segnatura has
given way to tension and mystery. Where the earlier room is dominated by sky in
all directions, here space is closed in and cut off. Where sky is visible, it is beyond
reach, or shadowed by storm-clouds, or lit by a waning moon. All four walls are
about miracles and the saving hand of God in the hour of man's need.

Like so much of Raphael's work, the relative reputations of the two rooms have
largely been governed by the history of taste. Broadly speaking, an age of certainty
will turn to the Segnatura and an age of doubt will turn to the Heliodorus. The
Segnatura is the more famous because it has been valued longer by centuries more
confident than our own. It will probably always answer more deeply to the needs
of those who feel the things of the spirit in terms of affirmation rather than struggle.
The Heliodorus room clearly lacks harmony on the same intricate scale, its pro-
gramme was more disrupted by events, assistants are known to be at work, and a
major break occasioned by Julius's death occurs in the middle. It can be argued that
all these qualifications make it, aesthetically, just that much the inferior achievement
of the two. On the other hand, in two of the frescoes at least, the *Mass at Bolsena* and 70
the *Liberation of Peter*, Raphael surpasses in imagination and technique anything in 67
the Segnatura except the loftiness of the conception as a whole. But in fact the two
rooms are no more comparable than day and night. They speak for a balance of
opposites, and nothing demonstrates more powerfully Raphael's range and univer-
sality than that he should have given expression to both, on such a scale, in a virtually
unbroken sequence of four and half years' work, with only a palace doorway to
separate our experience of them.

The Heliodorus room bears two dates, 1512 and 1514 and, inasmuch as Raphael's
life is bound up with the fortunes of the Papacy, they span the most traumatic years
he ever knew. The first of them saw Julius II's grand political design apparently in
ruins, and then almost miraculously turned to triumph. The next year he was dead,
and succeeded by a Pope who loaded Raphael with more honours than even Julius
had done, but was a man of utterly different character, different standards and
different moral fibre. Julius clearly planned the room, though he did not live to see
it completed: his image dominates three of its walls. He had been absent from
Rome, taking the battlefield against his enemies, for a year. He returned in time to
celebrate the Mass of the Assumption under Michelangelo's almost finished Sistine
ceiling on 15 August 1511, but he returned without victory and with dangerous
rebellion stirring against him even within his own camp. At sixty-eight, physically
exhausted, his political ambitions unachieved, the Papacy he had fought to strengthen
now divided against itself, he required Raphael to design a room about God's
intervention on behalf of those who put their lives in His hand.

As in the Segnatura, earlier frescoes were ruthlessly stripped, including one by
Piero della Francesca on the *Heliodorus* wall. And as before, the theme is announced

on the ceiling: Abraham, Noah, Moses and Jacob each in turn hear the voice of God in a critical hour. The incident of Heliodorus is a rather obscure one from the Second Book of Maccabees, but it was apt to Julius's purpose as a tale of foreigners (namely the French) trying to loot the House of the Lord (namely the Papal States). Heliodorus, treasurer to Seleucus, King of Asia, had heard of treasure stored in the Temple at Jerusalem and broke in by force to demand that it be surrendered to him. Raphael exploits all the local colour of the Bible narrative: 'The city was consumed with terror. The women ran to the gates and to the walls, others looked out of windows and all made supplication . . . Then the Lord of Spirits and the Prince of all Powers caused a great apparition – a horse with its rider, his armour all gold, smiting Heliodorus with its forefeet. And two youths stood either side and scourged him. And Heliodorus fell unto the ground and was compassed with great darkness . . .' As in the *School of Athens*, the scene is set against a plunging perspective of architectural space, but, as this is not contemplative allegory but narrative action, the action itself is designed in depth and accentuates it. The terrorised crowd on one side leads back into the focal centre of the temple where the High Priest, with the features of Julius, kneels in prayer. On the other side, his prayer is answered like a rushing wind returning to the foreground, sending Heliodorus and his spilled loot sprawling into the extreme bottom corner of the design.

Nowhere does Raphael quite so dynamically exploit the principle (which derives from classical aesthetics) that the eye reads naturally from left to right and that pictorial narrative should be told from left to right also. In the *Heliodorus* it not only sweeps from corner to corner in a great arc, it gathers speed as it goes. How the movement originally kicked off on the left we can no longer see, because the group with the Pope was added later and obscures the first section of the crowd. But what an inspired addition it is! The art of *contrapposto* is usually only associated with figures, to achieve that twist of the body in two directions which is yet united in a single action. But it was a principle extended to spatial design also, to ensure that whatever happened on one side was countered by its opposite on the other and that they balanced out. The Papal group sends the whole impetuous movement of the *Heliodorus* on its way but anchors it like a rock. Its weight is leant slightly backwards as if to brace itself against the shock of those collapsing figures on the other side of the room.

It seems almost certain that the painting was begun while Julius's fortunes appeared at their most desperate, and that the Papal group was added as part of the celebrations when they suddenly turned. In April 1512 he had lost the Battle of Ravenna to the French and a council of dissident cardinals in Milan had declared his suspension as Pope. A month later his allies within the Church crushed the cardinals' rebellion at the Lateran Council in Rome, and a realignment of his political allies, with notable reinforcements from the Swiss, allowed him in June to recapture Bologna and hear that the French were abandoning their claims and withdrawing all their forces at long last from Italy. This turmoil of events is the bridge between the *Heliodorus* fresco and the one which follows it, the *Mass at Bolsena*. The contrast

D · M · D · X · IIII ·

The Expulsion of Heliodorus, Raphael; with Julius II, Marcantonio Raimondi and, behind him, Raphael (Vatican)

between them is complete, like peace after the storm, and the second fresco is in some ways so contained round its apparently self-explanatory celebration of a Mass that, unlike the *Heliodorus*, it can give rich and varied pleasure as a painting long before one feels concerned to know what is happening. The drama is there, but this time it is an inner drama and one of the great examples of Raphael's gift for what his contemporaries called the 'poetry' of narrative thought.

On his way to Bologna, when success still hung in the balance and with it, in a sense, the justification of his life, Julius had stopped at the Cathedral of Orvieto to do homage to the sacred relic which that cathedral had been built to house. It was a Corporal Cloth, used in the Mass, which had been the occasion of a miracle at Bolsena in 1263. A priest of wavering faith had doubted the mystery of Transub-stantiation – that the bread and wine became truly the body and blood of Christ at the moment of consecration. As he prayed for reassurance, the chalice itself had flowed blood. This is the subject of the painting. To know the story is to understand how almost any other painter might have vulgarised it. Raphael shows no blood, no anguished reaction. For priest and watching Pope alike, the moment of truth is inward, spiritual and completely still. Then there is built up around it a presence of actuality and a transition to the normal world which, again without overt drama, turn the whole painting into what for Julius it celebrated – certainty restored in the triumph of faith. Below him on the right are the cardinals loyal to his cause who had helped turn the tide of fortune, and below them Julius's expression of gratitude to his new and crucial allies, the Swiss. He had granted them in perpetuity the right to be the Pope's personal bodyguard, as they still are today. They are dressed here as northern mercenaries, but their official uniform was to be designed for them, possibly with advice from Raphael, by Castiglione.

This famous group always rivets attention with its realism, but it is worth noticing how again Raphael applies the *contrapposto* principle to balance them on the other side. Against their soldierly masculine presence he places a particularly ap-pealing group of women and children. And between the two he achieves a range of expressive colour which has often led to speculation about the influence of Venetian painting on this fresco, for it does marshal its effects with a chromatic richness unlike anything else in Rome at that period. We know Raphael had worked along-side Sebastiano del Piombo at the Villa Farnesina. Lorenzo Lotto is recorded working at the Vatican in 1509. Paintings from that home of colourists where Giorgione had just died and Titian was coming to maturity would certainly have been in circu-lation. Raphael's Umbrian background had already carried him through Florence with a far subtler colour-sense than most Central Italian artists, and his sensitivity to all outside influences would have made him acutely aware of what Venice was contributing to the art of the new century. Through colour and atmosphere Venetian painting was demonstrating precisely that control of pictorial unity which he himself was aiming for in the design of space. One of the still unexplored areas of Raphael scholarship is the extent of his possible Venetian contacts, and there are in particular certain portraits around the second decade of the sixteenth century which are at

Detail from the Mass at Bolsena, Raphael (Vatican)

present attributed to painters like Sebastiano but may yet be added to the corpus of Raphael's work.

Julius gave thanks for his success by retiring for four days of private prayer to the church in Rome where he had officiated before becoming Pope. It was dedicated to San Pietro in Vincoli, St Peter in Chains – the imprisonment of Rome's patron saint from which an angel had released him. Julius then returned to the Vatican through illuminated streets and to the cheers of his people. In Raphael's *Liberation of St Peter*, his third fresco in the Stanza di Eliodoro, he once again gave the features of Julius to the central character and they were to be his farewell to the great Pope. Julius died on the 21 February 1513, and the fresco which was planned to symbolise his escape from past dangers reads now like an allegory of his release from the prison of this world. Even more than the *Mass at Bolsena* it is a scene which tells its own story with magnificent narrative power and concentrated realism. A few rooms away in the Vatican is a small chapel frescoed sixty years earlier by Fra Angelico for Pope Nicholas V. A mere detail in it of heads seen beyond a prison grating is just the kind of motif that would catch a painter's eye and be stored in a visual memory like Raphael's to become the germ of his most arresting invention here. His huge prison grille lies flat with the surface of the wall, yet on this constricted and already darkest side of the room, space is more three-dimensional and the lighting more atmospheric than in any of the more openly planned frescoes. A night-piece on this scale had never been attempted before, and it anticipates a whole century of tenebrist painting but with less melodrama and a more profoundly lyrical feeling for the supernatural.

The death of Julius is a convenient point at which to mark the division of Raphael's years in Rome into two periods. It was a decisive event in his life and both his personal circumstances and the direction of his work change character after it. Julius had been a driving inspiration and perhaps something of a spiritual father to the painter almost forty years his junior. He had concentrated almost all Raphael's creative energies on the frescoing of two apartments into which had been poured a compendious vision of man and man's achievement. In the art of pure painting Raphael had, by the age of thirty, mastered a range of subject-matter and expression which was broader than Michelangelo's, technically in advance of Leonardo and still far ahead of Titian – the only living masters with whom he could be compared. Now, when Julius was gone and a more worldly, relaxed and self-indulgent regime changed the kind of pressures that were put on him, his energies began to move outward. His art became more multi-faceted and embraced different fields of interest. It reflected a less idealistic world at the same time as it explored a new range of classical and religious imagery. The artist himself became the master-mind of an activity to which assistants gave much of the outward form, and he passed from close personal involvement with the medium of painting to a deeper concern with the problems of environmental design and architecture.

On the other hand, artists do not develop entirely at the same pace as outward

events, nor entirely conditioned by them. There is an internal logic to Raphael's art on which history merely dances attendance, and some of its pattern is apparent before Julius's death just as other parts of it become clearer later. It is a steady movement which starts with mastering the world of appearances and pictorial space, and advances from that towards the world of real space in which art becomes an environment for living and not life's mirror. It is broadly speaking a movement from painting through interior design to the pure abstraction of space designed as a building. And although the progression is not in a straight line, although it involves activities which continually overlap and although it becomes more difficult to grasp as a unified vision as the work becomes more diversified, the pattern is basically consistent. Its ideal at all stages is to relive the nobility of the ancient world in modern terms. Its method is to make the spectator of art experience through his physical senses and his awakened imagination what it is like to walk tall through such a world.

A change of tone becomes apparent in the fourth fresco of the Heliodorus 73
room, planned for Julius but including for the first time the portrait of his successor, Leo X. Leo is already both the cardinals riding behind the Pope, but now, where Julius should have been, his self-satisfied features are those of the Pope also. The subject is that of his namesake, Leo I, halting the hordes of Attila the Hun at the very gates of the Holy City. Above him St Peter and St Paul, patron-saints of Rome, fly to his support, and in the distance is the Colosseum. Again the narrative reads from left to right, from contained certainty to a pandemonium of dismay, and the lighting-effects read with it, from clearing skies to storm-clouds and darkness driven back on itself. Raphael's design rises to the challenge of yet another new subject, war. Perhaps for the first time since he had arrived in Florence, he knew how to put to use his memory of those rival battle-pieces by Leonardo and Michelangelo which had been intended for the Palazzo Vecchio. The rearing horses on the right are Leonardo's, the groom turning and pointing in the centre foreground is a clothed version of a Michelangelo soldier from the *Battle of Cascina* cartoon. But Raphael adds visual excitement with more exotic details. The skin-tight gold chain-mail of Attila's horsemen comes from the reliefs on Trajan's Column in Rome, together with the group of barbaric war-trumpets. An extraordinary feathered helmet just above and to the right of the Michelangelesque groom can only be a trophy from Mexico, indicating that spoils from the New World were by now reaching the princely collections of Europe. On either side of an agitated flapping of banners, fires burn in the woods and consume a distant town. It is a recurring detail of war's realities which possibly derives from Raphael's own youthful travels across Italy and may have reminded him that his own forebears had been driven from the countryside by marauding armies to the shelter of Urbino.

But it is in this fresco that we are faced with the question of Raphael's assistants and their contribution to his output from now on. They may have executed much of it and even designed some details within Raphael's master-plan. It has never been easy to detect their work stylistically, let alone to be sure how it affects our aesthetic

135

Detail from The Meeting of Leo the Great and Attila, *Raphael; with portraits of the new pope (above left) and 'barbarians' (above right) in chain-mail armour from Trajan's Column (below)*

judgement. The fact that *The Meeting of Leo and Attila* is less masterly than the other three frescoes in the room need only mean that Raphael is not consistently in top form. At the same time, his assistants are nearly always at the top of theirs. His technical requirements demanded more than usual competence from them and their ability to sink their individual identities in his was correspondingly skilful. With him already in the later stages of the Segnatura was probably Giovanni Francesco Penni, a young Florentine whose particular *forte* was his deft translation of Raphael's sketches into working drawings. By the time of the Heliodorus room, Giovanni da Udine had joined him, and became a specialist in rendering architectural detail, animals, realistic still-life and decorative ornament in general. Baldassare Peruzzi, the architect of the Villa Farnesina, was a friendly colleague rather than assistant who was to work closely with Raphael on architectural projects; he may have looked in on the Heliodorus room to advise with *trompe-l'oeil* effects Raphael was already projecting. The hand of any of these is impossible to identify for certain. But it is generally felt that Raphael did not himself paint, for example, the whole group of Heliodorus and his attackers, the right-hand angel in the *Liberation of St Peter*, and certain parts of the ceiling. Equally impossible to pin down is the presence of two other helpers, the most interesting of all Raphael's collaborators. One of them became his chief assistant, heir to his estate and a creator of the later style called Mannerism. He was the *enfant prodige* of Raphael's circle, Giulio Romano, who may have been only fourteen at this time (the precise date of his birth is disputed). The other was the finest Italian engraver of his age, Marcantonio Raimondi – in fact, after Dürer, the finest in Europe. His increasingly fruitful relationship with Raphael was based on engravings for which Raphael provided the designs, a method of mass-production they learned from Dürer himself. Marc-antonio may in fact have nothing to do with the execution of the Heliodorus room, but there must be some significance in the fact that Vasari identifies him positively as the leading chair-carrier, the one who looks out front, bearing Pope Julius into the scene of the *Expulsion of Heliodorus*.

Apart from the presence of assistants, the *Meeting of Leo and Attila* suggests one other change of tone. Castiglione in *The Courtier* includes a discussion on the nature of jokes, and quotes one remarkable example from Raphael relating to this fresco. Two cardinals ventured to suggest that the artist had painted the faces of St Peter and St Paul too red (they are indeed in a reddish shadow because of the light behind them). 'They are blushing,' said Raphael, 'to think the church is led by men like you.' If that was a joke it was a very sharp one; it makes one think twice about Raphael's reputed mildness and speculate about a spirit of criticism among more thoughtful members of the Papal court. The Heliodorus room as a whole evokes a curious atmosphere of unease and even foreboding, and with hindsight one would say that here if anywhere in his work Raphael reflects the troubling undercurrents of his age. One seems to hear the first rumbles of that storm which would ultimately break about the Church as a consequence of the policies of the two Popes under whom he served. That storm, like Attila's, would come upon it from the north.

And it is well to remember that two northerners came on different occasions to Raphael's Rome as friends and left it dangerously disillusioned by what they found.

One was Erasmus, who first visited the Papal court in 1506 and was there again while Raphael was painting the *School of Athens*. The most famous scholar in Europe and its greatest Humanist, he adored Rome for its classical learning and its intellectual brilliance. But he was also Europe's most widely-read author and a known critic of abuses within the Church. He had been present in St Peter's that Good Friday when Tommaso Inghirami preached a sermon so rich with classical allusions and humanist philosophy that he quite forgot to point the Christian moral of it all. For many beyond Rome, in those years when the brooding Protestant spirit was gathering to declare itself, the guidance of Erasmus and his views were the focus of anxious hope. 'O Erasmus of Rotterdam,' wrote Dürer in his journals at the very time Pope Julius was succeeded by Pope Leo, 'where wilt thou take thy stand? Hark, thou knight of Christ, ride forth . . . protect the truth.'

Erasmus believed the Church should be reformed from within. Another man did not. Luther arrived in Rome in 1511 as an ordained priest and former monk whose first act was to kneel and kiss the soil of the Holy City. What he saw drove him from the Catholic fold. The new St Peter's was being financed by granting to any donor who contributed towards the building funds a plenary indulgence of his sins. Julius had started the practice, and under Leo the selling of indulgences became a scandal spread through Europe by the Church's travelling salesmen. Luther wrote his ninety-five theses against it and nailed them to the door of Wittemberg church. One looks again at the Attila fresco and wonders to what extent art can be prophetic. Ostensibly it is a painting about victory for the Papacy. In the light of Raphael's answer to the cardinals, it could almost be about the seeds of its greatest defeat.

Leo was a Medici from Florence, the younger son of Lorenzo the Magnificent. The Medici family were bankers, and even in the third generation there remained a streak of monied vulgarity about Leo. His taste for luxury and his cult of connoisseurship, his irresponsibility in government and pursuit of popularity and pleasure, betoken a man born to wealth without its cares. He was a lover of the beautiful, a collector of *objets d'art*, a devotee of classical learning who boasted he had been born in a library, and an amateur of music who was proud of his own delicate hands. There is comment enough in the most notorious remark attributed to him: 'God has given us the Papacy. Let us enjoy it.' He had no doubt he was presiding over a Golden Age of culture, and he fostered it lavishly. Raphael was a particular jewel in his crown. 'In the art of painting all men know you to excel,' he wrote in the Papal brief appointing his favourite artist to the high honour of Architect of St Peter's with a handsome rise in salary to go with it. His partiality was a clear snub to Michelangelo and the real cause of antagonism between the two artists. From now on Raphael was singled out for distinction. He was assured of wealth, influence and social status of a kind never before accorded to any painter.

A series of portraits between 1514 and 1518 reflects the tone of shrewd and sophisticated intelligence at Leo's court, as well as something of Raphael's immediate circle of friends. One of the latest of them, as it happens, is that of Leo himself, the hands and *objets d'art* and famous 'spying glass' observed with a realism to match the penetrating observation of the Pope and his attendant cardinals, Giulio de' Medici on the left and Luigi de' Rossi on the right. Cardinals proliferated at Leo's court: he once created thirty-one in a single day to protect his interests in the Curia, not all of

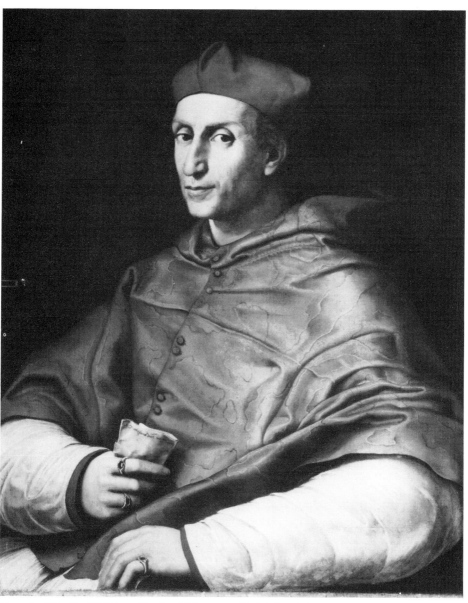

Portrait of Cardinal Bibbiena, Raphael (Florence, Pitti Palace)

76 them for ecclesiastical merit. As Papal librarian, Tommaso Inghirami, whose brilliant portrait exists in two versions, gave Raphael access to unexpected sources

63 of imagery: the stylised flames in *Moses and the Burning Bush* on the ceiling of the Heliodorus room, for instance, can only derive from the Vatican's wealth of Persian and Chinese manuscripts. Cardinal Bibbiena was Leo's close adviser and shared many of Raphael's own interests: he even had plans, which Raphael seems diplomatically to have side-stepped, for marrying his niece to the artist. The beauti-

77 ful portrait of an unnamed cardinal in the Prado was painted earlier but it epitomises at its best the aristocratic, intellectual ambience of these contacts at the Vatican.

17 The great portrait of Castiglione can be dated to 1514. He is shown as he would have wished to be remembered, the pattern of courtly reticence, contained but not aloof, sober of dress, scholarly, practical and kind. Andrea Navagero and Agostino Beazzano, who both came from Venice, were among Raphael's circle of literary friends. Members of Roman high society like Bindo Altoviti were also influential collectors and valuable patrons. A delicate miniature on the lid of a circular box records Valerio Belli, whose work as a medallist and engraver of gems could have

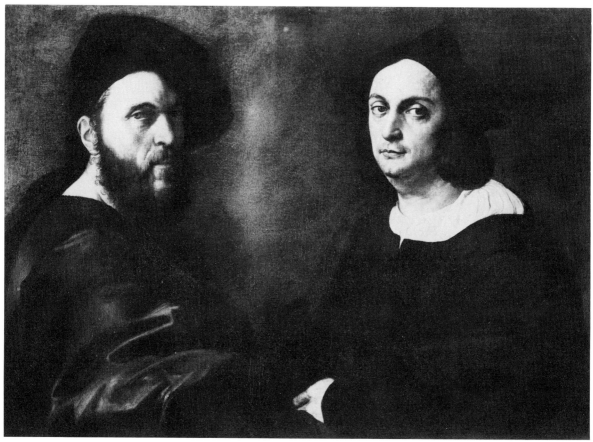

Double portrait of Andrea Navagero and Agostino Beazzano, Raphael (Rome, Doria-Pamphili Gallery)

140

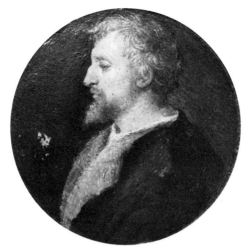

Miniature of Valerio Belli, Raphael (Private Collection)

brought him into professional contact with Raphael, but who is also documented as godfather to Raphael's daughter. The information halts us in our tracks, but nothing more is known. Raphael's child is one of those tantalising blanks in the account like the identity of the man gesticulating in the foreground of his self-portrait of 1518. 114 With whom would Raphael share such a portrait? With his 'fencing-master', as tradition describes him? With one of his workshop team, like Polidoro da Caravaggio? The portraits give us faces, but the flavour of Raphael's life in these years is sometimes more vividly caught from other sources. We have a description of him, for example, on a trip to Tivoli in 1516 in company with Cardinal Bembo, Castiglione, Beazzano and Navagero. There is a sudden glimpse of that coterie of choice spirits, some of them known to each other since Urbino, taking an afternoon off from Rome to enjoy a picnic and talk literature and art and classical antiquity in the romantic surroundings of Hadrian's Villa.

But one friend was missing. The year after Julius's death, Raphael lost Bramante also. He was just seventy and on his deathbed urged that his protégé should be appointed his successor as *capomaestro* of St Peter's, the architect in charge. To understand how profoundly this responsibility affected the rest of Raphael's life and work, we need to retrace something of Bramante's own architectural position and its influence on Raphael's thought. He had come to Rome in his mid-fifties, in 1499. Many students of antiquity had done so before him – Brunelleschi, Alberti and Donatello among them – but none was so methodical in his research, so determined to codify the exact vocabulary of Imperial Roman style, or in a position to put it immediately into practice in Rome itself. His first experiment had been the cloister of S. Maria della Pace, begun in 1500. In 1502 he built the *Tempietto*, a crucial development of the circular religious building which would lead to his project for St Peter's. For Julius II, he applied the secular elements of Roman style – his knowledge of villas, courtyards and amphitheatres – to an enormous extension of the Vatican Palace. His arcaded loggias for the Cortile di S. Damaso were later to be frescoed by Raphael and his assistants, and Raphael's Papal Apartments, the Stanze,

The Tempietto, by Bramante (Rome, Church of San Pietro in Montorio)

View of the Forum in Rome, Piranesi, etching about 1750

looked out over Bramante's huge sequence of garden, sculpture court and amphitheatre which now linked the original Palace with the Belvedere. In all this, Bramante's aim and his achievement were to inform a Renaissance grace of proportion with a more correct classicism and an authentically Roman feeling for sobriety and size.

The sheer scale on which Ancient Rome had been built was an ever-present inspiration, a challenge to think in huge, heroic terms. Its giant monuments rose gaunt and gap-toothed all over the city. For centuries they had dwarfed the generations which feared them as superhuman or the work of devils, plundered them for building materials or nested in their ruins like house-martins. Only with the start of the Renaissance did people stop being over-awed by them and begin trying to learn from them instead. In many parts of the mediaeval city and the Borgo which have now disappeared, fragments of Roman masonry were incorporated haphazard into later buildings and provided more plentiful material for study than we have today. On the other hand, the Forum was still largely buried and used for grazing cows and goats. Much of the interior of the Colosseum was silted up and had full-grown trees rooted in it. Triumphal columns and arches could only be seen above ground for half their height, as prints and engravings right up until the nineteenth century still show. The Renaissance started excavating in a passion for achaeology not unmixed with the spirit of a treasure-hunt. It was an insalubrious business digging down into the rubbish tips in areas like the Forum which were malarious. But it was one which engaged more and more of Raphael's curiosity and interest. It may even have been in part responsible for his death.

Continued on page 161

In and around Rome, the inspiration of classical antiquity was ever-present (75), and classical scholarship dominated the brilliant intellectual tone at the Papal Court (76, 77). Raphael sought to interpret the antique Roman spirit for both secular and sacred purposes. For the Church, he made it Christian (78, 79). At the Villa Farnesina he expressed it in subjects from classical mythology, first in his *Galatea* (80–82), then as a ceiling decoration executed by assistants from his designs (83, 85). Raphael's mistress and favourite model (87) could pose for a Venus or a Madonna (86 and compare 53, 54). His religious architecture obeyed strictly classical rules (88); and his continuing work at the Vatican introduced into a Christian context examples of antique Roman decoration (94), of Roman architecture (90) and even of Roman arms and armour (92).

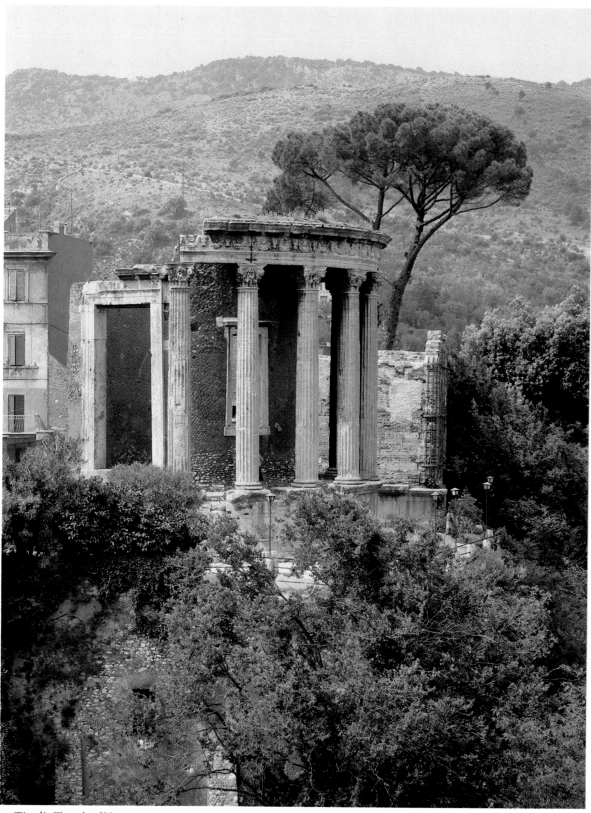

75 Tivoli, *Temple of Vesta*

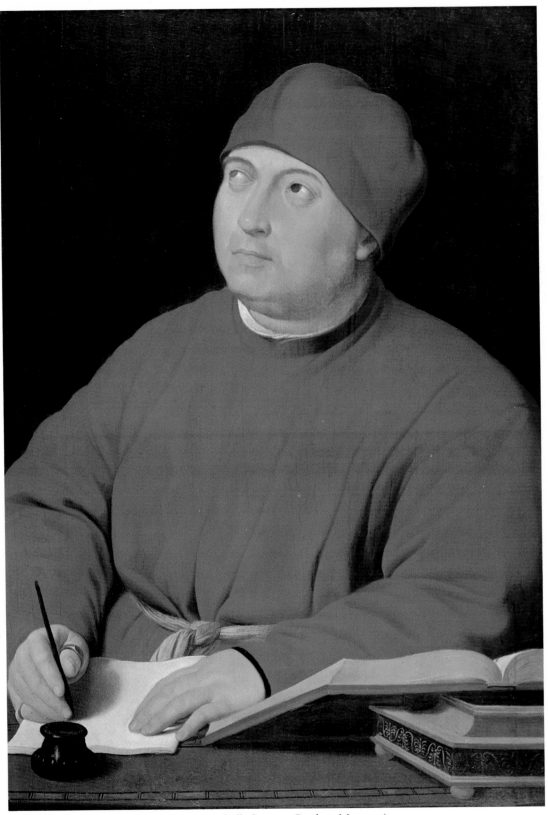

76 *Tommaso Inghirami*, Raphael (Boston, Isabella Stewart Gardner Museum)

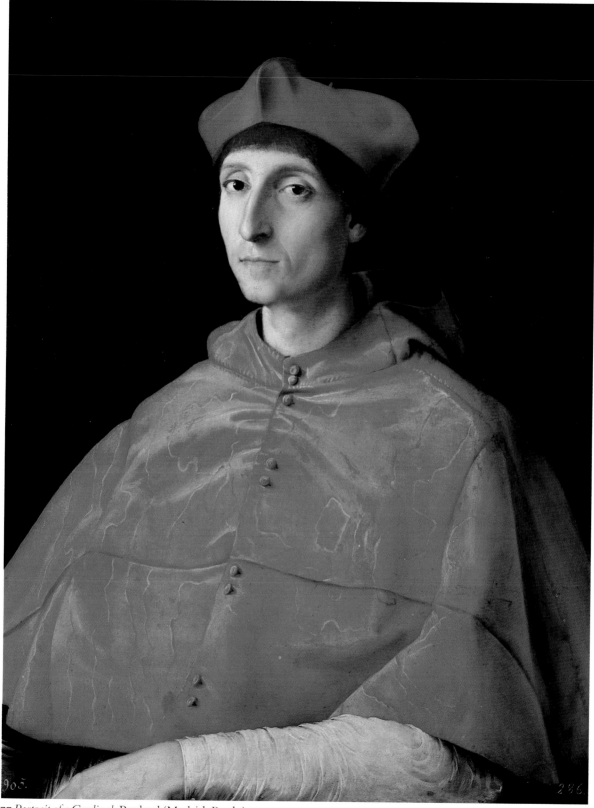

77 Portrait of a Cardinal, Raphael (Madrid, Prado)

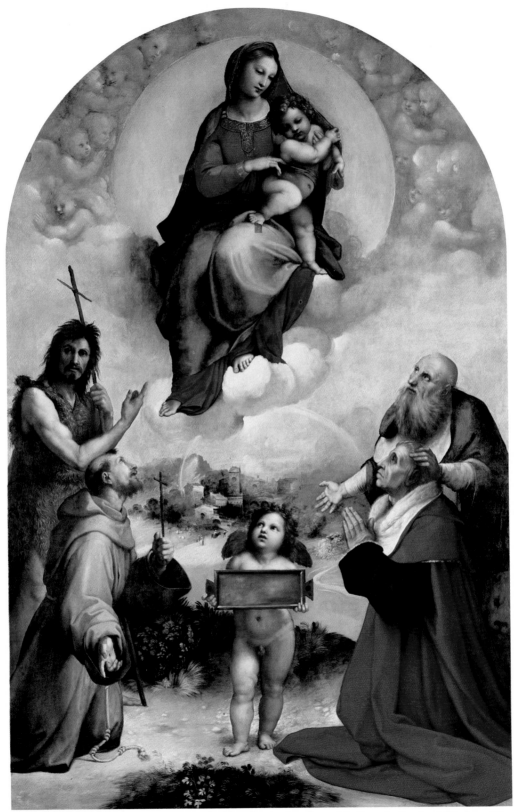

78 Madonna of Foligno and 79 (opposite) detail of St John the Baptist and St Francis, Raphael (Vatican, Pincoteca)

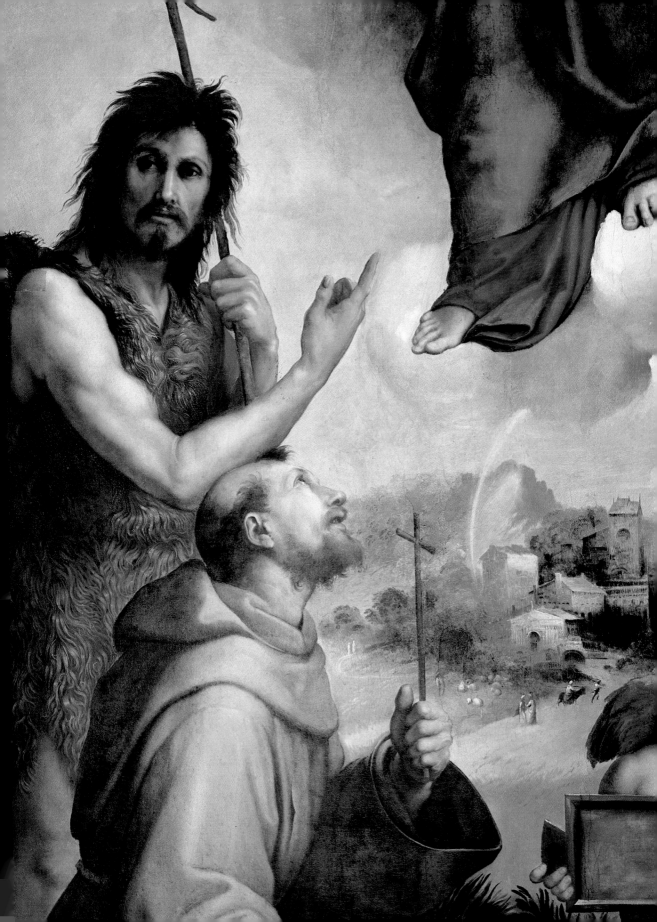

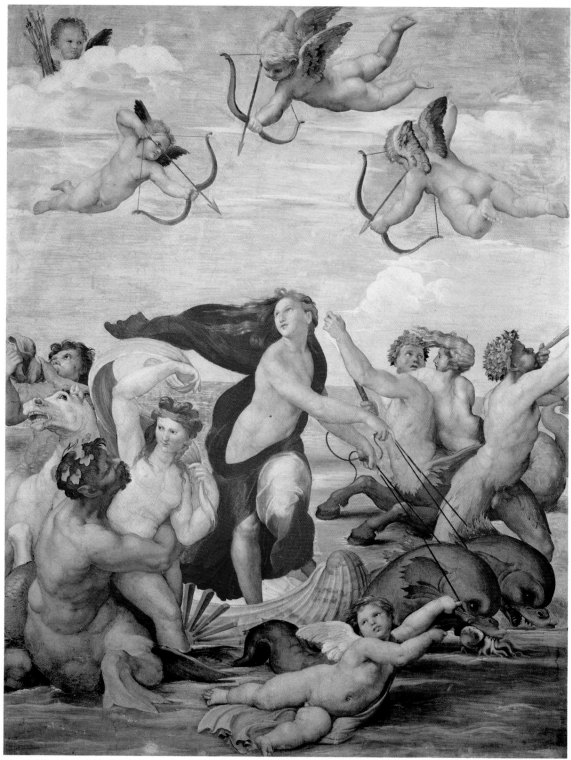

80–82 *The Triumph of Galatea*, and details (opposite), Raphael (Rome, Villa Farnesina)

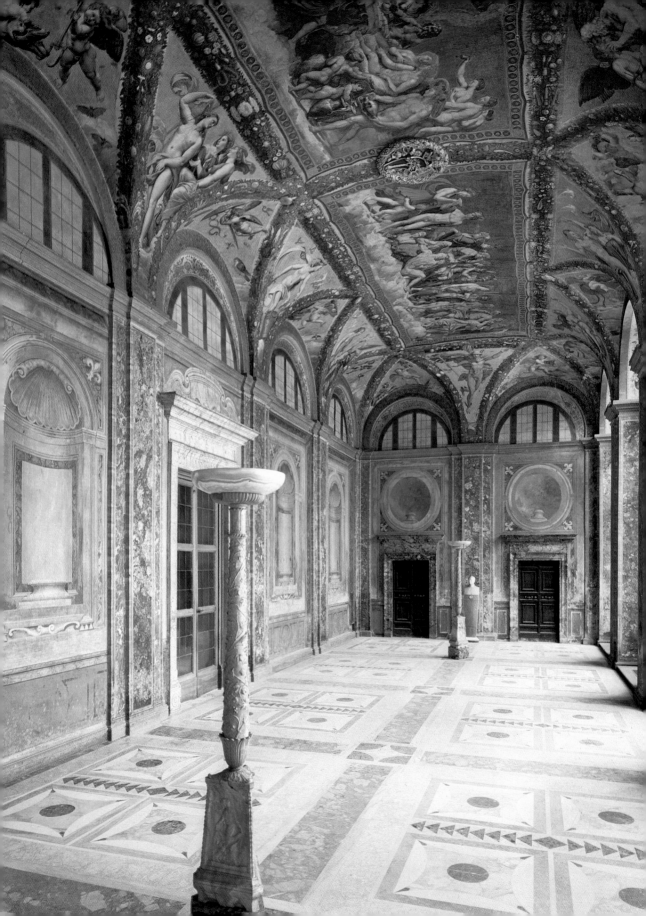

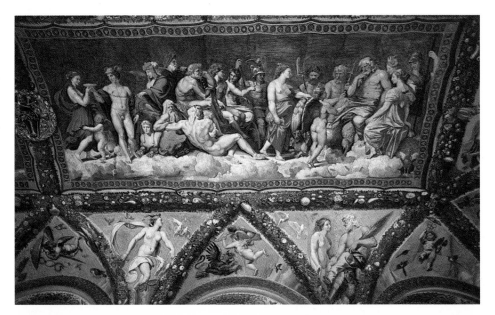

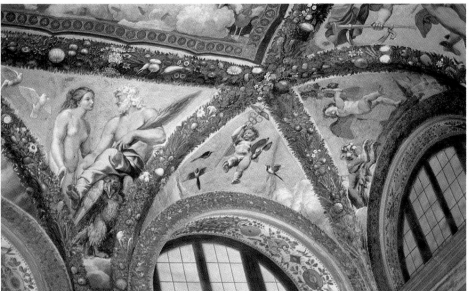

83 (opposite) Rome, loggia of the Villa Farnesina, *Psyche frescoes*, and 84, 85 (above) details, Raphael and assistants

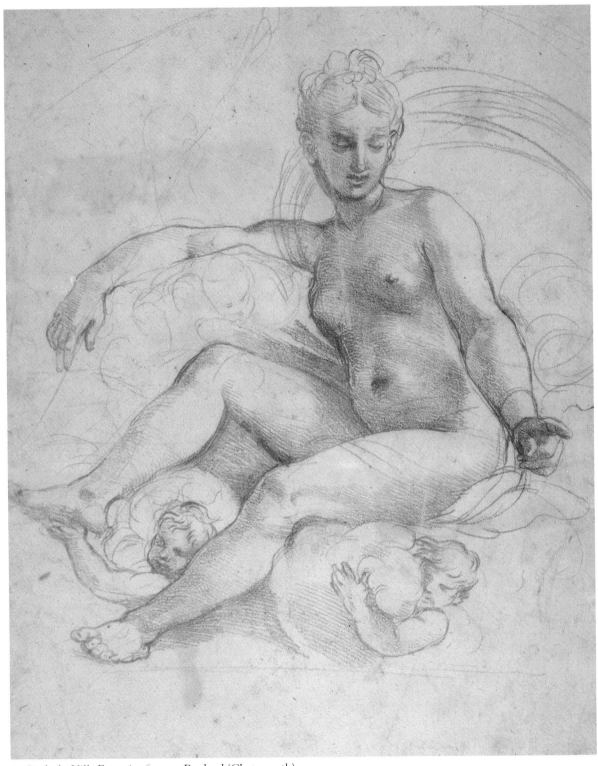

86 *Study for Villa Farnesina frescoes*, Raphael (Chatsworth)

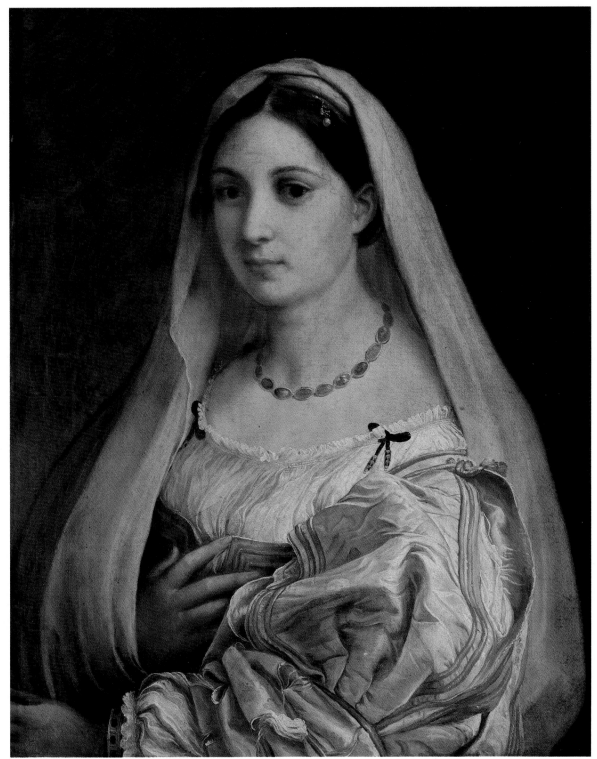

87 *La Donna Velata*, Raphael (Florence, Pitti Palace)

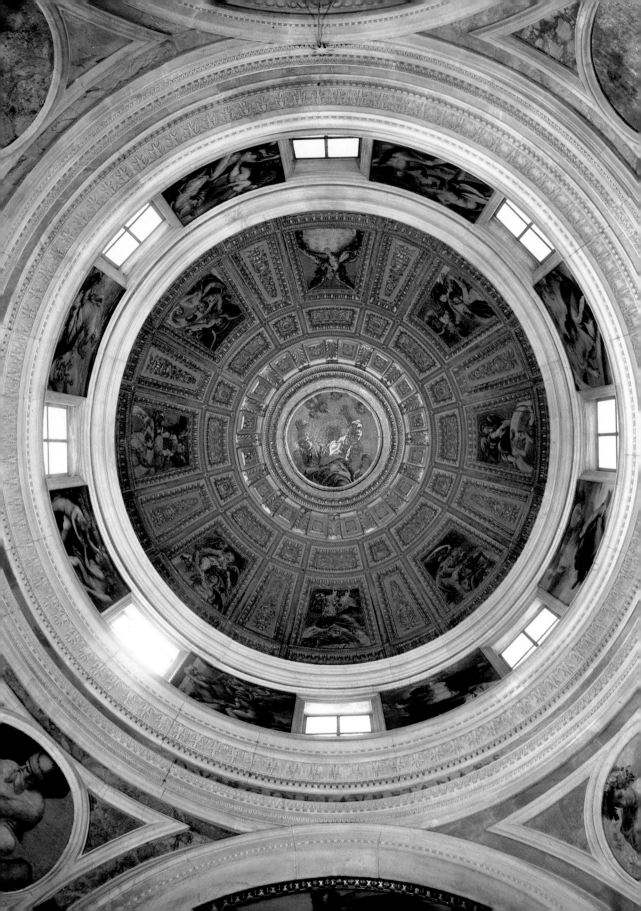

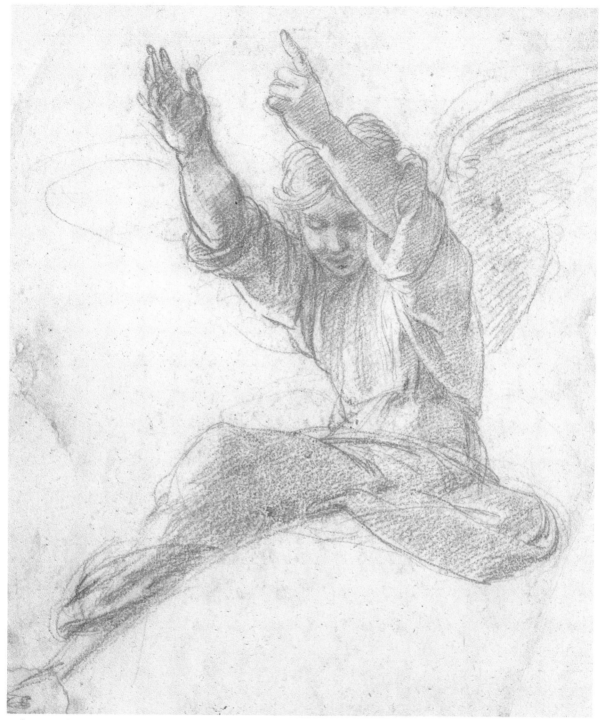

88 (opposite) Rome, Santa Maria del Popolo, *Chigi Chapel cupola*
89 (above) *Study for angel on Chigi Chapel cupola*, Raphael (Oxford, Ashmolean)

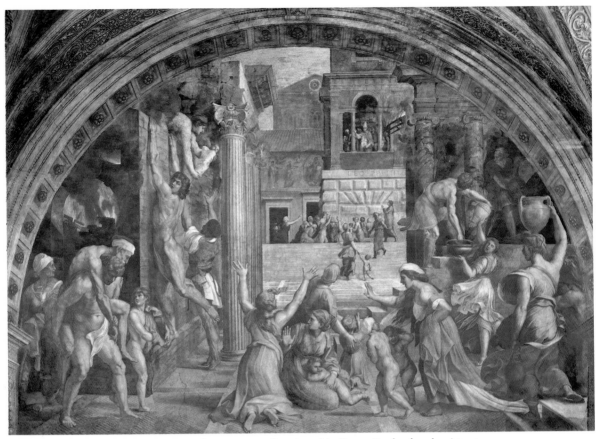

VATICAN, RAPHAEL ROOMS: STANZA DELL'INCENDIO 90 *Burning of the Borgo*, Raphael and assistants
91 (below) *Burning of the Borgo*, detail

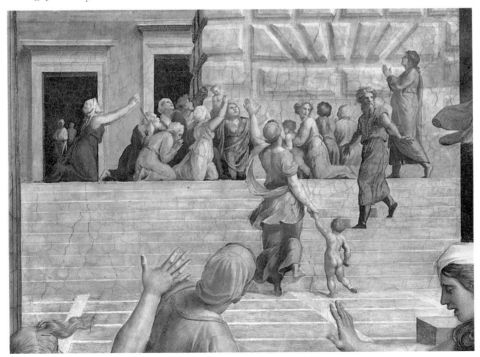

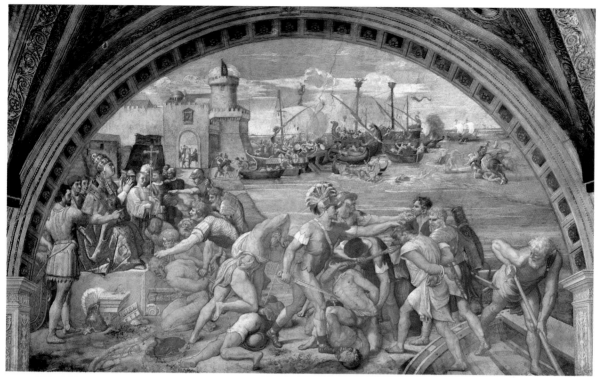

VATICAN, RAPHAEL ROOMS: STANZA DELL'INCENDIO 92 *The Battle of Ostia*, Raphael and assistants
93 (below) *The Battle of Ostia*, detail 94 (overleaf) Vatican, Raphael's Loggetta

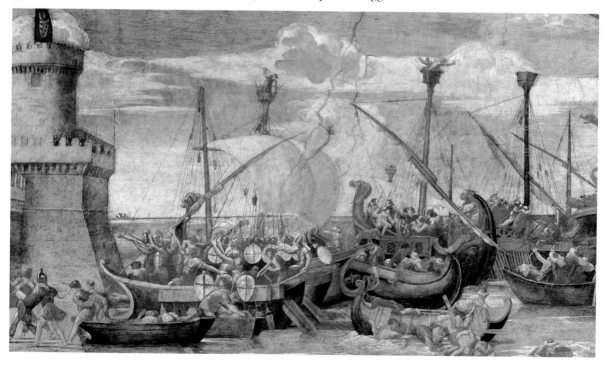

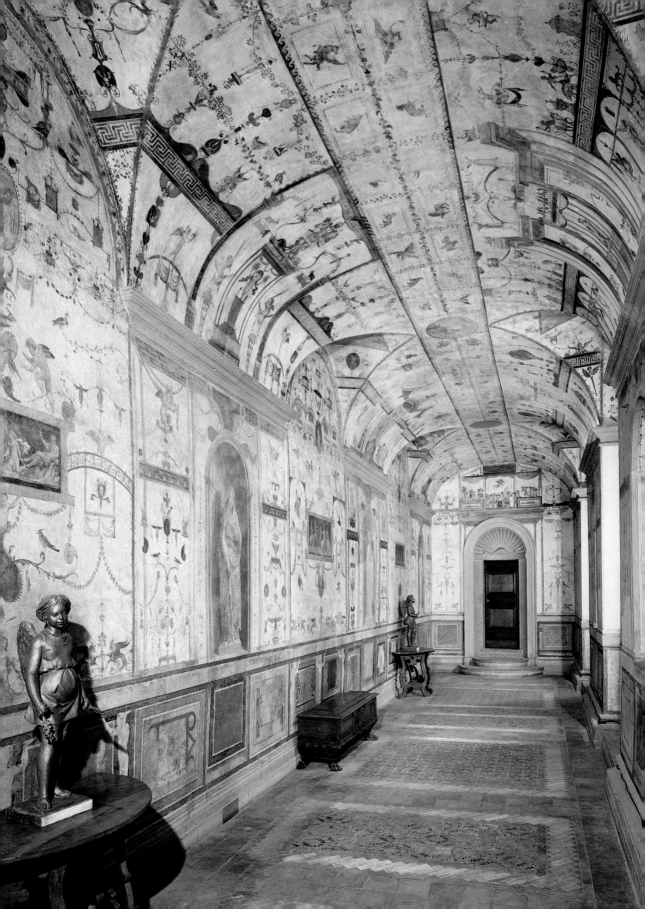

Essential to the enthusiasm for Ancient Rome was a belief to which Pope Julius, Bramante and Raphael equally subscribed. Roman architecture was neither a pagan nor a secular style. It was the true Christian architecture, embodying a long, unbroken tradition. Christian Rome was both the historical continuation and the spiritual heir of Imperial Rome, its inheritance ensured when Constantine turned Christian and founded the first St Peter's. The earliest patterns for Christian churches had been Roman patterns. One of them had been the rectilinear type of vaulted hall with central aisle and apses which in Imperial times had served for law-courts, markets and the seats of the money-changers, and were called basilicas. The Roman term became a church one, and the first St Peter's was of the rectangular basilica-pattern. A second prototype was circular. Its most famous exemplars were small Roman temples like the so-called 'Temple of Vesta' in Rome itself and another at Tivoli, and the form had been adopted and Christianised to mark particularly the shrines of saints or the site of a martyrdom – a *martyrium*. Bramante's Tempietto was circular because it stood where St Peter was believed to have been crucified. The new St Peter's would be circular because it stood above his place of burial.

But one particular building from the past was the focus of every concept the Renaissance idealised as 'Roman'. That was the Pantheon. It was unique in Rome as

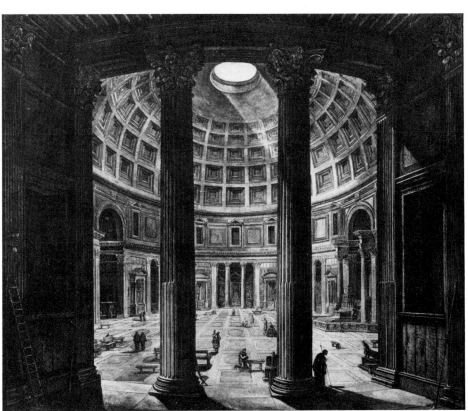

Interior of the Pantheon, Rome, Piranesi, etching about 1750

a structure that had survived intact, circular, vast, an architectural and engineering masterpiece, and a place of worship since its foundation. Raphael's favourite building and Bramante's main inspiration for St Peter's, it was thought at the time to date back to the Republic, but it is known now to have been conceived by Hadrian in the second century. It was the living symbol of Rome's continuity, for in the seventh century an Emperor (albeit a usurper to that title) had presented it to a Pope, and from a pantheon to all Rome's gods it had been diplomatically re-dedicated to All Saints and Martyrs. Even Bramante failed by less than three feet to match the diameter of what remained, until well into the twentieth century, the largest self-supporting dome in the world. But the aesthetics of the Pantheon were as much an object-lesson as its engineering. It is as high as the dome is wide, and the simplicity of that proportion gives it a harmony that belies its actual vastness. Even today its scale is barely credible from a distance until you are among the giant columns of the portico and pass into the huge sweep of the interior. It is the grandest expression of that sense of space to which Raphael's intuition kept returning, and in the dome is that memorable feature which spiritualises the whole physical impression. Like a searchlight probing the interior, the sole illumination comes from a twenty-eight-foot-wide *oculus* open to the sky. It is the eye of Heaven in that circular space which symbolises the perfection of God.

There is an inconspicuous little church on the banks of the Tiber almost opposite the Villa Farnesina which is believed to have been designed by Raphael very soon after his arrival in Rome. Bramante probably helped him, but its dedication to the patron-saint of goldsmiths, Sant' Eligio degli Orefici, could be connected with the fact that Raphael's father had belonged to the goldsmiths' guild. On the floor a Greek cross in grey marble announces the centralised, symmetrical plan, and above

Greek Cross in inlaid marble, floor of Sant'Eligio degli Orefici, Rome

it a small dome is lit by an *oculus* below the lantern and windows round the drum to give a diffused atmospheric clarity to white surfaces and basic geometric forms outlined in grey. The purity of the white and grey may be a colourist's memory of chapels by Brunelleschi in Florence, where Raphael had just come from. But the articulation of square space below and round dome above is not only Bramantesque, it is clearly Raphael's ideal. As a structure he repeats it almost identically (it is a simpler form of the St Peter's plan) in the only other religious building he ever had time to formulate. That is the chapel in Santa Maria del Popolo built for Agostino 88 Chigi – one of those funeral chapels commissioned by Renaissance grandees long before their death – which was virtually completed in 1516, finished by other hands several years later, but not publicly seen until 1554.

It is important to recognise the formal similarity between Sant' Eligio and the Chigi Chapel in order to appreciate the totally different effect. The change is pictorial not architectural, from cool linear precision to full-bodied colour and the exploitation of textural contrast. 'Modern architecture,' Raphael noted to the Pope, 'has become quite close to the manner of the ancients (but) the ornamentation is not in such precious materials.' The materials he employed here include different coloured marbles, stucco, stone, bronze, mosaic and gilding, themselves serving a concept which brings together architecture, sculpture and painting. Raphael's painting unfortunately was never executed, and the otherwise quite impressive altarpiece by Sebastiano del Piombo which takes its place is far darker and more claustrophobic than Raphael would have allowed. Moving outward from painted space to sculptured space, as he wanted more and more to do, Raphael designed niches for four statues at the corners of the chapel, only two of which were actually executed from his drawings by Lorenzetto – one of Elias and one of Jonah on his whale. The 'manner of the ancients' finds expression in Corinthian capitals and carved festoons derived from the Pantheon, and in two towering pyramid silhouettes in reddish marble on either side to mark the tombs of Agostino and his brother: the form is both archaeologically correct for funeral monuments and recalls one of Rome's most striking landmarks, the Pyramid of Cestius. Light pours in from above to catch the glitter of gold coffering and mosaic colour round the dome, where saints and signs of the Zodiac intermingle (for Agostino was interested in astrology) round God the Father seen overhead against a blue mosaic sky. The Chigi Chapel faces another chapel across the nave of Santa Maria del Popolo which is designed in earlier Renaissance taste and frescoed by Raphael's former colleague from Perugia days, Pinturicchio. Nothing could emphasise more dramatically how far Raphael's vision had pushed forward than the contrast between them. In one leap the Chigi Chapel has left the entire Renaissance idiom behind and heralds the Baroque. It anticipates all that Catholic church interiors later became, and though it is sober compared with the ecstacies of Tridentine religiosity which the following century would indulge, the richness and elaboration of its ornament clearly prepare for them. Within the development of Raphael's own vocabulary, the Chapel is an almost impatient declaration that no single medium can express the full emotional

potential of visual art. It is an invitation to experience form, colour and space, illusion and reality, abstract design and figurative content, in a marriage of media and an all-embracing, unified vision.

Jonah, carved by Lorenzetto from Raphael's design, in the Chigi Chapel

Study for the Almighty in the ceiling of the Chigi Chapel, Raphael, red chalk
(Oxford, Ashmolean Museum)

To have Bramante's concept for the greatest church in Christendom as a guide
and inspiration was very different from having personal responsibility for St Peter's
as a structure. Though he shared that responsibility with Antonio da Sangallo, its
problems occupied Raphael for the rest of his life without much progress towards
their solution. He conferred every morning with the Pope about them. He tidied
up and finished parts that had been begun. But Bramante had left only sketchy
notions of how he had intended to proceed, and no sooner were his technical
expertise and commanding personality removed than his ideas were challenged on
practical grounds by his assistant architects. The constant difficulty was how to raise
and support a dome of the huge dimensions required by the foundations already
prepared for it, and Raphael did not as yet have the professional experience to argue
a point which was about engineering rather than aesthetics. The building hardly
advanced at all. It was not till long afterwards that Michelangelo did finally raise a

redesigned dome over Bramante's groundplan. But it was Raphael who first proposed a major change in that plan in order to include a nave, giving the church a directional interior rather than a centralised one. All subsequent designs followed suit, even though it involved one curious feature which still distinguishes St Peter's from most other Christian churches. Because there is rising ground immediately to the west of Bramante's site for the dome (which was itself conditioned by the site of St Peter's tomb), any nave-extension could only run eastwards. St Peter's therefore has its altar at the west end and its entrance to the east.

Raphael had had the advantage of Bramante's personal teaching, but Bramante himself had been an exception to the general rule that architects were seen primarily as artists whose workmen sorted out the practicalities. When St Peter's was thrust upon him, Raphael was still essentially an amateur of architecture whose qualifications were aesthetic or related to archaeology. He set out immediately to make himself a professional. The basic text-book was Vitruvius, the Bible of Renaissance

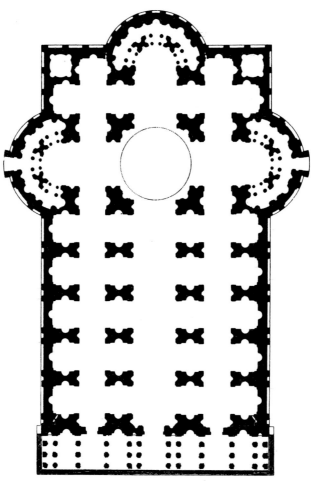

Raphael's project for redesigning St Peter's, from Serlio's *Treatise on Architecture*

classicists. A pupil of Bramante's had made the first Italian translation from the Latin, but for his own use Raphael commissioned one in Tuscan dialect from Marco Fabio Calvo of Ravenna. He is said to have known it by heart, and his personal copy, with marginal notes, is still preserved. 'I raise myself higher with thought,' he wrote to Castiglione: 'I would like to find the beautiful form of ancient edifices, but I do not know whether my flight will be like that of Icarus. Vitruvius gives me much help, but I need more.' That extra help came from archaeology. An immediate consequence of his St Peter's appointment was that next year, in 1515, he was made Commissioner of Antiquities for Rome. His growing obsession with architecture was fed by the unrivalled opportunities for study which this new responsibility afforded.

The maintenance of all classical monuments, from the Colosseum downwards, now came under his charge. All archaeological finds in the city had to be registered with him and the disposal and care of them approved by him – this part of his duties put him under constant siege from hopeful collectors of antiques. Not least, he decreed which marbles should be allocated as building material for St Peter's, and which burned down to provide lime for the same purpose. But a particular interest was overseeing excavations in the city. If he could get down to the foundations of the 'ancient edifices', he could check their measurements and proportions against the prescriptions of Vitruvius and understand more intimately the secrets of their 'beautiful form'. The idea took hold in his mind that he would construct an enormous scale-model of Ancient Rome based on his findings. It would have been his version of those text-books of classical style which were to be published not many years later by Serlio and Palladio, and if the model had ever been built it might have been equally influential. It never was, and all Raphael managed was a sketch-history of architecture up to his own time which he wrote in 1519 for Pope Leo. He gave a notably penetrating and succinct account of it, although the literary style is thought to have been polished up for the occasion by Castiglione.

Vasari tells us he employed draughtsmen as far away as Greece to provide him with architectural information, and within his own workshop he was training Giulio Romano, in particular, to take as much interest in the subject as himself. The team of assistants was working from 1514 onwards on the third of the Papal Apartments, and in the best-known of the frescoes in that room, the *Burning of the Borgo*, architectural details almost compete for prominence with the dramatic subject-matter. A fire is raging in mediaeval Rome, but the drama is given a classical slant by inserting incidents from the Fall of Troy (on the left, for instance, an Aeneas-figure is rescuing Anchises from the flames). This allows for a huge portico of Corinthian pillars to be copied from the Temple of Mars Ultor, another in Ionic style to be copied from the Temple of Saturn, and the Pope in the background whose blessing quells the fire (and whose name, naturally, is another Leo) to be framed in the classical style of window called 'Serlian'. Giulio Romano is credited with most of the execution of the *Burning of the Borgo* and is also closely associated with Raphael's essays in secular and domestic architecture. There are only a few

The facade of the Palazzo Vidoni-Caffarelli, Rome, designed by Raphael

examples of it, but it is remarkable enough that in these hectic years the master saw two *palazzi* built in Rome, one in Florence, other designs contemplated and the vast complex of the Villa Madama at least started.

His pattern for a *palazzo* was the one he lived in himself, which he had taken over from Bramante. Palladio has left us a drawing of it – a regular, rational structure of two storeys which clearly articulates its function. Below is a sturdy ground-floor weighted by 'rustication' and with openings on to the street for shops: for this there were antique precedents still visible in Rome. Above it are the living quarters, a *piano nobile* given breadth by a calmly disciplined alternation of plain windows and paired columns. With slight elaboration and counterpoint, and extended to three storeys, this pattern remains the model for the Palazzo Vidoni-Caffarelli in Rome and the more openly-planned Palazzo Pandolfini in Florence. The later Palazzo Branconio-Dell' Aquila was close to St Peter's Square and has disappeared with the rest of the Borgo, but a pen-sketch by Parmigianino gives us a spirited impression of a very different kind of façade. There are now sturdy Doric columns along the ground-floor supporting a *piano nobile* which is not structurally more weighty than before, but visually is very much so. An elaborately variegated composition of pediments, windows, niches for statues and great swags of ornamental carving produces a complex and ostentatious effect, which is less to our taste

The Palazzo Branconio-Dell'Aquila, Parmigianino, pen and ink (Uffizi)

today than it can have been for Leo X's Rome. But it reflects exactly that same access of a new 'pictorial' richness which distinguishes the Chigi Chapel from Sant' Eligio. As in so much of Raphael's later development, one feels that he became conscious before anybody else that the 'pure classical moment' had reached its peak and was already passing. It could not be artificially prolonged, and the only way forward was to vary the accent and heighten the vocabulary. Giulio Romano, Raphael's most perceptive pupil, was to base his career on that premise.

This second decade of the century is full of such signs of a transition, of a cultural moment becoming conscious of its own ripeness and beginning to play on that consciousness. One of the signs is that art is allowed to descend more often from its high pedestal and join hands with entertainment. Pope Leo was never a man to resist entertainment, and he had a particular fondness for the *burla*, the kind of buffoonery which involved elaborate practical jokes and parodies even of his own favourite pursuits of poetry and music. On one occasion a court-fool called Baraballo of Gaeta, egged on by Leo's praises, applied for the reward of a poet's laurel crown. He was ceremonially dressed in purple, mounted on an elephant and put at the head of a procession to take him to the Capitol. The jest got no further because the crowds and kettledrums alarmed the elephant, which refused to move. But it is commemorated on – of all places – the doors between the Stanza della Segnatura and the Stanza di Eliodoro. Raphael did not design the doors but he was drawn into the later history of the elephant, called Hanno. When it died, a favourite with all Rome, he painted a funeral portrait above its tomb in the Cortile del Belvedere. It was in the open air and has long vanished, but an echo of it survives as a fountain-head in the garden of the Villa Madama.

The incident reminds us that Raphael was a courtier at a pleasure-loving court. The temperament which made him personally so loved was the temperament which could bring lightness, grace and charm into his art. And in much of his late work it is as important in one direction to understand his fantasy and wit, his pleasure in providing civilised entertainment for a civilised society, as it is important in another direction to understand his high seriousness. It is in this context that we hear of him, late in the decade, as a theatrical designer and producer. He staged two plays by Ariosto, one in the residence of Cardinal Cibo with Pope Leo in the audience, and the other in the Castel Sant' Angelo. Bramante had already made provision for an outdoor theatre in the Vatican when he designed the Cortile del Belvedere. But Raphael's performances were indoors, furnished with illusionistic perspective scenery which drew rounds of applause led by the Pope. The creation of an apparently 'real' world beyond the frame of a proscenium – a theatrical idiom which is still with us – is first fully documented in 1514 for a comedy called *La Calandria*, written by Cardinal Bibbiena and designed by Perruzzi. It was a development closely parallel to Raphael's own. His great frescoes had confronted the spectator with a simulated action as an audience is confronted with a play. But now he needed only the right setting to lead the audience into the action itself, like actors moving within the 'pictorial' space of the new theatres.

In 1517 the last of Agostino Chigi's commissions brought him back to the Villa Farnesina where he had painted his *Galatea* six years before. He was working again with Perruzzi, whose aim in designing the villa had been to introduce a whole series of spatial effects linking indoors and outdoors. On the first floor he had frescoed the main living-room with an illusion as striking as any of his own stage-settings. The two end-walls are entirely taken up with *trompe-l'oeil* perspectives to look like open loggias with distant views of Trastevere and the Borgo. He needed Raphael now to achieve an even more elaborate effect on the ground-floor, where a real loggia led from the gardens into the reception-hall and was the main entrance to the villa.

To appreciate what they planned, it is necessary first to think what the house was like in its heyday. As created by Chigi, the international banker who held the purse-strings of nations and was known as Il Magnifico, it was a showplace for his spectacular style of high living. The rendezvous of rank, wealth, talent and fashion, it was as famous for its gardens and the treasures displayed in the house as for the prodigal scale of its hospitality. The Tiber flowed beneath its windows then, and there is a famous story of banqueters throwing their gold dishes into the river, only for the prudent host to retrieve them later by means of nets which he had already spread out of sight beneath the water. The loggia with which Raphael was entrusted was to be turned into an airy pergola festooned with garlands and greenery and hung with tapestries. Illusion would mingle with reality, the decorations of the garden would reach into the house, and overhead in the summer sky gods and goddesses, cupids on the wing and flights of birds would add a frolicsome touch of the erotic to the general sense of celebration.

With his 'inner team' of Giulio Romano, Francesco Penni and Giovanni da 83–85
Udine to help him, Raphael set about what could and should have been his most
festive conception. It is doubly difficult to appreciate now, because the loggia has
been glassed in, the lower walls were not designed to look as bare as they do today,
and the frescoes on the ceiling were seriously coarsened in the seventeenth century
by the over-painting of Carlo Maratta – although, to do Maratta justice, they would
not have survived at all without him. The theme of the ceiling is the second part of
the story of Cupid and Psyche, when Psyche is received among the Gods of Olympus:

Study of Venus and Psyche, Raphael, red chalk (Louvre)

the first part, which takes place on earth, would have been depicted lower down, round the walls. The central scenes are shown on two panels painted as if they were awnings overhead strung from the ribs of the open pergola. Beyond them is sky and the comings and goings of naked immortals. Their original splendour can be felt in a number of very beautiful drawings of the nude by Raphael himself, one of which – of Venus reclining on a cloud – looks forward three centuries to anticipate the whole art of Boucher. Along the ribs of the pergola, festoons of flowers and fruit were painted with fulsome realism by Giovanni da Udine. They preserve best of all the intention of the whole decoration to create for Agostino Chigi's guests an environment fit for a summer banquet in a garden.

The Psyche Loggia is the work of an artist who can adapt his style and mood to an almost Shakespearean range, and his work on it is enlivened by an anecdote which is the nearest to high comedy in the Raphael legend. It is told briefly and primly by Vasari, but confirmed a century later by the descendant and biographer of Agostino Chigi who became Pope Alexander VII. Raphael was becoming so persistently diverted from his work by a greater interest in La Fornarina that his two employers at the Villa and the Vatican conspired to spirit the lady out of the painter's reach. The remedy was worse than the illness. He fell into such a languid melancholy that they were obliged to spirit her back again, and the crisis was only finally resolved by giving her rooms in the Villa itself.

In a similar mood it is worth considering the interlude of Cardinal Bibbiena's bathroom. It is usually referred to in Raphael's oeuvre as the 'Stufetta', but a bathroom it is, within modest requirements. A square vaulted chamber in the Vatican not much more than seven feet across, it is frescoed from floor to ceiling in what was now the fashionably antique manner, but with little inset scenes of amatory dalliance whose leading character is Venus. Cardinal Bembo had suggested passages from Ovid and Servio to Cardinal Bibbiena, who lent the relevant texts to Raphael. The frescoes are in a poor state of preservation, but their slightly *risqué* charm (given where they are) and their light-hearted wit and fantasy, as in a small detail of Cupid in a chariot drawn by snails, link them both with the tone of the Cupid and Psyche frescoes and with Raphael's further development in the Vatican Loggetta of the so-called *grotteschi* style of decoration.

The term *grotteschi* comes not from 'grotesque' but from 'grotto', the name given to excavated chambers in which remnants of antique frescoes were being discovered. These frescoes had been known to many Renaissance students of classical archaeology, but Raphael's enthusiasm for them and revival of their technique gave the style a currency which spread across Europe and was still influencing Neoclassic decoration in the late eighteenth and early nineteenth centuries. Some of the finest examples were being uncovered in chambers and passages beneath the ruins of the Baths of Trajan, which meant that they must belong to the long-lost palace of Nero, his legendary 'Golden House', the Domus Aurea. Students had to scramble down to them through shafts and bore-holes, and there are still names and dates written on the walls by Raphael's contemporaries as they struggled down. What

86

94

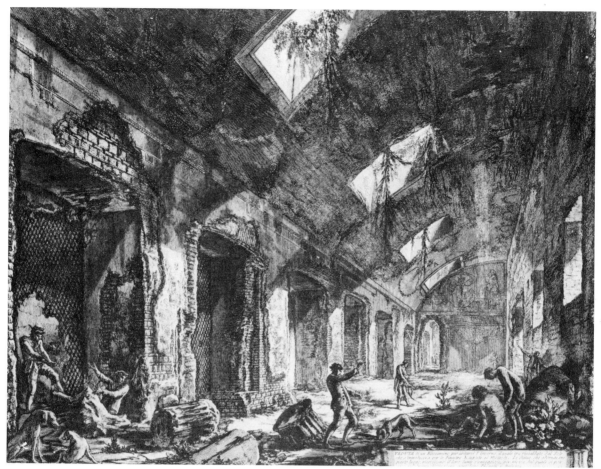

Ruins of a Roman Solarium, Piranesi, etching about 1750

they found were decorations which mixed architectural elements in false perspective with landscapes, masks, festoons, still-life, genre-scenes and entrancing inventions of pure, whimsical fancy. The attraction of the style was its airy lightness of effect coupled with unfettered variety of incident, adaptable to any shape or size of wall, and capable of incorporating any kind of subject-matter. The long galleries in the Vatican called Raphael's Loggias and the Loggetta, and the great hall of the Villa Madama, offer the most sustained application of the style as conceived by Raphael. He himself never laid brush to any of them. They were carried out and mostly designed by his workshop. But the mind and spirit and lyricism behind them are Raphael's own. With the exception of the great Gothic cathedrals of the north, they are perhaps the most extraordinary examples in Europe of an inspired artistic vision achieved by many hands working as one.

While the Vatican Apartments were still in progress, and the work on St Peter's had to be pressed forward; during the years when the Chigi Chapel was built, the late portraits painted, the Cupid and Psyche frescoes executed and the Vatican Loggias planned; while orders for paintings or architecture had to be organised

with his assistants and his official duties called for constant supervision of Rome's antiquities, another huge Papal commission was added to Raphael's workload. Leo wanted to put his own splendid finishing touch to the Sistine Chapel. Michelangelo's ceiling had been unveiled in 1512. Below it, the chapel walls carried an earlier fresco cycle executed in the 1480s by Perugino, Botticelli, Pintoricchio, Signorelli and Ghirlandaio. Below that, surrounding the choir at ground-level, Leo wanted a set of tapestries by Raphael. No expense was to be spared on the costliest of coloured silks and gold thread, and they would be woven by the best weavers in Europe, the Flemings. They were ordered probably towards the end of 1514, initial payments are recorded the following year, and most of the set was in position for a St Stephen's Day service on 26 December, 1519, just three months before Raphael's death.

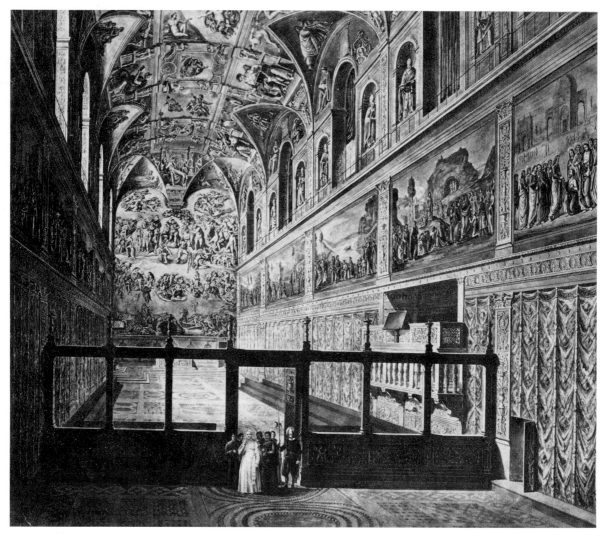

Interior of the Sistine Chapel in the nineteenth century, anonymous

The subjects were to be episodes from the lives of St Peter and St Paul, four relating to St Peter starting to the right of the altar and continuing down the side of the chapel as far as the *cantoria*: and four relating to St Paul mirroring them down the left-hand side, with a fifth and a small extra one completing the choir-space. At that time, of course, Michelangelo's *Last Judgement* was not even envisaged. The altar-wall still had frescoes by Perugino, and windows above them sent a strong light down the length of the chapel; Raphael incorporated it in the directional lighting of his designs. His problem was to set a scale and a visual impact at eye-level which would balance the overwhelming competition of the two levels of fresco above them. They also had to register against the full panoply of ecclesiastical costume ranged in front of them when the chapel was in use. His solution was to rely on extreme richness of texture and colour in scenes containing almost life-size figures in spatial groupings of the utmost clarity.

Raphael's tapestry designs are one of the grandest expressions of Christianised 97–104 classicism which the Renaissance has bequeathed us. But they set us two problems in coming to terms with them. One is trying to judge the effect Raphael intended. Various sets of tapestries were woven from them, but they all look different because the weavers were expected to improvise to some extent in passages of pattern and decoration. The first and original set is preserved, though incomplete now, in the Vatican, but it has faded to a point where the colour-scheme is distorted and bears 96 no resemblance to contemporary descriptions of its glittering richness and lifelike realism. Seven full-scale working cartoons also, by a near-miracle, survive: they are painted on sheets of paper which had been cut into strips for the weavers to work from and they were only rescued and re-assembled after a century of use. They can obviously give no effect of silk and gold thread, and their resin-based body-colours have also distorted with time. The most conspicuous example is a red vegetable dye which has now gone white: in the *Miraculous Draught of Fishes*, for example, the colour of Christ's robe can only be judged by the red of its reflection in the water below the boat.

The other problem is a subtler kind of interference, and it is based on our response to classical idiom in a Bible narrative. The premise of Raphael's style is that noble events call for noble action and heroic types. But in non-Mediterranean and non-Catholic countries – and the home of the tapestry cartoons since the seventeenth century has been England – Protestant realism in such matters gives us a different moral slant on the way these stories are told. It is the legacy above all of Rembrandt, who taught us to visualise the New Testament more humbly, as the impact of extraordinary events on very ordinary men. The problem focuses on Raphael at this point only because the idiom of the tapestries, reproduced and disseminated throughout Europe, affected the imagery of Bible narrative for centuries to come. And it is noticeable how the cartoons today, displayed in London's Victoria and Albert Museum in a space roughly proportionate to the Sistine Chapel itself, and therefore the most complete experience of Raphael's high classical manner to be obtained outside the walls of the Vatican, are often slow to make their full impact.

Continued on page 189

175

Pope Leo X prided himself on presiding over a Golden Age of culture (95). Two years after Michelangelo had completed the ceiling of the Sistine Chapel, he commissioned Raphael to design a set of tapestries to match it. Woven in Flanders at enormous expense, they involved the left-to-right reversal of the working cartoons for them (96, 97), seven of which survive out of a set of ten (97–105). They illustrate the lives of Rome's two patron-saints, St Peter (97–100) and St Paul (101–104). In the last years of his life, Raphael was more interested in archaeology and architecture than in painting, but his *Transfiguration* broke entirely new ground with its harsh contrasts and dramatic lighting (106–110). It was still not quite finished when, without warning, he fell sick of a fever and died on his thirty-seventh birthday, 6 April, 1520.

95 *Pope Leo X and Cardinals*, Raphael (Florence, Uffizi)

96 Christ's Charge to Peter, Vatican tapestry after design by Raphael

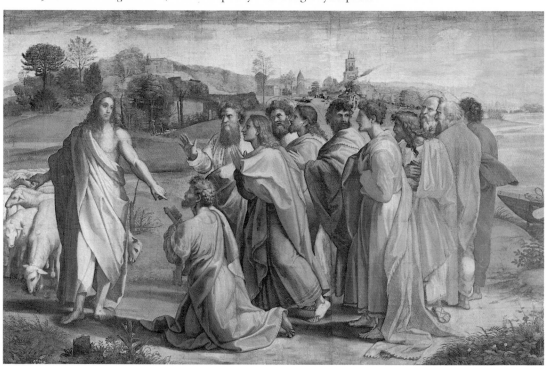

97 Christ's Charge to Peter, cartoon for tapestry, Raphael (London V & A)

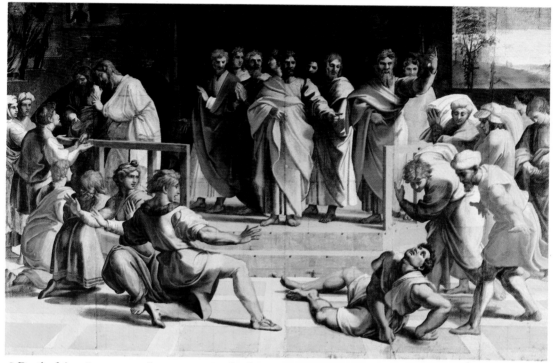

98 *Death of Ananias*, cartoon for tapestry, Raphael (London, V & A)

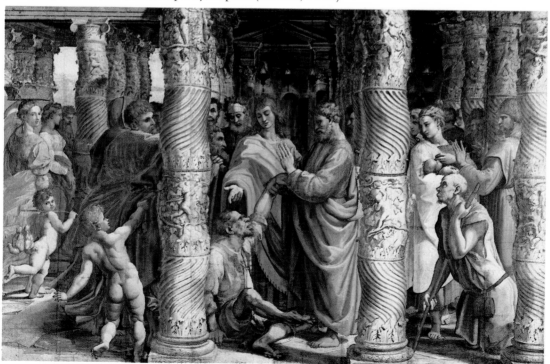

99 *Peter and John heal the Lame Man*, cartoon for tapestry, Raphael (London V & A)

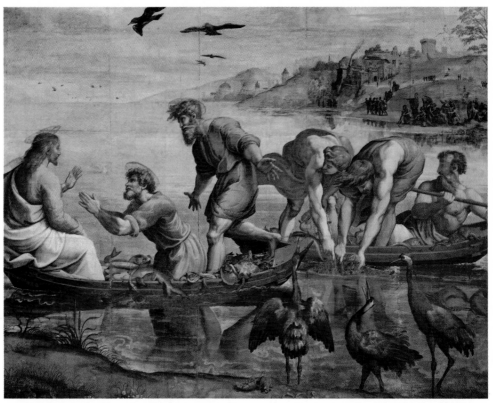

100 *The Miraculous Draught of Fishes*, cartoon for tapestry, Raphael, and 102 (opposite) detail

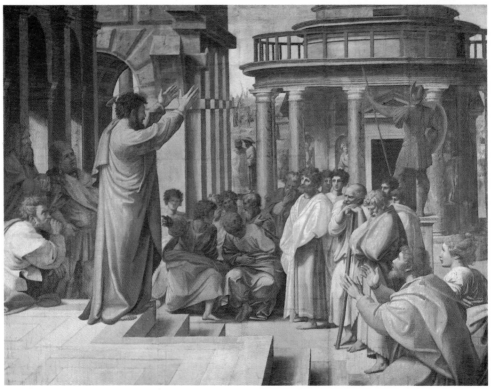

101 *Paul preaching in Athens*, cartoon for tapestry, Raphael (London, V & A)

103 *The Blinding of Elymas*, cartoon for tapestry, Raphael (London, V & A)

104 and 105 *The Sacrifice at Lystra*, cartoon for tapestry, Raphael, and detail (opposite) (London, V & A)

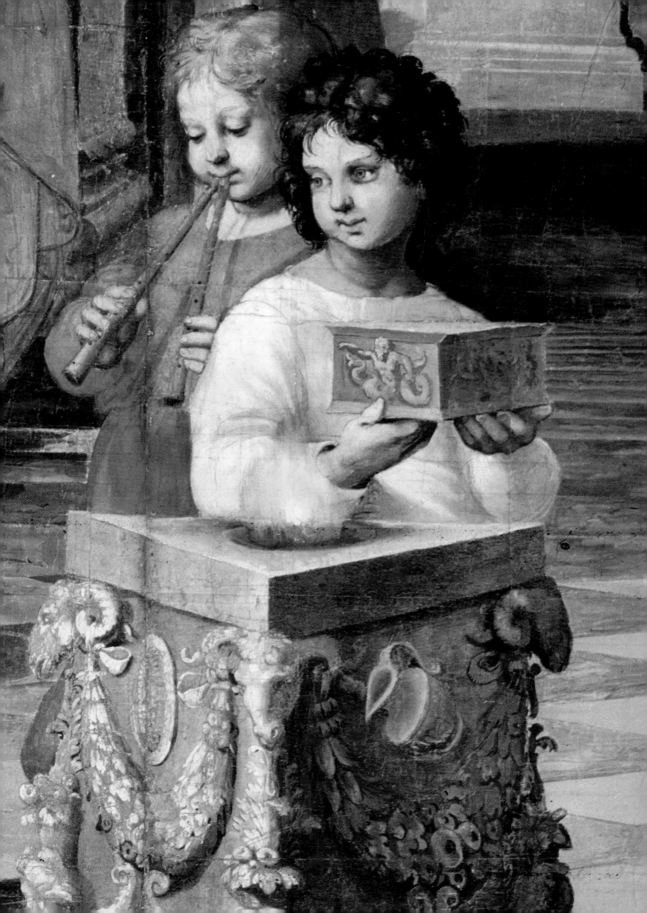

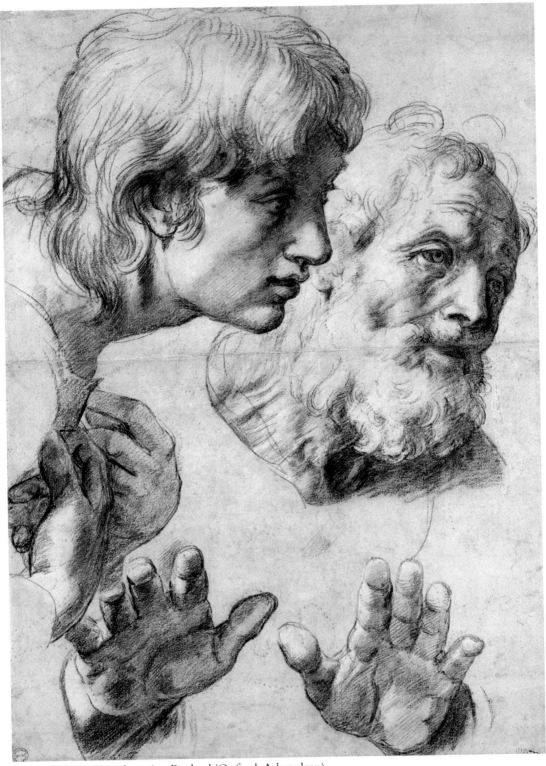

106 *Study for the Transfiguration*, Raphael (Oxford, Ashmolean)

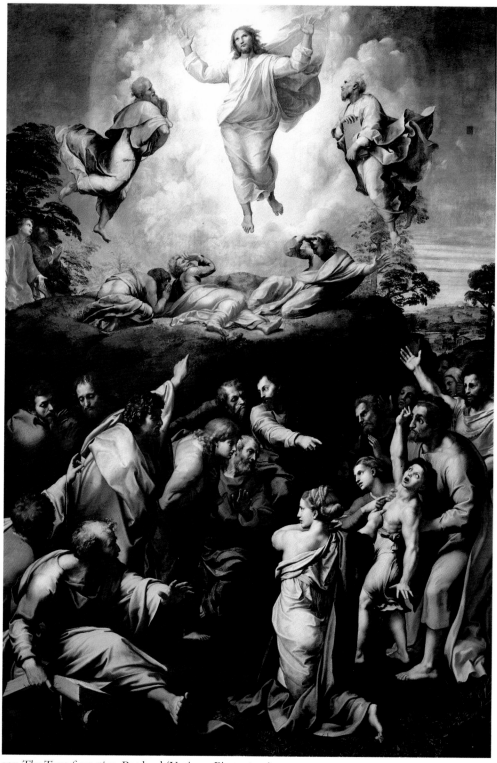

107 *The Transfiguration*, Raphael (Vatican, Pinacoteca)

108 and 111 (opposite) *The Transfiguration*, details

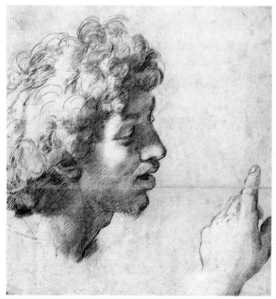

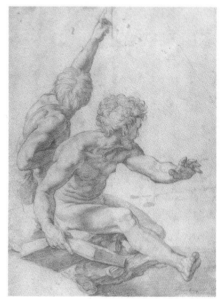

109 and 110 Studies for *The Transfiguration* (Chatsworth)

186

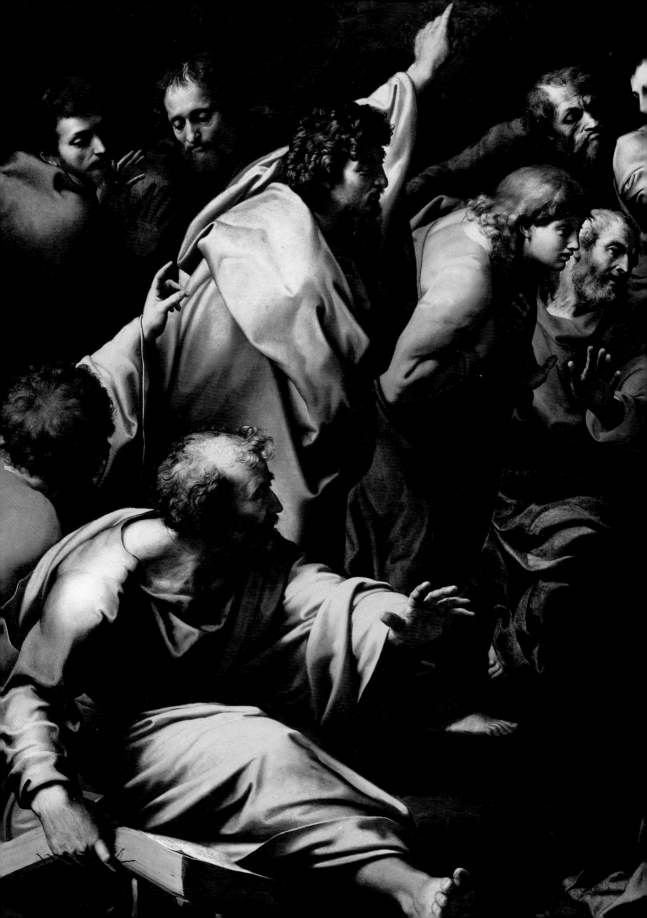

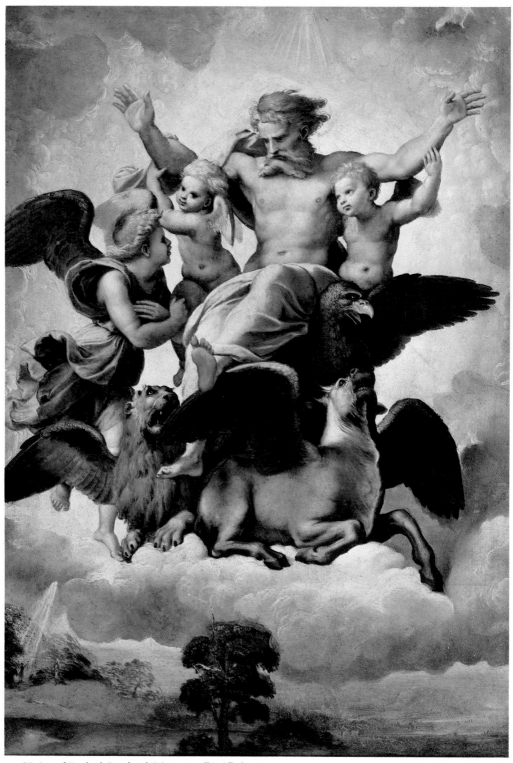

112 *Vision of Ezekiel*, Raphael (Florence, Pitti Palace)

When they do, the memory cannot be dislodged. We call an artist classical in the extended meaning of the word when form, function and meaning in his work are so integrated that the final effect seems inevitable and somehow quite simple. Two of Raphael's less 'popular' designs in this series are concentrated round a single figure which is both unforgettable and tells the whole story in one. In the *Blinding of Elymas*, the eye is led straight to a man with his eyes closed, his hands feeling the air before him, and his feet searching for the ground which has disappeared. In the *Death of Ananias*, the crowd opens in dismay to reveal a figure which has collapsed in a writhing posture very similar to that which Raphael devised for his Heliodorus. Of the very few studies which have survived for these designs, one demonstrates how Raphael had to search for a fully meaningful illustration of *Christ's Charge to Peter*. The study shows a conventionally rhetorical and admonitory gesture of Christ's hand pointing to heaven. In the cartoon, the hands are spread calmly to either side, one to indicate 'Feed my sheep', the other to entrust the keys of heaven

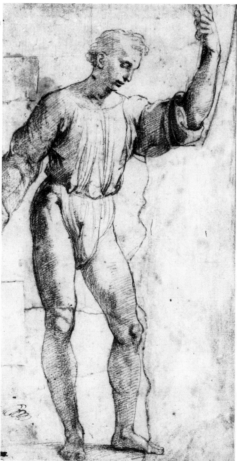

Study for Christ's Charge to Peter, Raphael,
red chalk (Louvre)

to Peter. The most memorable sequence is that of the *Miraculous Draught of Fishes*, remembering always that it should develop from left to right but is reversed in the cartoons because the tapestries were woven from the back, not the front. Each gesture concentrates a statement. The sons of Zebedee are all muscle and strain, because the miracle is about loaded nets which a moment before had been empty. Andrew is amazement and question. Peter is instinctive recognition and worship. Christ sits separated from them by the sudden rise and fall of heads, calmness in command and blessing.

But the series is 'classical' in the antique sense also, particularly where archaeological detail strengthens the setting of St Paul's story against the background of the Roman Empire. A major discovery in Rome in 1515, the year the cartoons got under way, had been the relief panels of the *Triumph of Marcus Aurelius* which are now in the Capitoline Museum, and they undoubtedly affected Raphael with their

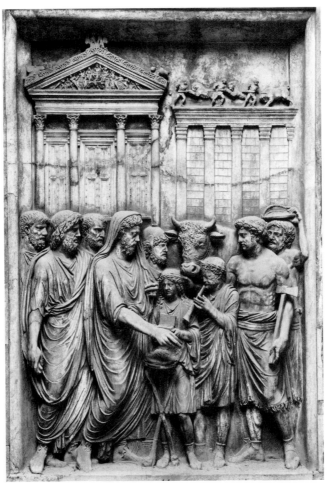

Roman Relief of Marcus Aurelius dedicating a sacrifice
(Rome, Capitoline Museum)

190

sense of Roman *gravitas*. But we hear of him also trying to get legal possession of another relief which is today in the Uffizi and supplies the complete central incident for the *Sacrifice at Lystra*. Paul has healed a cripple and is straightway hailed as a god and offered the sacrifice of an ox: Raphael's care has been to see that the pagan ceremony is historically correct in detail. Another instance is that of the spiral columns which so strikingly condense the space in the *Healing of the Lame Man*. Six columns of this design, which were brought by Constantine from Greece for the old St Peter's and are still preserved in the present one (they inspired Bernini's *baldacchino* over the High Altar), had come to be regarded as originals from the Temple of Solomon in Jerusalem. Raphael's use of them here is therefore instantly to identify and authenticate his setting of the scene in the Temple. They also heighten one of the most emotional narratives in the series. If it is thought of, like the tapestry, in reverse, it moves from anxious constriction on the left, through the incident of the healing, to a joyous release on the right, with a sense of regained youth and light in the sky beyond.

The last great patron to come into Raphael's life was the cardinal whose saturnine 95 features are seen on the left of the portrait of Pope Leo, and who was to become the tragic Pope Clement VII – Giulio de' Medici. His first approach was to Raphael the architect. He wanted a villa built on the slopes of Monte Mario overlooking Rome and it was to be exceedingly grand, more palace than villa. Begun around 1516 and known now as the Villa Madama, it was still far from finished at Raphael's death. What we see today is half the original design, so that what should have been a circular atrium in the centre of the whole complex was sliced down the middle and now welcomes the visitor as a semicircular façade to the half that got built. During the Sack of Rome in 1527 Giulio, who was then Pope, saw the villa go up in flames. Later it was restored, lapsed again into neglect, dwindled to a mere farm-house, only to be restored once more in our own time to something close to its original splendour. Its survival is astonishing, for its crowning glory – the great Loggia – is the Raphael workshop's most sumptuous and yet delicately detailed interior.

The villa had extensive formal gardens along the hillside which rose to terraces, walks, arbours and fountains round the house itself, and it was an idealised re-creation of what Pliny had described of the Roman villas of Imperial times. Antonio da Sangallo the Elder and Giulio Romano shared the layout of the grounds and most of the architectural design, but it was Giovanni da Udine who carried off the palm by the beauty of his applied ornament in the Loggia. As architecture, the high triple-vaulted hall is princely but not elaborate. Its magnificence is the effect of colour and the sensitive detailing of surfaces. Large areas of brilliant white set off the patterned areas of clear, strong colour which is at its richest overhead. But the surfaces are brought alive by a fine network of stucco modelling in the most delicate low relief. Splendour is precisely scaled to refinement in a way which makes the room a triumph of lightness, balance and visual articulation. It is the High Renaissance answer to the Golden House of Nero.

The cardinal's second approach to Raphael was for a painting. He must have been fully aware that by now not even the King of France could expect a Raphael painting which was entirely from Raphael's own hand. He wanted a large altarpiece for the Cathedral of Narbonne and rather provocatively put it out to tender, as it were, with Raphael and Sebastiano del Piombo simultaneously. Perhaps he knew exactly what both would do and did. Sebastiano, fearful of being eclipsed, applied for advice and help to Michelangelo, who was in Florence. Raphael, possibly aware that in some sense he was being set up in competition with his great rival, undertook the entire execution of his *Transfiguration of Christ* himself. Cardinal Giulio's scheme was probably put forward very late in 1516, for on the following 19 January one of Michelangelo's informants in Rome, Leonardo Sellaio, wrote to him with news of it. Clearly not a Raphael supporter, he wrote again exactly a year later with a gleeful report that the Cupid and Psyche frescoes were now finished and 'a disgrace for an artist with such a reputation – even worse than the last Papal Apartment' (that would have been the *Burning of the Borgo*). To know he was being sniped at in this way could have been provocation enough for Raphael to take up his brushes again and prove that he was not just the head of a workshop. But it was also an opportunity to press forward into areas of expression which even he had not explored. Sebastiano, for his part, is believed to have got the help he wanted in the form of designs from Michelangelo. But having finished his own altarpiece, a huge *Raising of Lazarus* which is now in the National Gallery in London, he delayed exhibiting it for fear – so we are told – that Raphael would see it, improve on it and win the commission.

107 But Raphael was taking his time and planning something more original – two consecutive scenes from St Mark's Gospel bound like a vast figure-eight into one composition. In the top half, Christ is transfigured before Peter, James and John whom he had taken 'up a high mountain apart', while Moses and Elijah appear beside him. In the lower half, the rest of the disciples are powerless in his absence to help a possessed boy whom his father had brought to them to cure. Raphael's double subject and strongly contrasted treatment of the two halves worried critics from Vasari onwards: he seemed to have negated the classical principles of unity and harmony. To Vasari the inky shadows below were the fault of Raphael's mixing his colours with lampblack which had made them fade. Giulio Romano was blamed for having reputedly finished the lower half in a different style from Raphael's. About 1800 a coat of varnish tinted with Avignon yellow was painted over the entire surface during a restoration in Paris, and for the next century and a half no one knew what the painting really looked like. But a major cleaning and restoration at the Vatican, which was only completed in 1976, re-established its true condition and, with it, Raphael's revolutionary boldness. He had not, except for one tiny area, left it unfinished, the colours had not faded. The violent contrasts were entirely intentional.

The power of his idea lies precisely in the division into halves. Darkness below is transfigured by light above, and it is the epileptic boy, the one most in the grip of

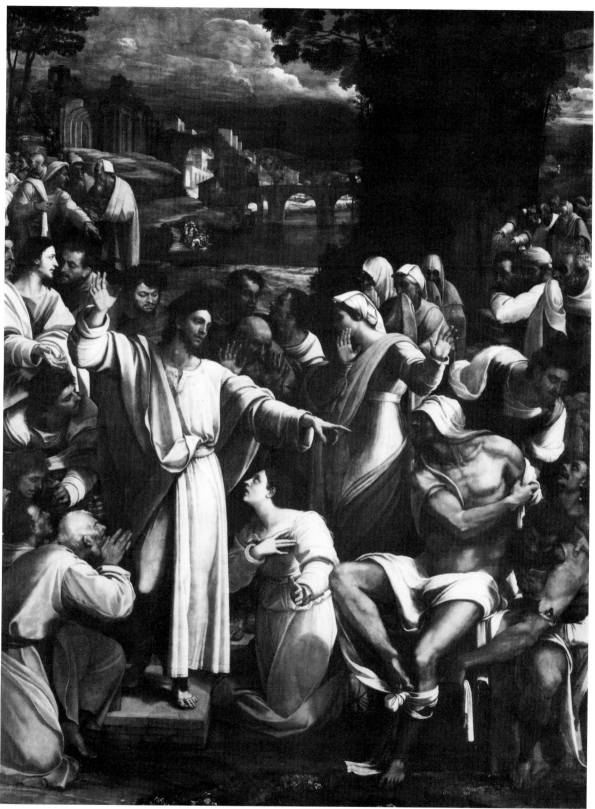

The Raising of Lazarus, Sebastiano del Piombo (London, National Gallery)

darkness, who instinctively looks upward. Goethe understood the significance at a time when the painting was out of favour. 'The source of salvation,' he wrote, 'can come only from Christ, so the two scenes *are* one.' Image after image seems to surface from the stored experience of twenty years' work to find expression somewhere in this painting. Light pours from above with a spiritual force remarkable even for a lover of light like Raphael. The scene of the Transfiguration itself takes to the air against that circle of radiance which symbolises Heaven in the domes of Sant' Eligio and the Chigi Chapel. A glimmering landscape on the right waits its own turn to be transfigured by the rising sun. In the lower scene, immediately below Christ, the face of an old man is remembered from Leonardo's *Adoration of the Magi*. The kneeling woman in the centre turns with Michelangelesque magnificence. Even the head of St Andrew, in the foreground on the left, started from a drawing which is like a memory of Bramante.

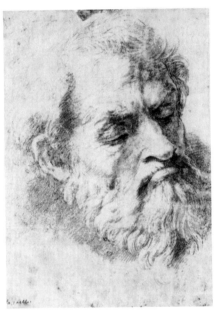
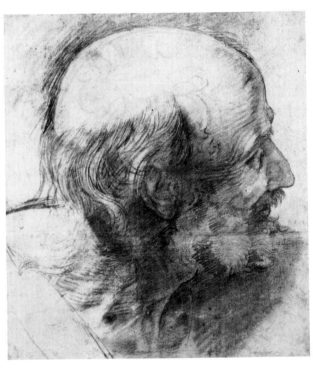

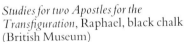
Studies for two Apostles for the Transfiguration, Raphael, black chalk (British Museum)

III But it is still the lower scene as a whole which remains startling in its agitation, its acid strength of colour and its harsh lighting. It shows us a world of confusion and doubt which Michelangelo would have understood in spirit but whose visual means look forward eighty years to Caravaggio. On the right-hand side the forms are still logical and self-explanatory enough to cling to some semblance of a classical language. On the left they are broken up into spotlit fragments of gesture. Pictorially these depend for their meaning on the highly unclassical expedients of surprise and exclamatory emphasis, and Raphael does not hesitate to exaggerate the pose of a

194

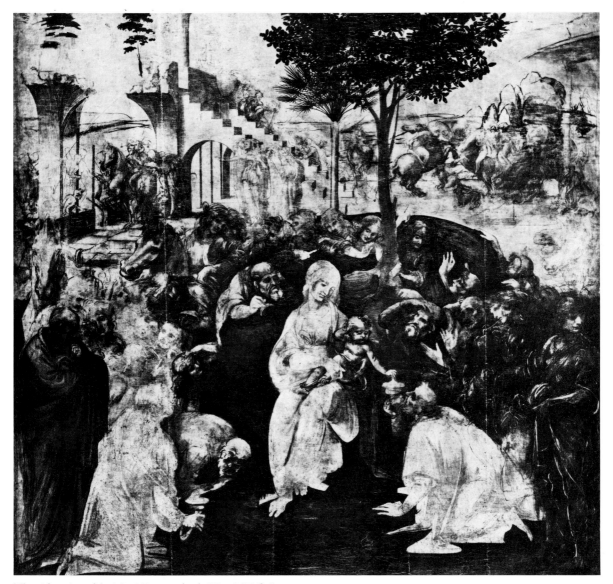

The Adoration of the Magi, Leonardo da Vinci (Uffizi)

key-figure like St Andrew beyond what is strictly natural. It is a splendid figure, but in its thrusting hand and leg Raphael set a precedent that would later be much abused – a precedent for rhetorical gesture. It was just ten years since he had painted the *School of Athens*. He had travelled further than most artists travel in a lifetime.

In the first months of 1520 the painting was nearing completion. On 24 March Raphael signed a lease on some new property near the Via Giulia. On the 28th he fell sick. He was dead ten days later and buried within twenty-four hours. The suddenness of it is unnatural. He died, we are told, of a 'continuous and acute fever'.

The rapid burial suggests something more serious, possibly a form of plague. He could even have caught it from long hours spent in underground excavations, in primitive conditions, digging among the ruins of Ancient Rome.

It was 6 April, which was a Good Friday. It was also his thirty-seventh birthday. The *Transfiguration* stood at the head of his sick-bed, and that night there were portents: 'The Papal Palace opened and threatened to crumble and His Holiness fled his apartments'. An enormous funeral procession bore Raphael to the Pantheon, where he is buried. There is a story that La Fornarina could only be induced to let go of his coffin on Pope Leo's promise to have him beatified. Unfortunately it is too late a story to be true, but the emotional tensions of that day generated an atmosphere in which all things became believable and legend was born. That Leo must at least have promised to make Raphael a cardinal was translated almost immediately from supposition to fact. A cardinal wrote his epitaph. A cardinal's niece, the unfortunate Maria Bibbiena who died too soon to marry him, was commemorated on his tomb. Surely he himself had been intended for the ranks of those who remained to mourn him?

The Pope was grief-stricken. With Raphael's death his Golden Age seemed to have lost its meaning. Leo survived him by only a year.

Part Three
The Divine Raphael

Raphael was young when he died, but to be nearer forty than thirty was perhaps not inordinately young in an age when life-expectancy was limited. No one at first seems to have made particular mention of it. Grief and shock in Rome were at the unexpectedness of the death. A light had gone out without warning. An untiring source of energy was suddenly switched off. Great hopes and projects were left hanging in the air, and developments which had been eagerly awaited would not now be realised. The world of scholarship was as sensible of its loss as the world of art and architecture, and the keenest regret seems to have been for the projected model of Ancient Rome. Epitaphs and poems on Raphael's death, including one by Castiglione, mention it before anything else as the great contribution to the age which would never now be achieved. Only gradually does it become apparent that what the age had really been robbed of was its sense of youth. Other great shapers of the High Renaissance had been rather markedly long-lived. Perugino was now in his mid-seventies and had another three years left him. Leonardo had died only the year before at seventy-seven. Julius II and Bramante had both been seventy. Michelangelo was to live another forty-four years. Raphael himself began to be remembered as even younger than he had been – not as he was in the prime of life but as he had looked when he came to Rome in his mid-twenties, beardless and full of promise. Even the bust made for his tomb in the Pantheon reverted to this earlier image, and it has remained the standard one ever since. He belongs with the company of the cruelly short-lived – of Masaccio, Giorgione, Géricault and Seurat: Keats and Shelley: Mozart, Schubert and Mendelssohn. 'Those whom the gods love die young.'

That element of poignancy had its share in the Raphael legend, and helped particularly to colour it with love for the artist himself. We have to account for the fact that he has been not only the most influential but also the most revered artist in history, and part of the phenomenon is due to what we are repeatedly told of his personality. Vasari's description of it has already been quoted. Other writers catch the same tone of wonder that anyone could walk the earth so richly endowed and of so angelic a nature. Even allowing for exaggerations of sentiment, all the evidence points to a quite exceptional charisma and something about the man which remained in memory as almost saintly. His very surname, Santi, has a suggestive effect. One writer ignores the epitaph in the Pantheon and quotes his age at his death as thirty-three, as if to hint at a parallel with Christ. The temptation to elaborate and myth-ologise such a reputation proved irresistible, and some of the most fanciful accretions to it were products of the eighteenth and nineteenth centuries when Raphael-worship was at its least restrained. In our own century we do not readily give our

hearts to heroes untainted by human blemish. But to understand Raphael's sovereign hold on three centuries of European culture, we have to appreciate to what an extent earlier generations were happy to adore him for being, to all intents and purposes, 'perfect'. Of course the personal legend only bolstered the artistic reputation and helped to spread it beyond strictly artistic concerns: it would never have sustained Raphael's influence by itself. But the same standards held good for Raphael the artist as for Raphael the man, and once again they date historically almost from the moment he died. Once again it is Vasari who sets the tone: 'It is indeed due to [Raphael] that the arts, colouring and invention have all been brought to such perfection that further progress can hardly be expected, and it is unlikely that anyone will surpass him.' It sounds like a recipe for stagnation. That it wasn't is due partly to Raphael's own range and variety, which allowed people to approach him from different directions at different times, and due partly to the fact that he came to stand for ideals and principles only tenuously related to the actual evidence of his paintings.

The practice of calling him 'divine' also began early. It is as annoying an adjective as 'perfect', but even as a conventional superlative it is significant that it has been used consistently of only one other artist. That is Michelangelo, and it was used of him for the same reason as it was used of Raphael, to indicate a certain absolute superiority in a particular sphere. The two artists continued to divide allegiances as they had in their lifetime, because in any argument about absolutes they stood as archetypes of contrasted temperament – the Apollonian and the Dionysiac, the reasoned and the inspired, the contained and the uncontainable. Michelangelo was to prove the more immediate and overwhelming influence. Living until 1564, he totally dazzled the later sixteenth century and was the prime motivator of the style called Mannerism. When that burned itself out in excesses of tortured sophistication, his energy and drama continued to have some effect on the Baroque. But in practice, Michelangelo could not be followed. His spirit was beyond emulation, and the style which served it was too singular to be anything but perilous as an example. Every attempt to make use of it ended in exaggeration and eccentricity. Raphael's influence operated in precisely the opposite way. He was undoubtedly a more comfortable artist to live with, his idiom was more natural, but it was felt also that through him the balance and harmony of the classical world had been brought within measurable reach.

The source-material of classicism, namely whatever relics of ancient art survived above ground or had been recovered from under it, consisted only of the fragments of a culture. They were like disjointed words from sentences that were never complete. Raphael was seen as an artist who had put meaningful sentences together from them, built the sentences into paragraphs, and restored them to the currency of speech in contexts of enormously varied range. Once artists had been taught the new syntax, they could adapt it to almost any tone of voice and any occasion, whether to tell stories or preach sermons, explore sacred or secular subject-matter, speak in the intimate accents of naturalism or the declamatory ones of rhetoric. The

language remained authentically classical. Raphael was the 'ideal' artist because he had reinterpreted antique art for the modern world. In that sense he was a master from whom guidance, principles and rules for the practice of art could profitably be derived. It was possible to learn from him and even borrow from him without copying him, as a surprising number of great artists did throughout the seventeenth, eighteenth and nineteenth centuries. Lesser ones sustained themselves on rules for drawing, designing or expressing sentiments in a Raphaelesque manner which brought them credit and approval when they had no original genius to offer. It was an approach which hardened into dogma, and what we call 'academic' classicism was the result.

Part of the Raphael Movement is therefore to do with the history of style in art. But from seeing Raphael as an 'ideal artist' in a practical sense, it was only a short step to seeing him as 'the artist of the ideal' in a theoretical sense. They are not at all the same thing, although they were often confused. To a quite remarkable degree, enthusiasts of the classical ideal tended to look through Raphael rather than at him whenever they changed their definition of Greek and Roman art. Raphael himself, it must be remembered, knew very little about the art of ancient Greece. Like the rest of his contemporaries, he based his own taste for the antique on evidence which was mostly Roman of the Imperial period, with a few examples of late Hellenistic art: at that time the styles were not very clearly distinguished. But as archaeology made Greek art better known, particularly in the eighteenth century, and as classical taste began to value Greek style as purer and more authentic than the Roman, the Raphael Movement conveniently kept pace. Raphael only had to be interpreted a little differently to remain, as before, the guardian angel of classical standards.

What was happening in fact was that the 'divine' Raphael was not one manifestation but two. One was an artist, the other was an idea. Fostered as it was by men of ideas – writers, poets, dramatists, philosophers and interpreters of taste – the second was an even deeper influence on taste and culture than the first. Few of those who talked about it had to look hard at pictures for inspiration (the outstanding exception was Goethe) and what they did look at was often Raphael at second-hand and much distorted in copies and the ubiquitous engravings. For their puposes, nevertheless, Raphael at second-hand was sufficient, because what they were extracting from Raphael's art was his expressive content and his 'sublime thought'. To the literary mind, these could be divorced from the execution of his paintings and be made to lead a virtually independent existence. A remarkable example has been quoted from a play of 1772 by Lessing called *Emilia Galotti*. One character who is a painter remarks to the Duke of Gonzaga, 'Raphael would still have been the greatest genius in art even if he had been born by some misfortune without hands – do you not agree?'. (The remark is more perceptive than it sounds: we have only to think how Surrealist art in our own century can convey powerful visual ideas which do not always need to have been painted). The ability to divorce content from form in the appreciation of Raphael had one very important result. The literary and philosophic 'idea' of Raphael was infinitely adaptable, and we find

each generation seeing him as the embodiment of its highest ideals even when these appear to be contradictory. For example, eighteenth century aesthetics and those of the Romantic Movement which followed it could hardly represent a more radical shift of values: the second is a repudiation of the first. But Raphael's reputation remains secure through both. In the earlier century he is praised in terms of a rationalist idealism. In the later one, the function of art is seen as religious and Raphael as the great exponent of Christian narrative.

The Raphael Movement only began to be undermined in the nineteenth century and even then retained firm strongholds in academic practice and popular taste almost to the end of it. One element in that undermining was the growth of landscape painting. From a subordinate and even despised position in the hierarchy of subject-matter considered proper to 'high art', landscape came for the first time to rank alongside figure-painting and ultimately to surpass it. From Turner, Constable, Corot and Caspar–David Friedrich to the art of the Impressionists, it absorbed into itself areas of feeling which only the depiction of the human figure had previously been thought capable of expressing. Not the least of these was 'religious' emotion. Nature and the exploration of light became secular man's substitute for the spiritual in art. This was happening at the same time as popular taste revered the religious values of Raphaelesque art above almost any of its other qualities, but in the long term it was an unequal contest. The artists who were shaping the century had no interest in Christian narrative or in noble thoughts personified in noble figures. Courbet called Monet the 'young man who did *not* paint angels'.

The radical decade of the 1840s saw the two traditions running neck and neck. But one was already in the ascendant and the other beginning its decline. The Raphael Movement was still capable, as we shall see, of some powerful manifestations. The influence of Ingres upheld Raphaelesque standards of design; the Nazarene painters revived a Raphaelesque tradition of mural painting on a public scale in Italy, Germany and England; the pioneer achievements of the art-historian J. D. Passavant and Queen Victoria's consort, Prince Albert, put Raphael scholarship on a new footing. But in the 1840s John Ruskin could already write of 'the pure and tasteless poison of the art of Raphael', and a band of youthful anti-academics could band together in a Brotherhood of protest and call themselves Pre-Raphaelites. The reaction was less against Raphael himself than against a stifling of response to the actual, visible world which was felt to be practised in his name. Artists had stopped using their eyes, had substituted rules and insincerity for observation and truth of feeling. The name Pre-Raphaelite was an emotional slogan rather than an accurate one. It was a muddled way of saying that art must have been a truer reflection of life before the Raphael Movement came into being and imposed its grand manner on academic thinking. But the intention was in line with that new tradition which would be in the ascendant for the remaining half of the century.

We date what is broadly called 'modern art' from the beginning of Impressionism, which started as a 'true' reflection of life. It grew rapidly into a much wider-ranging re-examination of what a painting is and what its subject-matter should be.

Neither Raphael's subject-matter nor the means he employed to express it – his sense of space, his harmonious grouping of figures, his references to a past and more 'ideal' civilisation, his search for noble gesture, his Christian-Catholic ethic – seemed to have any further relevance. Picasso is quoted as saying that he could draw like Raphael when he was ten (which would have been in the 1890s). It is not just an idle boast nor even a dismissal. It is a typically succinct and picturesque phrasing of why Raphael has been so difficult to appreciate justly for most of the twentieth century, let alone at the valuation which held good for three centuries before it. He was a superb solver and clarifier of pictorial problems, but as a primary education for artists, his lessons had become child's-play. His problems were not problems any more. Picasso fully understood the lure of Raphael's classicism, and in the early 1920s expressed his own version of it. Matisse understood it too, and in his old age, being taken round the Louvre in a wheel-chair, stayed longer before Raphael's *Belle Jardinière* than any other painting in the gallery.

But the past was the past. We are now a full century beyond the revolution which ended the Raphael Movement, and yet Raphael is no easier than he ever was to separate from his historical reputation. Nowadays it is not only Raphael-worship but the reaction against it which tends to infiltrate between us and his work. In a sense he is an artist who is only fully intelligible in the light of his fame.

Raphael's influence would never have been so widespread nor so long sustained if his art had not been readily accessible – more accessible, that is to say, than the great frescoes in the Vatican, which for long periods at a time were not on public view and could only be seen by the privileged: more accessible also than the celebrated works which were in the private collections of royalty or noble families. His art was accessible to everybody, throughout Europe. Engravings of it were already circulating in his lifetime and only increased in numbers with each succeeding century. Raphael is the first major artist to become public property by a process which parallels the spread of literature after the invention of printing, and he is almost the first to realise how valuable that process could be and to encourage it, both as potential advertisement and as an investment for fame.

He is said to have been alerted to it by Dürer. Dürer was the finest original engraver in Europe (original in the sense that he engraved his own designs). He was closely in touch with all the developments of the High Renaissance, and although he never returned to Italy after his second visit to Venice in 1506, he could rely on his engravings to keep his name and reputation alive there. He and Raphael exchanged compliments in the form of presentation drawings to each other, but Raphael also sent him a more comprehensive review of his own art in a set of engravings by Marcantonio Raimondi. We have already met Marcantonio helping to carry Pope Julius's chair in the foreground of the *Expulsion of Heliodorus from the* 65 *Temple*. His prominence there shows that by 1512 he was Raphael's honoured colleague, but their collaboration probably began three years earlier, when both were still very new to Rome. Raphael's first studies for a Marcantonio engraving

Landscape with classical ruins, Raphael; a study for *The Plague*,
chalk heightened with white (Windsor)

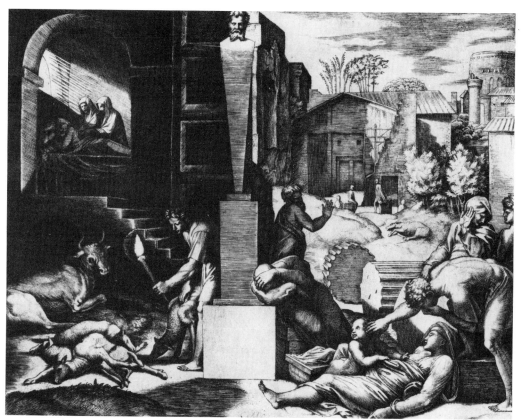

The Plague, Marcantonio Raimondi; engraving from a design by Raphael

appear as spin-off ideas on a sheet of drawings for the *Judgement of Solomon* panel on the ceiling of the Stanza della Segnatura.

Raphael did not himself engrave: with an interpreter as skilled and sympathetic as Marcantonio he had no need to. What he was able to do, as he did later with the most talented members of his workshop, was to farm out pictorial inventions which he was too busy to complete as paintings. His *Judgement of Solomon* panel, for instance, threw up ideas for soldiers about to murder children which could be valuable material for a *Massacre of the Innocents*. He prepared figure-studies for such a subject, instructed Marcantonio to give it a background based on Rome's most famous antique Roman bridge, the Ponte Fabricio, and left the engraver to produce the finished work. Marcantonio's contribution to Raphael's *oeuvre* is therefore crucial. The *Massacre of the Innocents*, a *Last Supper*, a dramatic design of Neptune commanding a sea-storm, a *Martyrdom of Saint Felicità*, a powerful subject called *The Plague*, and a famous *Judgement of Paris*, are all examples of Raphael at the height of his powers which would never have seen the light of day but for the engravings.

118, 119

Continued on page 210

For three and a half centuries after his death, Raphael's name remained synonymous with the highest ideals of classical culture; but his art was freely interpreted and even distorted to fit prevailing tastes. Around 1800 the colouring of the *Transfiguration* was toned down with tinted varnish. The *Canigiani Holy Family* originally had angels in the sky: they were painted out in the eighteenth century to make a more 'correct' Raphaelesque composition (113). The *Granduca Madonna* may once have had a landscape background (114). Some paintings long revered as authentic Raphaels have now been rejected from his *oeuvre* (116, 117). Others attributed to Giulio Romano or Sebastiano del Piombo are now accepted as his (115).

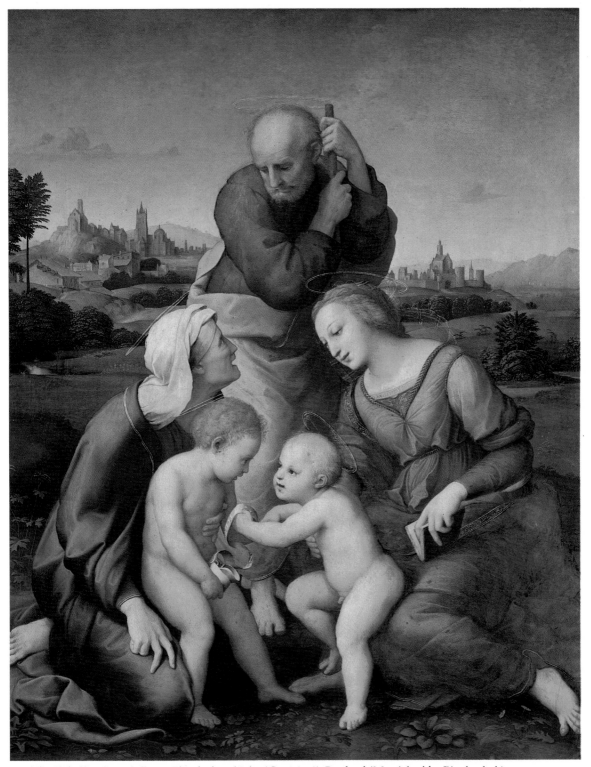

113 *The Holy Family with Saints Elizabeth and John (Canigiani)*, Raphael (Munich, Alte Pinakothek)

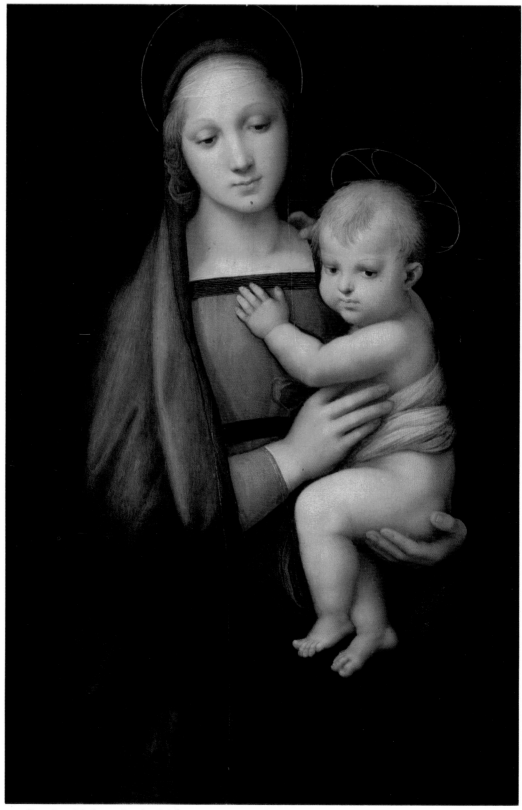

114 *Granduca Madonna*, Raphael (Florence, Pitti Palace)

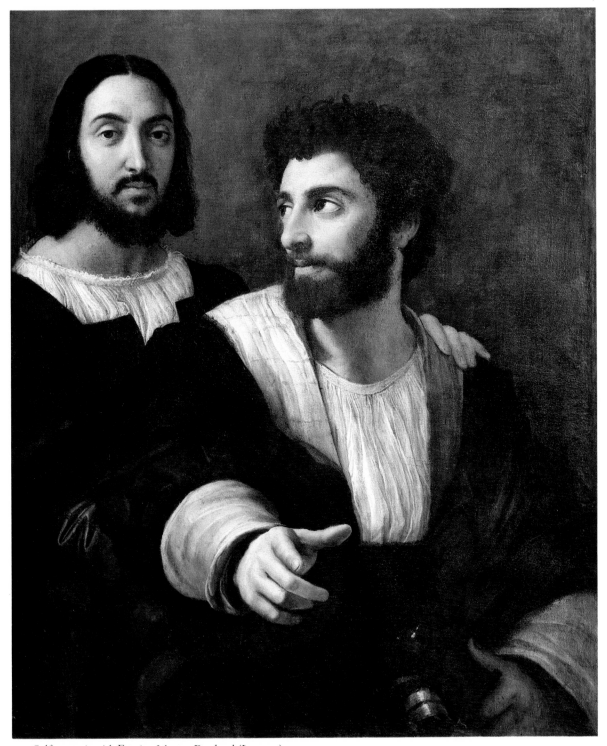

115 *Self-portrait with Fencing Master*, Raphael (Louvre)

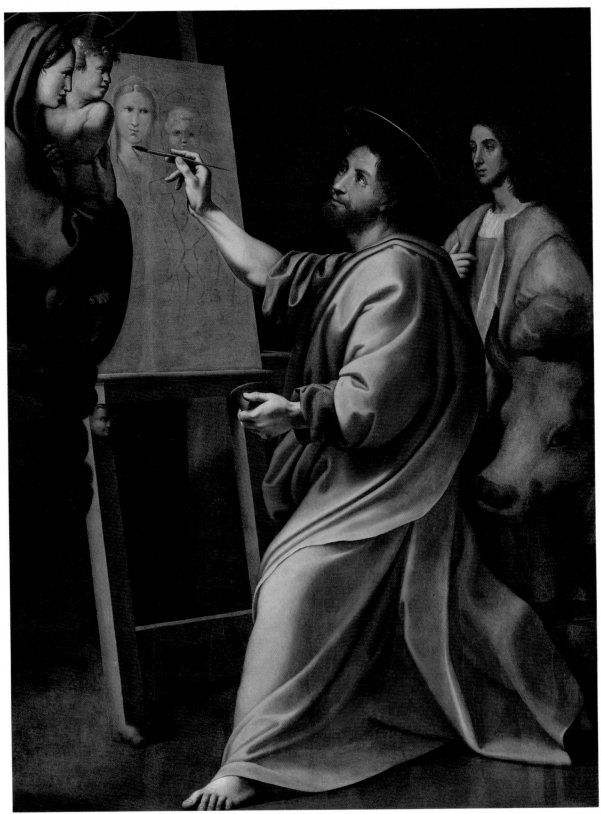

116 *St Luke painting the Virgin*, formerly attributed to Raphael (Rome, Accademia di S. Luca)

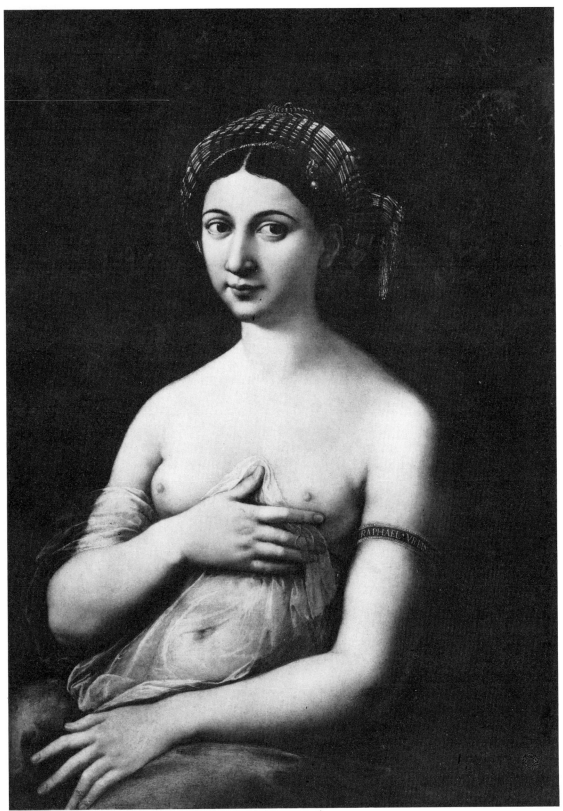

117 *La Fornarina*, Giulio Romano, formerly attributed to Raphael

The precision of Marcantonio's engraved line brings out one aspect of style which is present in Raphael's paintings but which tends to be softened by the colour and atmospheric effects of painting as well as by Raphael's continual transformations of his source-material. His sculptural approach to form is sharply emphasised, and Marcantonio is quite frequently more explicit than Raphael himself about the extent to which antique sculpture determines form, feeling and style. The *Judgement of Paris* engraving is a case in point. Several ideas in it can be traced to two specific Roman sarcophagi, the river-god on the right has identifiable Roman precedents, and the back and shoulder of Paris himself clearly derive from the famous *Belvedere Torso*. All this in spite of the curious *canard* which was spread about the design, that Raphael had destroyed an ancient carving in order to conceal how much he had borrowed from it. The engraving, which at the time 'astonished all Rome' and gave rise to numerous copies, paintings and cameos, evidently conveyed such an authentic effect of the antique that pedants were unwilling to concede Raphael his invention. The *Judgement of Paris* is also, of course, one of the most celebrated links in the transmission of antique imagery through Raphael to the art of a later age. The group on the right of it was the basis of Manet's composition for *Le Déjeuner sur l'Herbe* in 1863.

Raphael and the history of art owe Marcantonio a further debt. Apart from realising certain of Raphael's ideas in collaboration with the artist, he also copied some of Raphael's completed paintings. A set of Apostles for the Vatican was destroyed soon after Raphael's death during alterations to the room where they were frescoed, and the engravings are now the only evidence of them. But Marcantonio also seems to have had the run of Raphael's studio to pick and choose as he liked from miscellaneous drawings and to work the merest sketches into saleable designs under the master's name. One of these comes from a sheet with a sketch of architecture and a rough study for the ceiling of the Heliodorus room, in the corner of which Raphael had drawn a woman half-asleep in a window-seat – quite possibly one of his female models resting between posing sessions and quickly sketched from life. Marcantonio copied the figure, added an angel outside the window to make it the vision of a female saint, and this time allowed the image to be reversed from Raphael's original in the printing of the engraving. Angel and all, it re-appeared almost unchanged half a century later as one of Veronese's most beautiful paintings, the *Vision of St Helena*.

Marcantonio's prints were highly finished and must always have been expensive. Other, less sensitive engravers such as Agostino Veneziano and Marco Dente also reproduced Raphael's designs in his lifetime, but he seems to have encouraged one whose medium was notably clumsier and probably rather cheaper to produce. This was Ugo da Carpi who had 'discovered', according to Vasari, wood-block printing in two or three colours. Da Carpi's surviving prints are few, but they too rescue a handful of Raphael designs which would be otherwise unknown. Their great interest is that Raphael authorised them in spite of their decidedly rough-and-ready approximation to major works like the *Miraculous Draught of Fishes* tapestry. It is as

Pensive Woman, Marcantonio Raimondi; engraving after Raphael

though he wanted to ensure the availability of his images to a more popular audience than would ever enter the Sistine Chapel or be able to afford collectors' items like the engravings of Marcantonio.

Whether he would have sanctioned some of the later reproductions which poured from the engravers' presses in the sixteenth and seventeenth centuries is more doubtful. Some of them were abysmally crude, many were obviously copies of copies and were printed with the original design in reverse, and others freely

altered details of dress and architecture to suit the taste of different periods. In the eighteenth and nineteenth centuries technical standards and accuracy both improved, and the more responsible engravers always attempted to copy direct from the original work. But it is still remarkable to what an extent even informed taste and opinion had to be based on distorted evidence, and no less remarkable that so much of the message got through in spite of it. When comprehensive sets of engravings became popular in the early nineteenth century, for example, the style adopted for them was the fashionable Neoclassic one of pure outline. Three essential elements of Raphael's personality as a painter were thereby cut out – his sense of space, his sense of modelling and what engravings always lacked, his colour. They were elements on which much of his hard-won unity of pictorial effect was based. But his admirers merely concentrated all the more on his design, his sentiment, and the clarity of his narrative.

Particularly popular was the set known as Raphael's Bible. This consisted of fifty-two scenes in groups of four, the main groups dealing with episodes from the lives of the Old Testament patriarchs – Noah and Abraham; Isaac, Jacob, Joseph and Moses; Joshua, David and Solomon. The sequence opened with four scenes of the Creation and the story of Adam and Eve, and closed with four episodes from the Life of Christ. They were varied and lively, and they came from the ceiling panels of Raphael's Loggia in the Vatican, the groupings of four corresponding to the Loggia's thirteen bays. It was a sizeable sequence of images to include in Raphael's *oeuvre*, particularly as he painted none of them. The Loggia had been delegated to the workshop and was carried out by a team which now consisted of Giulio Romano, in charge of pictorial design, Giovanni da Udine, in charge of decorative design, Francesco Penni and another six assistants. Of the Bible panels themselves, we can assign the *Finding of Moses* with some certainty to Giulio Romano because Vasari mentions it by name. The others can only be tentatively attributed to individual members of the team.

Raphael's was the guiding thought of the Loggia. The general project was his, the prevailing style was his, probably the detailed planning of the divisions and the subject-matter were his. He certainly originated the concept which skilfully welded together three apparently disparate idioms – the *grotteschi* decoration of the wall-surfaces, the *trompe-l'oeil* architectural perspectives in the vault of each bay, and the pictorial episodes which were set into them. Beyond that, the assistants were contributing their own inventions. The Vatican Loggia is perhaps the most conspicuous example of how much the workshop extended the concept of 'Raphael' which was to be passed on to future generations. Giulio Romano inherited Raphael's artistic estate, which meant not only the direction of the workshop and its team but all the master's unfinished projects or outstanding commissions, together with the rich storehouse of his drawings, designs and sketchbooks. Between 1520, when Raphael died, and 1524, when Giulio Romano removed to Mantua and Francesco Penni also left Rome, the Raphael studio continued in business, effectively adding another four years' achievement to the master's life-work.

21

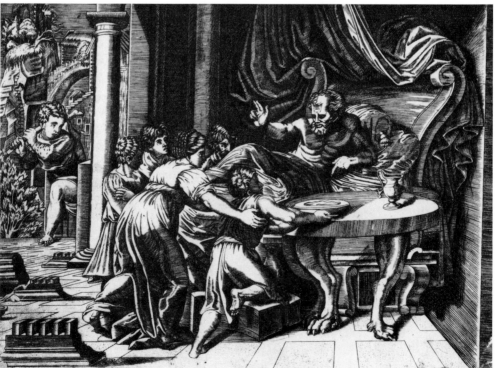

Isaac Blessing Jacob: etching from 'Raphael's Bible' by Giovanni Lanfranco, and a later, anonymous, engraving of the same subject

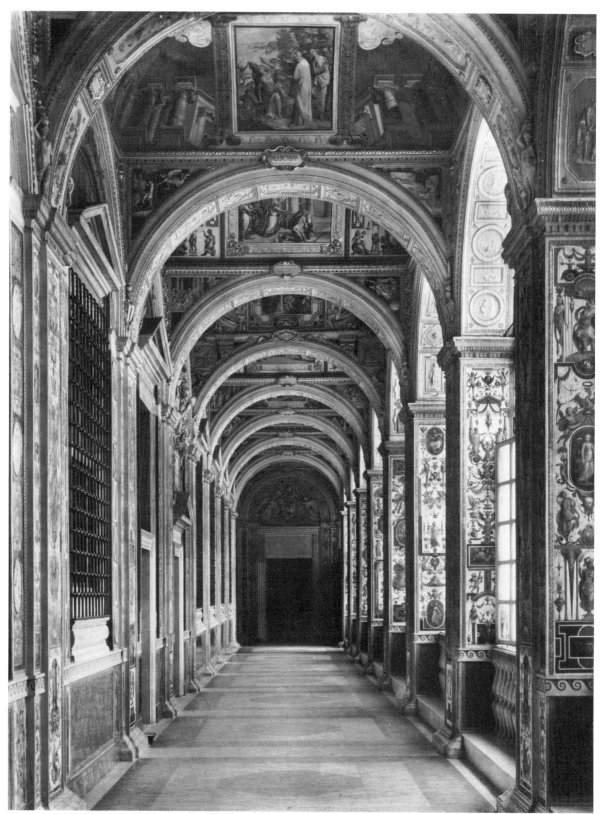

The Raphael Loggia in the Vatican

We have already seen how the third of the Vatican Stanze, which was to have frescoes dealing with former Popes called Leo, had begun to be delegated to assistants. Some scholars go so far as to say that only one figure of a child in the *Burning of the Borgo* was personally painted by Raphael. Giulio Romano is credited with the rest, although some of Raphael's most famous 'inventions' are included in it – the woman's figure on the right, for example, with a water-pot on her head; the man hanging from the wall on the left, who found his way into Rubens's *Battle of the Milvian Bridge*; and the man carrying his father (in reference to Aeneas's rescue of Anchises in the *Iliad*), who may have been studied by Bernini. The second fresco, the *Battle of Ostia*, is similarly attributed to Giulio executing Raphael's designs, with similar influential effect: the central soldier in the plumed helmet bequeathes a memorable *motif* to Jaques-Louis David's *Oath of the Horatii* of 1785.

The other two frescoes in the room, though painted in Raphael's lifetime, have always attracted less attention because they feel less characteristic of him. But what is 'characteristic' of an artist who was working at this same time towards the radical innovations of the *Transfiguration*? The *Battle of Ostia* already breaks entirely from Raphael's previous habit of designing a wall with a centralised perspective. The movement surges across the space in a diagonal that doubles back on itself to carry the eye to a distant and very high-set horizon. It was a new zig-zag device for recession which sent its echoes through Mannerist landscape (even those of Breughel, who was in Rome in 1553) and was used in more compact ways by Poussin. Even bolder is the third fresco, the *Coronation of Charlemagne*. An eye-catching line of

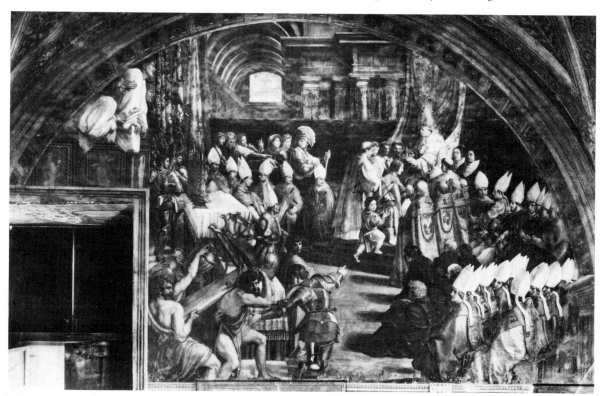

The Coronation of Charlemagne, Raphael from the Stanza dell' Incendio in the Vatican

robed and mitred bishops circles across and into the depth of the composition like the half-twist of a corkscrew, only for the spatial tension to be suddenly released down a tunnel of perspective placed high up and off-centre. The inventiveness of the design is nowhere matched in the quality of the painting, and one feels a change has taken place in the relationship between Raphael and his assistants. They are no longer extensions of his painting arm but collaborators in joint ideas. Giulio Romano, as we know from his later career, lacked neither invention nor daring on his own account. He was a coarse painter beside Raphael, but gifted, intelligent and with a strong streak of wayward, eccentric imagination. It is not difficult to see the master indulging and even being stimulated by his most precocious pupil.

But when Raphael died, and both his guidance and the constraint of his personality were removed, Giulio's more intemperate manner asserted itself in the major projects that had still to be completed. One of them was the Villa Madama, but there Giovanni da Udine's skill and taste are more on display than Giulio's. A second set of tapestries was designed to follow up the tremendous impression which had been made by the Sistine Chapel set, and it is difficult to know how much these may have been based on discarded Raphael designs or worked up by Giulio and his collaborators on their own initiative, drawing freely on the remaining stock of Raphael sketchbooks. The tapestries are still exhibited in the Vatican Museums, but even the most striking of them, like that of the *Massacre of the Innocents*, has a violence and visual restlessness that Raphael even at his most experimental could not have condoned. The same restlessness, the same failure of a larger controlling vision, characterises the frescoes of the Sala di Constantino. This was another of the Vatican Apartments which Raphael may have discussed but had no opportunity of beginning. The commission was even reopened to other designers, and was only won for the Raphael workshop by the concerted efforts of Giulio Romano and Francesco Penni against competition from Sebastiano del Piombo. For the enormous *Battle of the Milvian Bridge* (the victory by Constantine which won recognition for Christianity as the official religion of the Roman Empire) Giulio is said to have been working from a cartoon he designed with Raphael's approval. Whether this was true or not, the fresco was admired as coming within the broader canon of Raphael-inspired designs, and had its consequent effect on heroic battle-scenes.

Raphael's reputation in the centuries to come was therefore conditioned to a very considerable extent by a body of work which was only his by extension. The latter part of his career seemed proportionately weightier by the addition of what the workshop had achieved, and his 'late Roman' manner attracted an amount of critical attention which today looks excessive. In France in 1687, for example, Charles Perrault pronounced authoritatively that the *St Michael* and the *Holy Family of Francis I*, both very late, 'excel everything that Italy possesses'. A touch of chauvinism and deference to royalty can be suspected, as both works had been painted for France and were in the royal collection. But they had both been much repainted, and by modern standards neither of them can compare in quality with the *Castiglione* portrait which Cardinal Mazarin had by then brought into the

country. Perrault's rather absurd claim is nevertheless symptomatic. The important Raphael was the late Raphael, despite the workshop's heavy handling and more rhetorical tone. The work of Raphael's first Roman period was either less well-known or seemed quantitively less important, while Raphael of the years in Perugia and Florence had to wait until the early nineteenth century to be rediscovered.

And yet the influence and even the achievements of the Raphael workshop are not to be undervalued. They introduce qualities which do not fit the clear-eyed, level-headed image of the Raphael we may prefer and think we know. But so does the *Transfiguration*. The workshop may be allowing us glimpses of a mind and a pictorial vision as unpredictable as that which leaped from Florence to the Stanza della Segnatura, and from the Stanza della Segnatura to the Stanza di Eliodoro.

The history of the Raphael Movement is carried along on a steady groundswell by two kinds of partisan – theorists who used Raphael to illustrate their own ideas, and artists teaching or studying at art academies. Academies were intended in the first instance as learned bodies devoted to maintaining the status and standards of fine art. But their teaching programmes made them to some extent an institutionalised development from the workshops of the Renaissance. Raphael by his own career had done much to raise the artist in social and intellectual esteem, and the gradual appearance of the academies in the later sixteenth century was a direct consequence of that improved status. The first was founded in Florence in 1563 by Vasari, another – the Academy of St Luke – in Rome in 1593, and a particularly influential one in Bologna was directed by Ludovico Carracci and his cousins, Agostino and Annibale Carracci. The Academies of Fine Art based their teaching almost exclusively on the study of Nature (that is to say life-drawing) and the study of Antiquity. Their bias was therefore classical, and became more narrowly and even controversially so as the centuries went by. Raphael was enshrined in their curricula because he was, as the seventeenth-century art historian Bellori emphasised, the 'true classicist': in him Nature and Antiquity were combined.

There were always rebellions against the classical interpretation of art. But as the rebellions came from any number of directions and the classical viewpoint tended to remain the same, the Academies came to be seen as bastions of conform-ism and, by the nineteenth century, as the outright enemies of all experiment and freedom of expression. They were perhaps less so than they were later made out to be. The Royal Academy, for example, which was founded in London in 1768, was a liberal-minded institution which never suffered from outside control. That dread precedent was established by the French Academy in Paris which was founded in 1648. Thirteen years later it came under the direct control of Louis XIV's chief minister, Colbert and became an instrument of 'official' attitudes and policies. By a slow but inevitable association of ideas, the word 'academic' developed all the derogatory overtones it has today. Drawn into its embrace are notions of conserva-tism, rigidity, prejudice and establishment monopoly. Coloured by that association are classicism in art and the reputation of Raphael.

The Academies may have harboured great artists from time to time. The historical record tends to demonstrate that they did not produce them. It is Raphael's influence beyond and outside the academic tradition, sometimes on artists who would seem to share no common ground with him, that really begins to define what he achieved. Some of the influences are not even on painters. The illusionistic architectural perspectives of his stage designs were seen by Serlio, had their effect on Serlio's influential treatise on architecture and so passed into theatrical tradition. His architecture was admired and studied by Palladio, and so passed into the tradition of the classical villa and the English 'country house' of the eighteenth century. His revival of the antique Roman idiom for wall-decoration in the *grotteschi* style was redeveloped in Versailles and redeveloped again in the Neoclassic ornament of the Adam Brothers. His experiment of combining materials and media in a sumptuous environment which encloses the spectator's own space – the experiment, that is to say, of the Chigi Chapel – anticipates the practice of Bernini who, appropriately, completed that chapel and furnished Raphael's two unfilled niches with statues of his own.

In the field of painting Raphael's influence is both persistent and diffused. His repertory of motifs for figures and gestures is very wide and very varied, and most of them have the classical characteristic of being so apt as to look obvious. Once alerted to them, the eye seems to catch them everywhere, even in the work of artists who may well have arrived independently at a similar motif for a similar purpose and by a similar process of mind. Sometimes a Raphael quotation is so thoroughly absorbed, adapted and re-thought that only an echo or a suspicion justifies calling it a quotation. At other times it is plainly recognisable even in its adaptation. Within a year or two of Raphael's death, for example, Correggio was happily sending Raphael figures whirling round the domes of San Giovanni Evangelista and the Cathedral in Parma. His astonishing airborne visions in these two works, which illusionistically open up the domes to the sky and fill them with figures tumbling through space, have often been seen as anticipations of the Baroque. The Raphael he parallels is partly the Raphael of *The Transfiguration* and partly the Raphael who also anticipates the Baroque in the Chigi Chapel, with its golden dome and openings to the sky and figures seen from below. Correggio's glowing sensuality, on the other hand, takes its cue from the nudes of the Cupid and Psyche frescoes, and he is the first painter to start sweetening the sentiment of the Raphael Madonna and Child.

The seventeenth century, the great century of the Baroque, is when one might expect Raphael's influence to be least potent. In fact the very exuberance of the new style produced a correspondingly strong classical counter-balance. It is the century of Poussin as much as it is the century of Rubens and Bernini. Bernini himself, who was virtually the creator of the Baroque, would not even have considered he was anti-classical, however much he bent the rules: to him Poussin did not represent some opposing school of thought but was, on the contrary, 'the greatest and wisest painter who ever existed'. One finds admiration for Raphael, therefore, in artists

practising contrasting styles: in both Bernini and Poussin, in both Rubens and the Carracci. Bernini visited France and in a series of addresses to the Paris Academy contributed his views on the *querelle* between the advocates of drawing and the advocates of colour. By inclination he tended to support the claims of colour over those of line, but he used Raphael to illustrate points on both sides. He quotes, for example, the *Portrait of Leo X* as an example of Raphael's ability to paint with a colourist's brush as skilled as Titian's, only to warn the colourist-school on another occasion that they should correct their style by study of Raphael's controlled design. Poussin was perhaps a more ardent Raphaelist than Bernini but he was also a stricter classicist that Raphael. Compared with other painters Raphael was, he said, an angel: compared with antiquity, an ass. He gave his highest praise to the *Transfiguration*, but the works which influenced him more deeply were the tapestry-designs. His two great series of paintings on the *Seven Sacraments* are like a rethinking of the format and presentation of the tapestries as a sequence of scenes thematically linked but independent. He sets the figures further back in the picture-space than Raphael had, but where one subject – *Christ's Charge to Peter* – coincides 129
in both the *Sacraments* and the tapestries, Poussin's earlier and later version of it are equally haunted by Raphael's visualisation of the scene. At pains to image it afresh, he uses the very gesture of Christ's upward-pointing hand which Raphael had considered but abandoned.

At the beginning of the century the Academy which Ludovico Carracci had founded in Bologna set the pace for a firm consolidation of classical principles which helped to balance the influence of the Baroque. Not only was Raphael himself studied, but the Bolognese School encouraged the same devotion to life-drawing and the same judicious eclecticism which had been the foundations of Raphael's own practice and style. Domenichino and Guido Reni were pupils of the Carraccis, and both executed major works in Rome which kept that city the centre of a continuing tradition of Raphaelesque classicism until Poussin settled there in 1642. Rubens was also in Rome in the first decade of the century. It is easy to see the magnificent, tumultuous Rubens carrying back to Antwerp the memory of Michelangelo as the most lasting impression of his stay. It is less easy to see him as a conscientious student of Raphael. But Raphael quotations are frequent enough and 127
recognisable enough in Rubens to show that he was thoroughly familiar with the *Galatea*, the Cupid and Psyche loggia, the tapestries and at least the *Burning of the Borgo* among the Vatican frescoes. There is even a copy by him of the *Portrait of Castiglione*. But for once his fluency falters before that composed and tranquil image. Rubens's Baroque urgency looked to Raphael for something else – the telling drama of his gesture in narrative scenes.

Two other painters of the seventeenth century were affected by this same quality, and they are perhaps the most remarkable and, in a sense, the most moving examples of Raphael's influence. They are Caravaggio and Rembrandt. Neither has any obvious affinity with him in style or temperament. The art of both comes from

Continued on page 230

Raphael's compositions and imagery influenced later artists for generation after generation, but they were known largely through engravings. Those by Marcantonio Raimondi and Ugo da Carpi were authorised by Raphael himself: Veronese and Manet were among those who based paintings on them (118–122). The work of his assistants in the Vatican Loggia was believed to be his own and achieved immense popularity as 'Raphael's Bible' in a continuous flood of reproductions (123–125). But many artists visited Rome, and even when they responded to Raphael in such totally personal ways as Caravaggio, Rubens and Poussin, they at least knew him at first-hand (127–129). So, more surprisingly, did Rembrandt who never left Holland. He owned volumes of Raphael engravings, but he saw the *Castiglione* portrait at a picture-auction in Amsterdam (130–132).

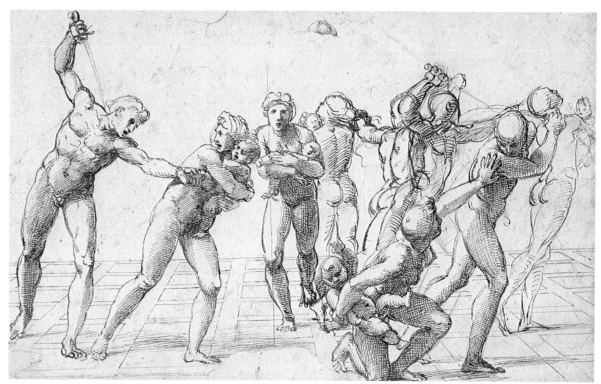

118 *Study for* The Massacre of the Innocents, Raphael (British Museum)

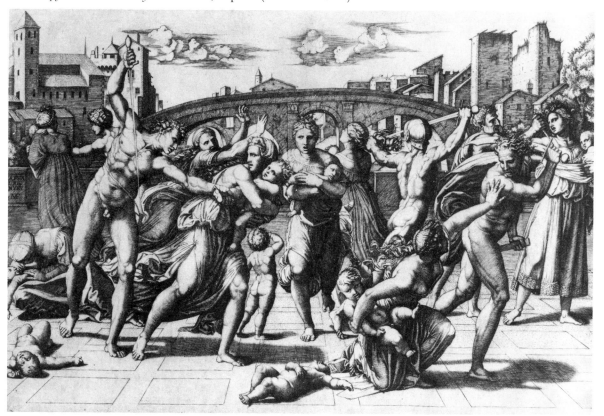

119 *The Massacre of the Innocents*, Marcantonio Raimondi after Raphael

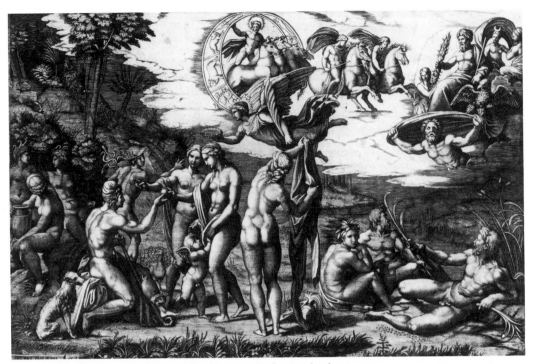

120 *The Judgement of Paris*, Marcantonio Raimondi after Raphael

121 *Le Déjeuner sur l'Herbe*, Manet (Louvre)

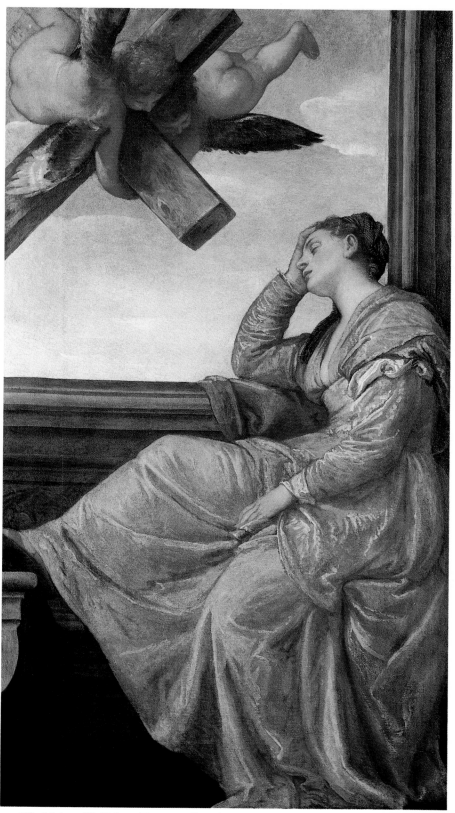

122 *The Vision of St Helena*, Veronese (London, National Gallery)

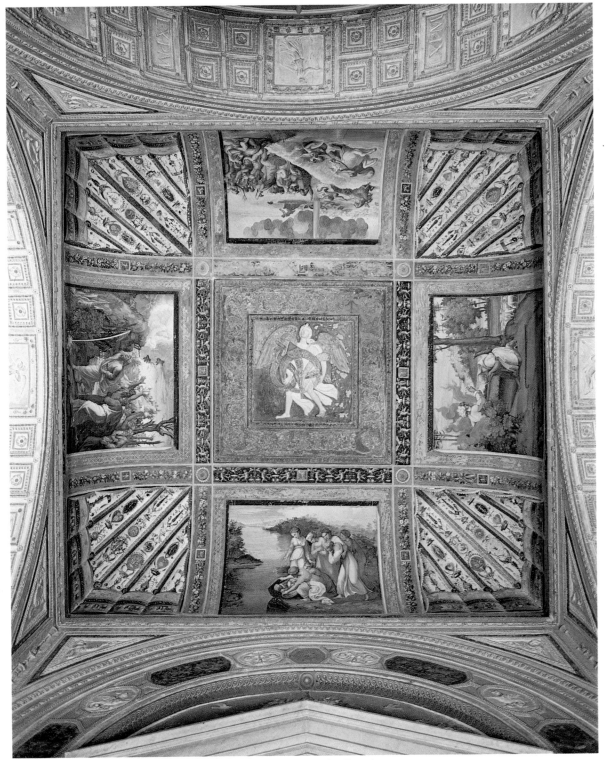

123 Vatican, Raphael's Loggia, *Scenes from the Life of Moses*, Raphael's assistants

124 *The Finding of Moses*, 16th-century engraving after Raphael

125 *The Finding of Moses*, 19th-century engraving after Raphael

126 *The Miraculous Draught of Fishes*, Ugo da Carpi after Raphael

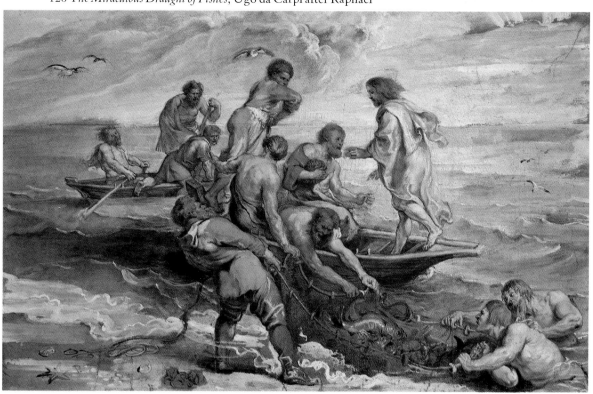

127 *The Miraculous Draught of Fishes*, Rubens (London, National Gallery)

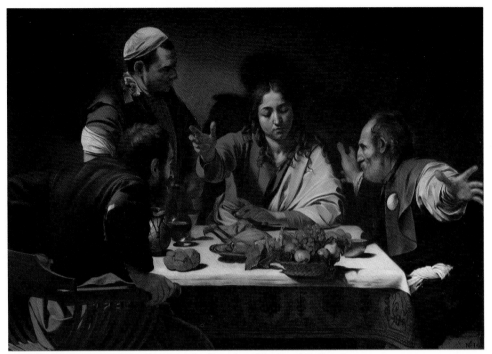

128 *The Supper at Emmaus*, Caravaggio (London, National Gallery)

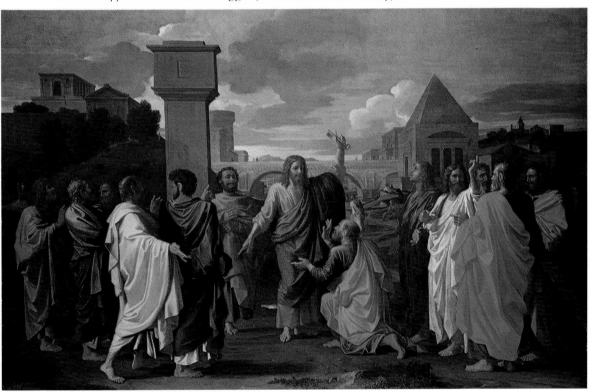

129 *The Sacrament of Ordination*, Poussin (Edinburgh, National Gallery of Scotland)

130 *Sketch of Raphael's portrait of Castiglione*, Rembrandt (Vienna)

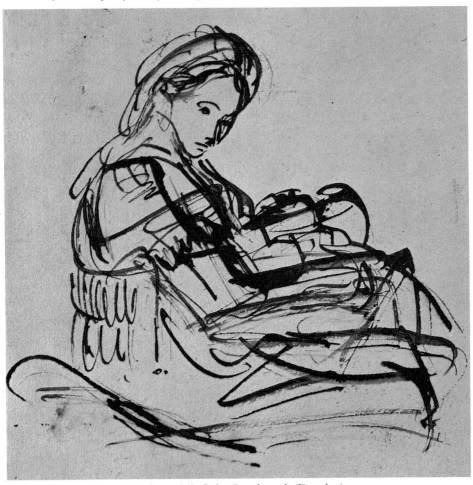

131 *Sketch after Raphael's Madonna della Sedia*, Rembrandt (Dresden)

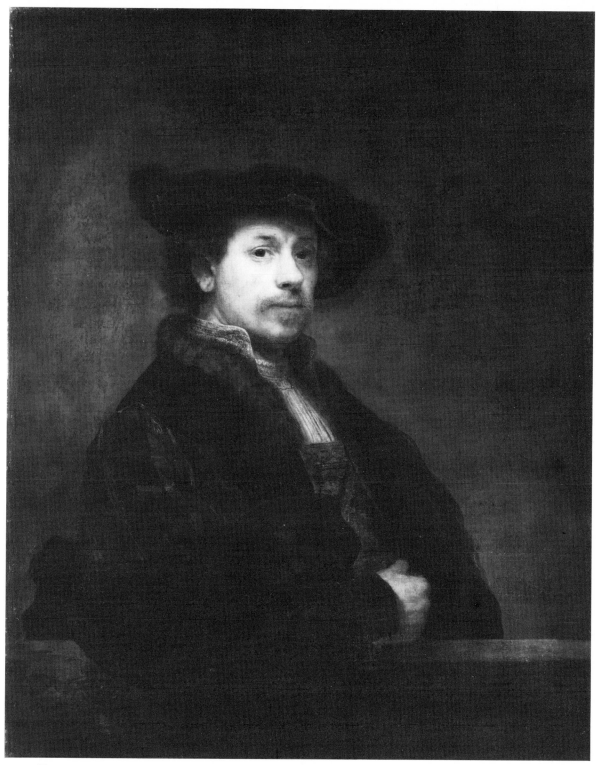

132 *Self-portrait*, 1640; Rembrandt (London, National Gallery)

a world of feeling utterly opposed to the certainties and idealism of the classical vision. But both were concerned with that economy of expression which tends to be an attribute of classical style. Caravaggio is so vividly dramatic that he almost obscures the actual simplicity of the images he uses. If he looked at the lower half of Raphael's *Transfiguration* for its violent lighting and emotional action, he saw also that the plunging shadows do not muffle one illogical form or one unfunctional contour. He uses realism to wrest more startling intensity from a scene than Raphael, but he does so with a Raphaelesque calm in the faces and what can only be called a Raphaelesque nobility in the turn of a figure or expressiveness of a gesture. Rembrandt, on the other hand, used Raphael as Raphael used classical sculpture: as a memory-bank for his own image-invention. In the sale of his studio effects were two 'Raphael' paintings (presumably copies) and three volumes of prints and engravings after his work. Only rarely does a Raphael motif re-emerge as recognisably as when the groping figure from the *Blinding of Elymas* is translated into Rembrandt's *The Blindness of Tobit*. Usually the very function of the image alters under Rembrandt's hand in the process of his remembering it. A famous example is the sketch he made of the Castiglione portrait when it came up for sale in an Amsterdam auction-room in 1639. He noted the date and also the price (3500 guilders), but the line of the hat was already changing shape as it reached the paper, and the features were taking on the familiar cast of Rembrandt's own. He had recognised a classic model for a self-portrait. Titian's so-called *Portrait of Ariosto* passed through Amsterdam in that same year – it may be earlier than the *Castiglione* and could even have influenced it. From a fusion of the two images in his mind, Rembrandt fashioned a type of half-length portrait which itself passed into the European tradition.

Studies of Feet, with an Annunciation, Agostino Carracci, pen and ink (Windsor)

The Blindness of Tobit, Rembrandt etching

Rembrandt is the outstanding example of an artist who could be nourished by Raphael imagery but remain wholly outside the Raphael Movement. Classical theorists were taking over by the eighteenth century, interpreting Raphael in terms of how faithful or unfaithful he had been to the art of antiquity. The rules for 'correct' classical painting grew stricter, and correctness was judged more by antiquarian standards than by Raphaelesque ones. The most celebrated exponent of Neoclassicism, for example, Anton Raffael Mengs (the middle name in honour of the painter) analysed the style of his idol in great detail. Raphael was not able to draw beautiful hands, he decided, because the hands of antique statues were usually missing and could give him no model. The 'history-painting' which dominated the period and represented the noblest form of imaginative art, was cast resolutely in the antique mould. Only towards the end of the century did the rules relax sufficiently to admit contemporary history to the same elevated category. A turning point was Benjamin West's *The Death of Wolfe* in 1771. West was an American who settled in London and in 1793 became the second President of the Royal Academy. His predecessor, Reynolds, had been more an enthusiast for Michelangelo than for Raphael, although he found Raphael a more comfortable

Continued on page 241

In the eighteenth and nineteenth centuries Raphael-worship reached such heights that in 1833 his tomb was opened to settle doubts about whether he was buried there (133). His paintings were enshrined in the 'most famous room in the world', the Tribuna of the Uffizi – although Zoffany's picture adds some that were elsewhere in Florence – (134–138). The largest painting Turner ever painted, an allegory of fame, sets within Rome, history's greatest city, the world's greatest artist: Raphael (139, 140). In France Raphael stood for the purest classical style (141, 142), in Germany for the highest ideals of religious art (143), and in England the first major study-collection of his imagery was assembled by Prince Albert, whose mausoleum at Windsor was embellished with copies of Raphael paintings (144).

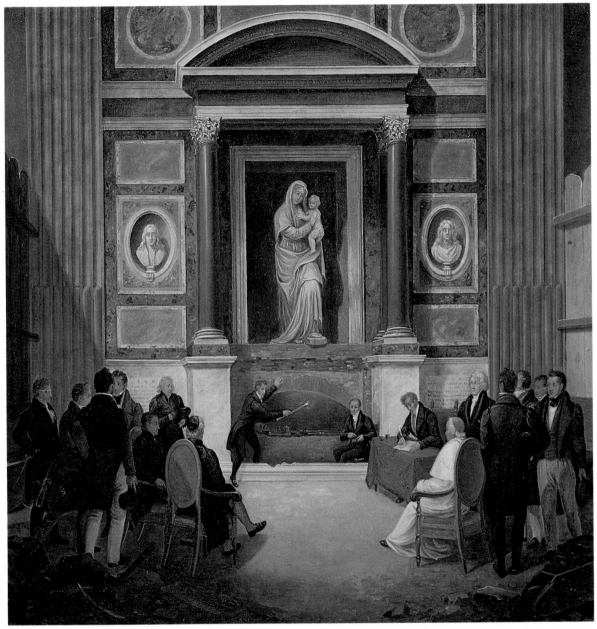

133 *The Opening of Raphael's Tomb*, Diofebi (Copenhagen, Thorvaldsen's Museum)

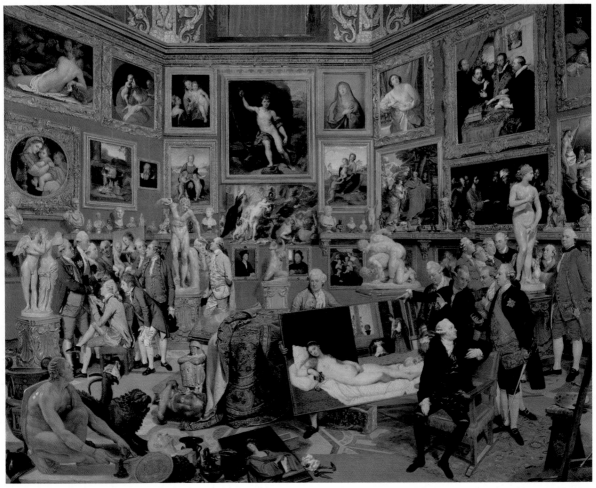

134 *The Tribuna of the Uffizi*, Zoffany, and 135–7 (below), details of Raphael paintings
138 (opposite) detail with the *Large Cowper Madonna* (Windsor)

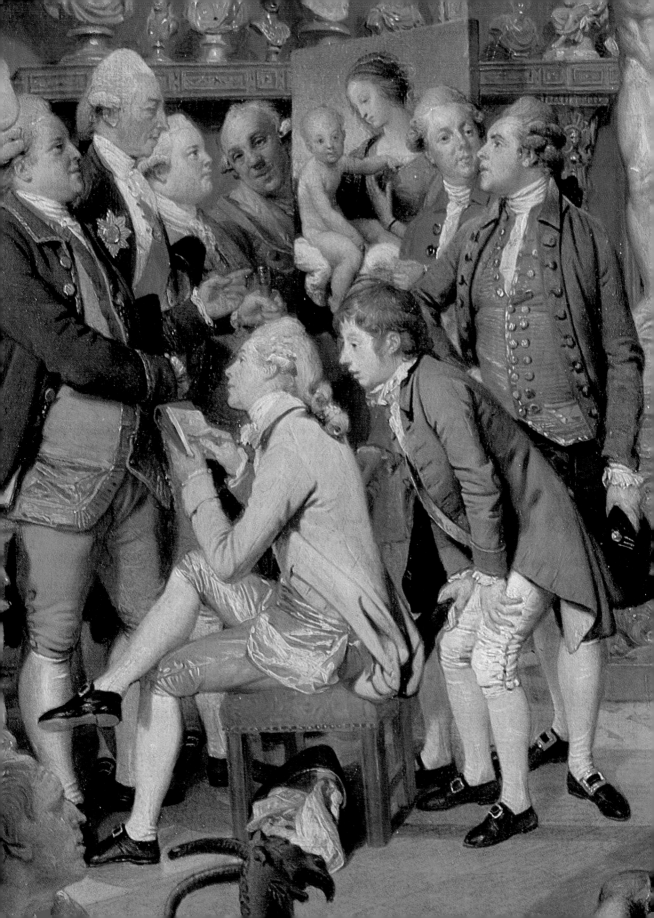

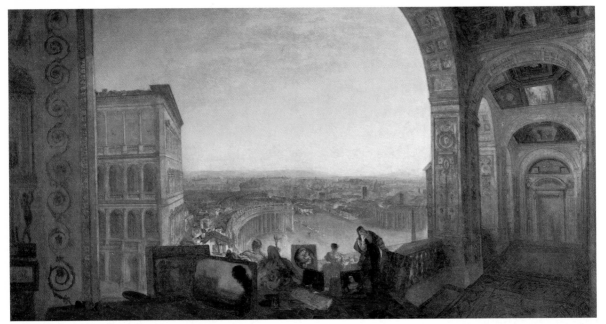

139 *Rome from the Vatican*, Turner (London, Tate Gallery)

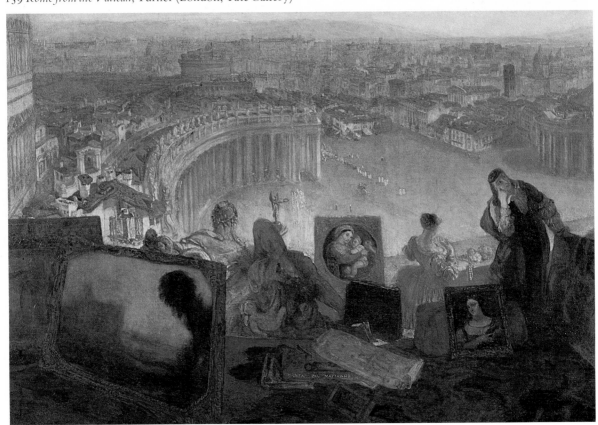

140 *Rome from the Vatican*, detail with Raphael and La Fornarina

236

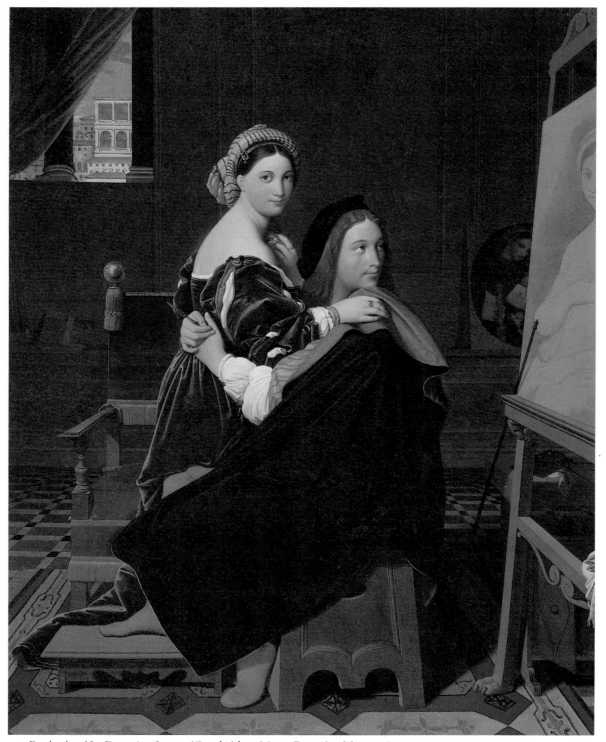

141 *Raphael and La Fornarina*, Ingres (Cambridge, Mass., Fogg Art Museum)

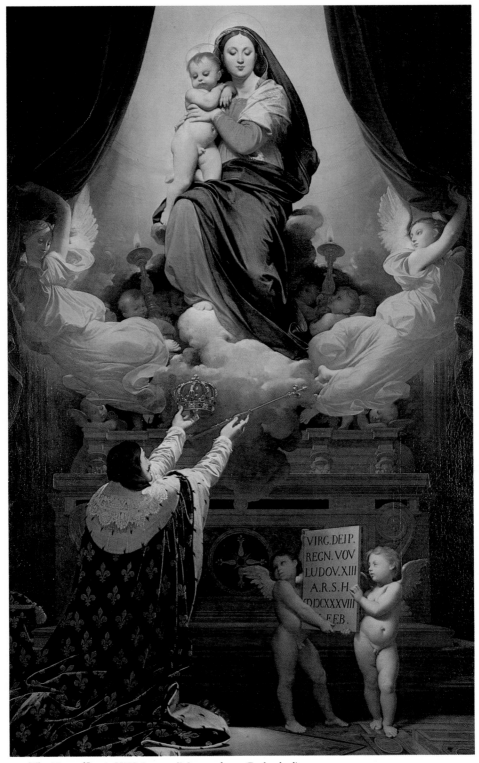

142 *The Vow of Louis XIII*, Ingres (Montauban, Cathedral)

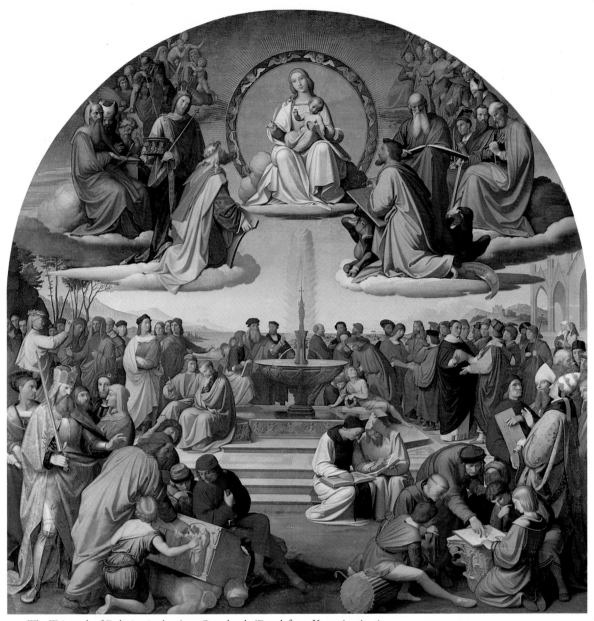

143 *The Triumph of Religion in the Arts*, Overbeck (Frankfurt, Kunstinstitut)

144 Windsor, The Royal Mausoleum, copy of Raphael's *Way to Calvary*

model for his occasional essays in classical allegory. But West was a confirmed Raphaelite and even became known as the American Raphael. The *Death of Wolfe* was a classical composition in Raphaelesque style but for the first time in contemporary costume, and its example led to another famous American essay in 'modern' history-painting, John Singleton Copley's *Brook Watson and the Shark*, of 1778. West had advised his compatriot about studying Raphael, and the picture adapts two Raphael motifs – one of them for the figure of Brook Watson himself, from a drawing of a fight with a sea-monster which was still attributed to Raphael in the eighteenth century; the other the gesture of his rescuers in the boat, which comes from the tapestry-design for the *Miraculous Draught of Fishes*.

With that massive, grinding gear-change of history, the nineteenth century, the Raphael Movement itself changed direction and character. The advent of Romanticism encouraged the growth of the artist's personal legend. A sentimental biography, based on Vasari but imaginatively elaborating on him, had already made its appearance. Now new myths gained currency. The painter had been divinely inspired by a miraculous vision which gave him the image for the *Sistine Madonna*. The *Madonna della Sedia* was of circular format because Raphael had seen a peasant-mother and her child outside a village inn, where the only painting-surface to hand was the end of a wine-barrel. Paintings of the scene round Raphael's death-bed proliferated; one of them by a certain Pierre Bergeret found its way from the Salon

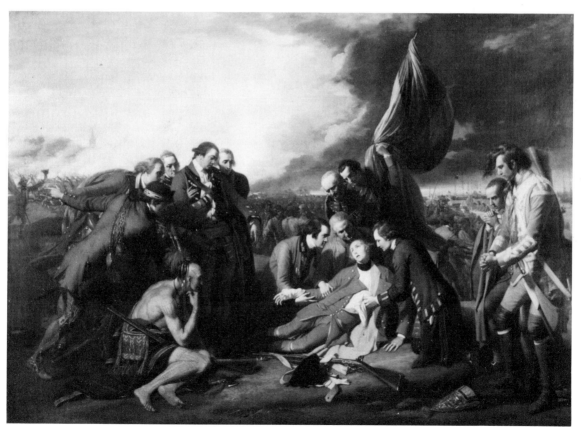

The Death of Wolfe, Benjamin West (National Gallery of Canada)

141 of 1806 to Napoleon's drawing-room at Malmaison. Even Ingres, the last of the great idolisers of Raphael, planned a series of five paintings on the artist's life. But the new concentration of interest on the man rather than the abstract principle of Raphael produced results hardly less bizarre than the myth-making. The Academy of St Luke in Rome had been exhibiting for some years what amounted to a sacred relic. It was reputed to be Raphael's skull. How it had come to be parted from his body was not explained, but the only way to prove or disprove its authenticity was

133 to open his tomb in the Pantheon. In 1833, with a Papal dispensation and much publicity, the skeleton was uncovered and found to be intact. Measurements of the skull were taken and checked satisfactorily against the self-portraits. One curious discovery was made. It was found that the larynx must have been unexpectedly large, indicating that the frail-looking youth with the long neck had spoken with a deep and resonant voice.

An opposite result of the re-focused interest was that scholarship began to sort out fact from fiction and Raphael from the Raphaelesque. The first of the great nineteenth-century monographs to appear was that of Quatremère de Quincy in 1824. The German scholar J. D. Passavant published his massive research between 1839 and 1858, to be followed between 1884 and 1891 by what is still a standard authority, Crowe and Cavalcaselle's *Raphael*. Passavant's work inspired an unexpected development in England. Prince Albert could reflect with some pride that the Raphaels in the English royal collection, which included all the surviving tapestry cartoons, constituted the finest holding of the artist's work outside Italy. His particular interest was how the drawings revealed the creative processes of

'The Remains of Raphael from a drawing taken on the spot,' anonymous print of 1833

Raphael's mind, and he set out to assemble a study-collection of all available comparative material. Photographs, reproductions and prints were tracked down all over the world, sorted and catalogued in 50 large folios. It was the earliest and most extensive study of its kind undertaken on any artist.

Prince Albert's passion for Raphael went further. He designed the royal residence on the Isle of Wight, Osborne House, as an example of Raphaelesque architecture, and the Royal Mausoleum at Windsor was similarly designed, with interior decor- 144 ation reproducing frescoes and paintings by the master. But it is through Prince Albert also that one of the earliest nineteenth-century manifestations of the Raphael Movement became linked to one of the last. The group of German painters called the Nazarenes, like the English Pre-Raphaelites who were partly inspired by them, aimed at a total rejection of academic classicism by reviving what they believed to be the standards of early Renaissance art. More specific in their ideas than the Pre-Raphaelites, they wanted a Christian art and a pure Christian style based on Dürer, Perugino and early Raphael. They came together as a group in Rome in 1810 and 143 made Raphael, even the later Raphael, their daily study. Over the next ten years they taught themselves the almost lost and certainly neglected art of fresco, leading a campaign for its revival as the proper vehicle for high art on a suitably noble scale. The Scottish painter William Dyce had met the Nazarenes in Rome, and when he introduced their theories and style to England in the 1840s, he introduced also their campaign for fresco. It bore fruit in an ambitious scheme, prompted and supported by Prince Albert, for frescoed history-scenes in the House of Lords in London. Dyce himself was responsible for those of the Robing Robe. But to all intents and purposes, they were the last manifestation of the Raphael Movement.

Raphael has now been out of fashion for the larger part of our century. That is long enough to free us from the legend. The Raphael Movement is dead and we do not need to respond to him as though the very foundations of culture were in question. On the other hand, we have not yet found the place for him in our own culture, and that has left us with certain difficulties. He is not like some artists whose former fame now seems almost inexplicable. We have no temptation to relegate his paintings to the cellar as historical curiosities. But he does represent a set of values which, for one reason or another, are in eclipse. There are parts of him that give us no difficulty, but they seem to be the secondary or incidental parts. The obviously major achievements, the grand machines, the most ambitious and profound statements are those on which previous centuries concentrated their attention but are just those which leave us today non-plussed and with a bankrupt vocabulary. We are led with dreadful inevitability towards words and attributes which have lost their power to convince us. Balance, harmony, grace, facility, naturalness, beauty are no longer persuasive virtues. They are all bound up with what has been understood by 'classical' standards and ideals, but our own century has never come to terms with them. Is that fact a reflection on the values themselves or a comment on our later age for being impatient with them? Are they in eclipse for purely tempor-

The Entombment (left), adaptation as a marble relief after a drawing by Raphael; and *Isaiah*, adapted from a Raphael fresco (Frogmore, Royal Mausoleum)

ary reasons? Or have they been outstripped by history and permanently replaced by different standards? Why is Raphael out of fashion? Why do we hesitate about him? Why are we slow to respond to so much which by any definition constitutes one of the most remarkable creative achievements in European art?

Our own cultural and aesthetic assumptions are every bit as partial as those of the centuries when Raphael's name was most potent. The question is whether ours are any more secure or more just, and even whether they are really, in spite of appearances, so different. What is most revealing about the history of Raphael's reputation is how the same arguments, the same groupings of prejudices for and against, keep recurring in circular repetition with only minor changes of emphasis. Each century recognises the same phenomenon – that somehow Raphael forces certain fundamental issues to a head because of what he is, or what he did, or what he stands for. That has been his great significance for the past. It helps our under-standing of him today if we can see that it remains a considerable part of his significance even now. For the issues are perennial and so, with some adjustment to the terminology, are the arguments. The history of Raphael's reputation can be a guide to questions we ask of art ourselves.

He has long been especially revered as a religious artist, but what beyond good art entitles him to that special place? One answer is self-evident to anyone who visits Italy. Reproductions of his Madonnas are familiar icons in homes, shops,

restaurants and on the dashboards of taxis. In one sense the audience for his devotional images has never changed. As was suggested earlier in this book, Raphael had a particular gift for responding to the tone and atmosphere of faith. Within a Latin Catholic context, he satisfies a need for accessible imagery and it is no part of art-criticism to question further. But there are those outside that context who can experience the spiritual content of a Byzantine Pantocrator or a Fra Angelico heaven but would not be equally moved by Raphael. We are in border country here between art and religion. Part of the problem is that we need to recognise in

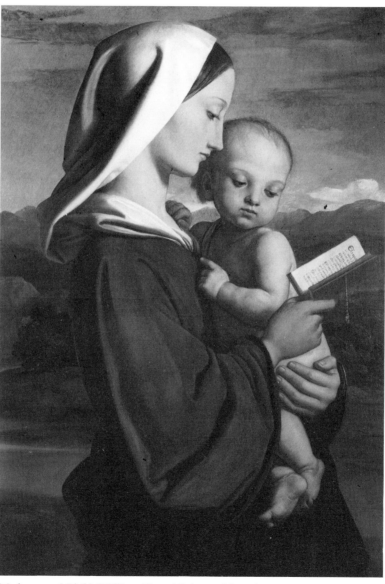

Madonna and Child, William Dyce (Osborne House)

245

ourselves a conditioned and specifically 'modern' unease. We do not respond to naturalistic imagery in religious subjects. Our instincts are not unlike those of the early nineteenth century when it discovered a deeper 'sincerity' in what it called 'primitive' art. By 'primitive' it meant Italian art before the High Renaissance and early Flemish painting. Our equivalent might be even earlier – twelfth-century Gothic, for example, or the Romanesque. Christian iconography stirs us most deeply when the style is furthest from an appearance of reality. But at Raphael's we halt in some confusion. His later religious painting involves a specifically doctrinal and public role, an exhortatory grandiloquence, even a theatricality which we find embarrassing. The early Madonnas, on the other hand, hover with gentle charm in an area of sentiment which is as much to do with human appeal as spiritual truth. We turn with more comfort to Rembrandt and the tenderness of his insight into the troubled, private, Protestant soul. The comparison is instructive about what each artist is in fact saying, in religious terms. Rembrandt moves us because his humanity is humble, his vision tragic, and his symbolism of light is that of grace piercing our darkness. Raphael's Christian imagery is about certainty, confidence and affirmation, bathed in a light which is the principle of existence.

The Christian tone of the tapestry designs has already been touched on. There too, Rembrandt and the contrast between Catholic and Protestant imagery are relevant, more particularly in relation to the noble and heroic types of humanity which a classical idiom favours. In a socially sensitive age like ours this faces us with another problem. Again it affects the later rather than the earlier work, but from the moment Raphael arrives in Rome to the end of his life, the manner and ethos and intention of his art are aristocratic. It is not only made for and reflects a privileged class, but its aesthetic of the noble and the ideal involves an aristocratic concept of art. Its cult of the antique is developed for an élitist intelligentsia. Its forays into pagan mythology, like the Cupid and Psyche frescoes whose influence was so widespread, depend on the taste of a leisured and sophisticated audience playing the pretence of Arcadian pleasures. They anticipate the spirit and even something of the style of Boucher's more piquant *rococo* diversions for the court of Louis XV. We are in border-country again, but this time between an aesthetic and a socio-moral response. The sensitive spot we touch here is whether classicism in figurative art cannot help but reflect certain undemocratic values.

It does undoubtedly reflect a hierarchy of artistic values which was itself rooted in the social order, for the concept of 'high art' goes back to a classification by Aristotle. Poetry and painting, he had said, could be judged by three categories of worth, according to whether the subject-matter treated of beings superior to ourselves, comparable to ourselves or inferior to ourselves. The first and highest category concerned itself only with the elevated and the beautiful, the second with the imitation of 'life', and the third with subjects which were mean, vulgar or prosaic. The Aristotelian principle not only affected the High Renaissance but classifications of art until at least the end of the eighteenth century, and it gave an authority to patrician values even when these were unconscious. To Raphael himself the aristo-

cratic code in its best sense was more personal. He had been brought up in a court exceptionally sensitive to nuances of behaviour and he subscribed to Castiglione's philosophy of manners. At least one aesthetic principle can reasonably be linked with that philosophy. In Ludovico Dolce's *Dialogo della Pittura*, published in Venice in 1557, Aretino is given the role of defining Raphael's virtues. He brings up the argument that an appearance of ease is the highest accomplishment of any art. He is of course only restating Horace's 'art conceals art', but an appearance of ease is central to Raphael's idiom. Partly aesthetic, partly social, it characterises a behavioural poise in his art which stems from his personality but which also contributes to the classical tone. It did much to determine the influence of his style during centuries which were socially structured in a very different manner from our own.

We face a different set of problems and prejudices when we approach the question of Raphael's eclecticism. Is there any artist of his stature who has so constantly to be defined in terms of other artists' styles? Is there any who leaves us so unsure whether even then we have defined the essence of himself? We see him as the sum of his parts, and at a conservative estimate they consist of Perugino, Leonardo, Michelangelo, Bramante, classical antiquity and a dash of Castiglione. Michelangelo himself put it more baldly: 'Everything Raphael had he got from me.' The problem was recognised in earlier centuries but never unduly worried them. It was even turned to praise. Bernini said that Raphael was like a great sea which collects the waters from all rivers and that he is therefore of the highest rank because in him are the perfections of all other painters put together. That argument is repeated over and over again in the course of the Raphael Movement, and it is an irritating one because the conclusion doesn't necessarily follow from the premise. Raphael is not proved excellent because he absorbed other excellences. Experience usually demonstrates that eclecticism in art weakens rather than strengthens. Each constituent tends to lose something of its individuality in the mix. We say that Raphael synthesises the best of his time, but we are still haunted by the adjective synthetic.

The issue here is the one which polarised the never-ending controversy of Raphael versus Michelangelo. It is still central to how we see art today, for it involves the question of originality. What does it mean to be 'original' in art, and is it something to be aimed at for its own sake? Vasari added a significant passage to his second edition of the *Lives* – at the prompting, it is said, of Michelangelo – to make clear that he saw Raphael's gifts as those of industry, application and intelligence; but they did not include in the last analysis the unique, God-given spark of true creativity. The true artist, according to this argument, is himself alone. He is to be valued above all for bringing into the world what no one else had thought of before. It is a pernicious argument because it overstates the case. It runs counter to any definition or value we may put upon the process of learning. But in all ages it seems to have a fatal attraction for those who want the *frisson* of what art can give before they look for its confirmation of our deepest feelings and beliefs about human experience.

Throughout the art of the twentieth century we have seen this argument

damagingly at work. It has forced artists into novelty even against their better instincts. It has aggravated the divisions and competitiveness of an art-industry which has been busier hunting for new definitions of art than considering whether well-tried ones might not serve. Most damagingly of all, it has affected the teaching of art in an over-reaction against 'academic' methods. The hopeful neophyte is encouraged never to copy, never to borrow, never to learn from example, but only to express himself and discover originality out of the depths of his inexperience. The attitude is damaging because it ignores how the true revolutionaries of our time have always worked, from Picasso to Duchamp to Jackson Pollock. What they ultimately reject or seek to go beyond they first profoundly and intimately understand.

Raphael is the archetypal representative, even to the point of being a disconcerting one, of the opposite argument – that art builds by conscious absorption of precedent, including copying and borrowing. It is a process which requires patience and humility, and these are not always compatible with energy and youth. It appears to lack the spice of experiment, but only to the short-sighted. It can obviously turn into a comfortable refuge for the conformist, and the 'academies' have always been accused of being that. But we are not concerned with conformists. The issue arose in an acute form in the middle of the most radical art-movement of the nineteenth century, which was Impressionism. The Impressionist ethic began by putting its faith totally in the 'truth' of what the eye perceives at any given moment. It rejected, in other words, all precedents in favour of the artist's unbiased 'original' visual experience. Around 1880 Impressionism experienced its famous crisis. The unbiased vision could not be sustained without help. Renoir went back to the Louvre to renew himself. Degas, that profound traditionalist, was confirmed in his constant warnings of what would happen. Pissarro looked for new disciplines. Monet alone (for there are always the great exceptions) refused to look behind him in order to go forward. One could say that the crisis years of Impressionism were the first major test in modern art of how far a revolt against tradition could go before the baby had been thrown out with the bath-water.

But if 'originality' has its dangers as a principle, is there not another and equal danger in underestimating it? May not the artist who conscientiously develops his skills within a framework of tradition and continuity lose something of his individual tone of voice? Raphael can seem, on casual acquaintance, to illustrate that dilemma. Many people can never quite escape the feeling that in his art some distinctiveness of personality has been too smoothed out. Where is the man himself behind such elegance and eloquence and suavity? Is there perhaps too evident a desire to please or a correctness which argues lack of an urgent personal vision? The feeling is by no means a purely modern one. In the eighteenth century, which could value suavity to the point of blandness, we often hear a slightly puzzled note in admirers who found the *Transfiguration*, for example, 'prodigious', but Raphael 'cool'. It depends, as always, on which Raphael one is talking about, and which period of his astonishingly condensed career, and in the end which particular work.

The real difficulty with him is not a lack of personality but finding any generalisation about personality which fits such varied expressions of mood and purpose. The search is not helped by having to include in that generalisation the Raphael who extended his activity through his workshop.

In his own time no concept of originality operated in the narrow sense that obsesses ours. His contemporaries rated the prevailing mind at work as a sufficient guarantee of value. A painting from the workshop was hall-marked 'Raphael' whichever hand had executed it. Nowadays we are so divided in our minds about such a practice that we react to it from opposite directions simultaneously. Part of us values the individuality of the artist so highly that only the unique, authenticated and wholly autograph work entirely satisfies us. Another part of us recognises why again and again in the art of our own time, artists have rebelled against that notion of individual uniqueness and the reasons for valuing it. They have produced 'multiples', they have exhibited 'found objects' and 'ready-mades', they have cultivated the 'impersonal' surface and 'mechanical' finish, they have ordered artworks from factories over the telephone. What they are insisting upon is what the Raphael workshop was about. The creative mind is paramount. Stamping the work with 'personality' is, by comparison, self-indulgent.

In three and a half centuries of discussion about what Raphael is or is not, one comment stands out for its modernity. For once it is not concerned with the ethos or meaning or content of his work but with the physical presence of his paintings. It occurs in the course of the famous *querelle* which raged in seventeenth-century France between the partisans of Rubens and Poussin, and centred on the relative importance of colour and drawing. In his *Dialogue sur le Coloris* of 1673, Roger de Piles argues that a good painting has an unmistakable visual immediacy. A good picture is striking at first sight. It should have the value of surprise, or what we would now call visual 'impact'. Raphael, he says, lacks this quality. He hastens to avoid blasphemy by stressing that it is the divine painter's only fault, and adds an important rider – examination and familiarity will reveal ever-increasing beauties. It is a very shrewd point, and it is one which is equally relevant to twentieth-century aesthetics, to our own habits of looking and to our appreciation of Raphael. We do not, on the whole, resort to examination and familiarity to reveal ever-increasing beauties. We want the short-term *frisson* of originality and surprise.

Modern art is largely based on visual impatience. It encourages the effect that can be taken in at a glance. We repay it by being much more easily impressed by visual simplicity, obviousness and 'impact' than by visual nuance or restraint. The major developments in painting at the turn of the twentieth century announced that this might well become a characteristic of modern art. Monet's evanescent subtleties of colour were succeeded by the exaggerated palette of the Fauves. Cézanne's slow and painstaking articulation of form in space became the more dynamic, fractured surfaces of Cubism. Of all twentieth-century painters, Picasso might seem to be a modern parallel to Raphael in terms of an art built on eclecticism and the synthesis of styles. But Picasso is predominantly an impact-painter, an artist

of visual and emotional shock, and that makes him an artist different in kind from Raphael. Or at least, different in kind from Raphael the Roman classicist, the Raphael of the *School of Athens* or the tapestry designs. If that is the Raphael we are talking about and not the Raphael of, say, the *Portrait of Tommaso Inghirami*, Roger de Piles was right. Raphael at his most classical can indeed be visually slow-working and even-paced. His most profound intentions would be forced out of balance if he were to have the surprise-value of Rembrandt, for example, who was the artist Roger de Piles had in mind for comparison.

But Roger was wrong if he was ignoring Raphael's visual clarity. Surprise-value can arrest the eye but cannot hold it if what the eye is trying to read is not immediately made clear. Raphael's continuing appeal to other artists is his gift for making clear what the eye needs to understand. It is a quality in his art which holds good at all points in his career, whether he is being thought of as a draughtsman or a colourist or a composer in space. It explains why Vasari could not withhold superlatives from him in spite of being convinced that Michelangelo was 'greater'. It explains his influence on the academies and teaching institutions of art when everybody else wanted to stress how gifted he was as poet, philosopher, antique Roman, connoisseur of the ideal, exponent of natural beauty or illustrator of Christian narrative. It explains why today, even when the ethos of his art seems remote or slow to stir our emotions, the individual paintings remain visually convincing, superbly thought through, beautifully put together, evocatively handled.

Clarity of this kind, one need hardly add, is classical. Raphael's life-long practice was to draw the *motif* again and again, to change it, refine it, condense and simplify it until visually it had resolved all ambiguities in a self-defining image. All artists we call classical follow in one way or another a similar procedure. It is irrelevant whether they borrow part of their solution from other artists, as Raphael borrowed from antiquity; or whether they check and re-check it against nature, as Raphael did by constant life-drawing; or whether they rely on something which can only happen between the working hand and the evolving image, as Raphael was intimating when he said: 'I follow an ideal in my mind.' It is a process which abstracts from the image what is visually essential to its meaning. 'Observe in Raphael,' advised Benjamin West in the 1770s, 'the imagination he used in arranging groups of figures, and all the different groups perfectly fitting the subject.' Ingres in the 1840s, ever re-drawing and refining the silhouettes of his own figures, worshipped above all the *clarté* of Raphael's. 'They say,' he would insist, 'what they propose to say.' It is what we see Degas doing as he concentrates on *motifs* of nudes and dancers. Or Seurat doing as he methodically builds up the images for *La Grande Jatte*. Or Cézanne doing as he studies the Provençal landscape, and can only explain his intention by holding up his hands and moving them together till the fingers lock. It is also what Mondrian is doing when he paints a tree or a chrysanthemum or a harbour-jetty, and goes on painting them until the marks on the canvas have abstracted from them the one clear visual message he wants to convey: until they 'say what they propose to say'.

We call the process classical. Why artists so struggle with it and have so often seen Raphael as a light on their path can perhaps be left to the words of a great Romantic and the last of the followers of Michelangelo – Auguste Rodin: 'Raphael's drawing is admired and with good reason. But it should not be admired for its own sake. It should be admired for what it means – the delicious serenity of spirit with which Raphael saw and which seems to expand from his heart to all nature.'

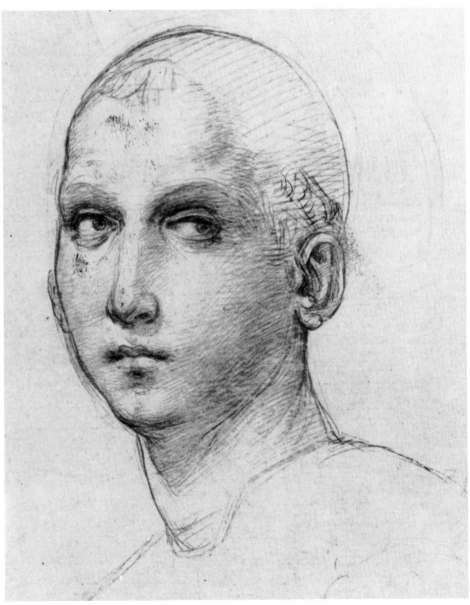

Study of a saint, for the Trinity fresco in San Severo, Raphael, silverpoint (Oxford, Ashmolean Museum)

I: Index of Works by Raphael

Italic figures refer to in-text illustrations,
roman figures to text references, not illustrated.
Dimensions are in centimetres.

II: General Index

Dates are given, where known, for Raphael's contemporaries.

Picture Credits